The Science

for the Camera

The Science and Art of Acting for the Camera provides a precise yet practical approach to help unlock the mysteries of acting for film and television as well as commercials. Written by veteran actor, producer, director John Howard Swain, the book offers a clear-cut, no-nonsense technique that equips aspiring or working actors with the necessary skills to succeed on camera. The technique teaches you how to build multi-dimensional characters; construct truthful and exciting relationships; ignite stimulating emotions; craft a series of discoveries guaranteed to energize your work; and much, much more. The book also provides instruction for actors working in commercials—from slating, to the dreaded "tell us about yourself" interview, to nailing "the tag" and embracing the cliché—and provides sample copy for students to practice.

John Howard Swain has coached a myriad of clients ranging from first-time performers to Emmy Award-winning actors, Supreme Court Justices and Fortune 500 executives. In addition to his New York stage credits he has also guest-starred in dozens of television's most iconic shows, including such classics as *Hill Street Blues* to *Law & Order: SVU*. As a director he has staged over twenty plays, including such hits as *That Championship Season*, *Veronica's Room*, and *The Owl and the Pussycat*. He has also directed four films: *Whose Life*, *Uncommon*, *Stand-by*, and the multi-award winning short, *A Younger Man*. Students from his program continue to work across the globe, and can be seen starring on Broadway, in television, and on film.

Praise for *The Science and Art of Acting for the Camera*

"John offers practical, common sense advice for actors on how to approach a text from both the analytical perspective as well as from the inner life of a character. He emphasizes that along with the importance of clarity and economy in technique and analysis, that the actor's work is also deeply personal and individual. It is the fusing of these elements—technique, analysis and individuality—that is the foundation of all great work."
— Tony Glazer, Director, *Junction, After the Sun Fell, Hostage, Those Things We Hold, Mired*

"John uses a clear and concise approach to simplify an incredibly complicated art form. In addition, his honest and realistic outlook on the business is refreshing and will be a great help to aspiring actors."
— Philip Huffman, Casting Associate, *Law & Order: SVU*

"John's approach to acting is the foundation of my work. He's given me a set of tools that I continually rely on. As I learn more from my experiences, I've gained even more respect for the depth and flexibility of his technique."
— Sumalee Montano, Actor, *Nashville, Nip/Tuck, Big Love, Boston Legal, Losing Control, West Wing, GloryDaze, Transformer Prime, Lincoln Heights, Shark, Final Approach*

"Since I started studying with John I've booked six national commercials, ten regional commercials, about twenty industrials plus roles in two different television series. Do I believe in what's he's teaching? You bet."
— Dave Boat, Actor

"I know when I see John Swain's name on an actor's resume that actor is serious about his craft and will be prepared. This is high caliber training."
— Joan Spangler, Owner, Look Talent Agency

"'You're booked' … are words our clients who study with John hear on a regular basis."
— John Erlendson, Owner, JE Talent Agency

"John's students are more confident, better at taking directions, and seem to be having a damned good time at their auditions. Thank you for making my job easier."
— Martha Sherratt, Sherratt Casting

The Science and Art of Acting for the Camera

A Practical Approach to Film, Television, and Commercial Acting

John Howard Swain

Routledge
Taylor & Francis Group

NEW YORK AND LONDON

First published 2018
by Routledge
711 Third Avenue, New York, NY 10017

and by Routledge
2 Park Square, Milton Park, Abingdon, Oxon OX14 4RN

Routledge is an imprint of the Taylor & Francis Group, an informa business

Library of Congress Cataloging in Publication Data
A catalog record for this book has been requested

ISBN: 978-1-138-23366-9 (hbk)
ISBN: 978-1-138-23367-6 (pbk)
ISBN: 978-1-315-30903-3 (ebk)

Typeset in Times New Roman and Optima
by Swales & Willis Ltd, Exeter, Devon, UK

Contents

To put what I've been teaching in a studio onto the pages of a book required the help of many dedicated people. It's impossible to name everyone so let me express my thanks to a few that represent the many.

To the teachers that taught at Full Circle Productions in San Francisco where this technique was developed: Celia Shuman, Joie Seldon, Janice Erlendson, Mary Moore, Kate London, David Skelly, Tom Kelly, Mary Mackey, Elizabeth Ross, and TJ Metz. To the administrative staff who held everything together so we could do our work in the classroom: Jennifer Skelly, Kristie Cox, Soraya Knight, Ginger Nicolay-Davis, and Jessica Raaum. And to Elizabeth Pickett for her many contributions.

To my New York crew: Stacey Scotte, class assistant and editor extraordinaire who made more corrections on this book than I would like to admit; Jessica Raaum Foster (same person as listed above, only married now and living in New York), ace camera operator; Sarah Ann Rodgers for her outstanding assistance; to Bill Brooks for the fantastic design work he did, inside and outside, on the first iterations of this book; to Al Wright for his wonderful photograph; and to the people at Routledge Publishing, especially Simon Jacobs, for championing this project.

To the actors: to say that I got as much as I gave is not an exaggeration. Each actor came with lessons to learn and lessons to teach. My goal, every time I stepped into the studio, was to stay open and receptive to what each person brought to the work because it is only from a place of openness that any real communication can take place.

And always to Marsha Mercant who has been and continues to be the brightest light in my life.

The proof of any kind of instruction is: does it work? The actors who studied the techniques outlined in this volume have booked, at current count, over 8,500 jobs. Not a week goes by in which I don't hear from a student about a new project he or she has booked.

Many of the actors who started with me when I began teaching are still in the business. Most have continued on as actors, several others have gone on to become directors, producers, and writers, but all of them cite the

experience of working with this technique as being the foundation for their work. Sharing this information has been an exciting, life-affirming experience for me and I thank you one and all.

<div align="right">John Howard Swain</div>

Acting—
creating an active thought process
that ignites an emotion that
provokes a behavior.

John Howard Swain

The purpose of this book is to introduce actors who want to work in the film/ television industry to a practical, proven technique. This technique, this way of working, with a few notable exceptions, also applies to actors working on stage.

Today there is a great deal of emphasis placed on naturalistic, instinctual acting. There is also a misconception that technique and instinct are not compatible. Nothing could be further from the truth.

Science, for our purposes, isn't about formulas or equations or the periodic table; rather we're talking about a systemic yet flexible body of knowledge you can employ throughout the course of your career. You will see how the science of this technique can enhance instinct and thereby produce art.

A shortstop on a baseball team will spend countless hours fielding grounders, practicing, working on his technique. With each ball hit in his direction he reminds himself, "Keep my eye on the ball. Put my body in front of the ball. Watch the ball into my glove." He does this hour after hour, day after day, transforming what are initially awkward, erratic actions into graceful, fluid movements. When game time comes he knows what to do and how to do it. It's ingrained in his consciousness and he no longer has to think about it; technique, the science of creating a body of knowledge, has transformed itself into art.

The same is true after he fields the ball. Before the batter steps into the batter's box, the shortstop has already worked out all the possible scenarios; he has planned in advance what to do in each situation. One out, runner on first, throw to second to start the double play. No outs, runner on second, check the runner and then throw to first.

The difference between actors and ball players is that actors know well in advance where, metaphorically, each ball is going to be hit. That doesn't mean we (and I include myself here as I am proud to say I made my living as an actor for nearly forty years) can relax, but rather the opposite—we need to be fully engaged at every moment. Our tools are more intangible than the bats, balls, and gloves of a baseball player. We are story interpreters, and to play our "game" we use words, movement, and action. We use these things to evoke emotions, not only in ourselves but in others as well. If our actions

aren't carefully planned and executed we will be regarded as bush leaguers, unworthy of the price of admission.

WHAT DOES IT TAKE TO BE AN ACTOR?

Actors are the hardest working people I know. When we first start out we often have to juggle a full-time job or several part-time jobs around audition and/or rehearsal schedules. Factor in an acting class once a week and you're rapidly approaching overload. Yet we do it. We work eight hours at a temp job or wait tables at two different restaurants and then go to a rehearsal where we spend four to six hours each night blocking, running lines, digging into the emotional lives of our characters, which also means dredging up our own emotional experiences. It staggers the mind. And yet we do it. Every actor I've ever known has done it.

The workday doesn't get any easier once actors break through and start "getting paid" for their work. The average day on a film shoot is ten to twelve hours. Sometimes sixteen. One project I worked on, we shot for twenty-two hours. And the conditions aren't always great. If we aren't working under blazing hot lights in a studio, we could find ourselves in the middle of a snowstorm, real or manmade. If a scene takes place in a blizzard we still have to say our lines, hit our marks, produce the right emotions, take after take, to insure the director gets his coverage. This isn't an occupation for the faint of heart.

Acting is also deceptive. When the work is good, everybody watching thinks, "What's so hard about that? I could do that." When the work is bad, those same people say, "Those people are getting paid to do that? I *know* I could do better than that." The reality is that acting is damned hard work. If you don't have a technique, a science you can rely on, then creating art, which is already difficult, becomes impossible.

ACTORS ARE SOME OF THE BRAVEST PEOPLE IN THE WORLD

I don't say this to diminish the heroic deeds of many other professions— police and fire personnel, the military, etc.—but actors, in order to do our job properly, do something every time we work that most people, given the choice, wouldn't do in a thousand years. We do in public what most people won't/can't do in private. We allow other people to see what we're feeling.

This isn't easy because from the day we're born we're assigned certain roles to play and we're programmed to act accordingly. Girls play with dolls; boys play with guns. It's okay for girls to cry; it's not okay for boys.

These attitudes are deeply ingrained in our consciousness. Yet in order for us to do our work we often have to break those molds and venture into uncharted territory.

If you've been cast in a film as a father whose children have drowned in a boating accident and you have to cry, can you do that? On cue? Repeatedly? In front of strangers?

In order to honor the emotional needs of the character, the actor playing the father has to overcome those stereotypes and go against the social conditioning he received while growing up. That takes a certain amount of grit.

WHAT MOTIVATES ACTORS?

What is it that drives us to do this sort of dauntless work on a daily basis? To swim against the tide? To work exhausting hours at every stage of our careers? What sets actors apart from most other people? The answer, in a word, is *PASSION*. The dictionary defines *passion* as "extreme, compelling emotion; intense emotional drive or excitement."

Thousands of years ago the religious leaders in ancient Greece realized their citizens needed an outlet, a public forum where they could express the intense emotions they were feeling. To accomplish this they created theatre, large interactive events where the combined efforts of the priests and the audience would culminate in a "play." This emotional channel was so important those early "plays" became a form of worship.

Today human beings feel those same emotions, but our inhibitions, our fear of being inappropriate, hinder us from expressing them in public.

The audience (and I was a member of the audience long before I became an actor) goes to see a film or a play because we want to laugh; we want to cry; we want to be scared. We want to be moved in some way. We go because we have the same needs the early Greeks had. Only today, instead of playing an active part in the story unfolding before us, we get our emotional hit from the safety and security of a darkened theatre where nobody can see us as we are guided to those emotional places by a company of actors.

I say "guided" because that is exactly what good actors do: they guide the audience; they take them up to, but not quite through, the final experience. That part of the journey, the final part, is up to each individual member of the audience. The actor's job should be to stimulate but never to dictate.

WHAT IS THE ACTOR'S FUNCTION?

We're interpreters. We bring the writer and director's visions to fruition. We're also the gatekeepers of emotion, the torchbearers who hold up the

light so each member of the audience can peer into his/her own soul. And because of this, the actor's job is more important now than ever before. The more intricate and complex the world becomes, the more meaningful our work is.

Our job, first and foremost, is to serve the story, the script. In order to do that, we need to understand the arc of the story. Once we know what the arc of the story is we then need to determine the emotional journey our character is going to take in order to fulfill that arc.

Then, in order to fulfill the character's emotional journey, we must have the craft necessary to successfully navigate the endless series of pitfalls the writer and director have intentionally created for us. Merely skimming the surface, getting from Point A to Point H without touching on the emotional peaks and valleys along the way, isn't very interesting. But getting from Point A to Point H with a fully developed character who understands the emotional journey—who dives down into the depths and soars up to the heights—is both interesting and exciting. And while we're plunging into those dark holes and finding those bright shining moments, we also have the responsibility of delivering not only ourselves but also a group of strangers—the members of the audience who have put their trust in us—safely on the other side of the last hazard.

To compound this issue: we must display those emotions in the precise amount at the exact right moment. Too much, too little, too soon, too late and we have failed.

To successfully complete this journey we can't simply report the events. That's what a newscaster does. As actors we have to live them. We are the scouts, the trailblazers, and if we don't lead the way, if we don't go on the journey ourselves, the audience can't go either. It's as simple as that.

FILM VS. STAGE

There are a variety of ways that working on stage is different than working on camera. In theatre we're trained to reach the guy sitting in the last row of the third balcony, not only vocally and physically but emotionally as well. We want him to see, hear and feel the things we're trying to convey. After all, he's the guy who really wants to see the play and the nosebleed seat he bought is the only one he can afford.

Much of that changes when an actor prepares for a role in film or TV because everyone in the audience, whether they're in a movie house or at home, is metaphorically moved up to the front row. Actors have to adjust accordingly; otherwise, they'll be guilty of the biggest sin of all: overacting.

While watching a play, the audience have a lot of things vying for their attention: the actors, of course, and the set; but the audience will also see the curtain, the lighting grid, the interior of the theatre itself, other audience members, etc. In a film or a TV show the director not only dictates what the audience sees but also the size of what they see. If the movie is about a guy gambling away his fortune, the director will probably start off with a wide shot of a casino, cut to a single of the protagonist, then to a close-up of the worried look on his face, then to an extreme close-up of his right forefinger nudging his last poker chip into the pot. In a large theatre this move might require the stage actor to use his arm, perhaps his whole upper body, to convey the same physical gesture.

Additionally, on stage the images are more or less constant. In film, images change quickly. There are a couple of reasons why this happens. One, because with film we have the ability to do it and, two, the film/TV audience have learned to absorb and assimilate the information presented to them at a faster rate. So, in order to keep the audience engaged, the director, working with an editor, pieces the scene together from the different angles he/she shot. And now, thanks to the advent of MTV, things have sped up so much that there'll be a cut approximately every three seconds. You can test this by counting how often cuts occur in a film or TV show. This again reflects how much the director dictates the viewing experience.

This is why the work you do, especially at the beginning of the process, when it's just you and the script, is crucial. Not only do you have to know what you're doing but you'll have to be able to repeat it take after take, often from a variety of angles so the director can get his/her coverage.

This is how Mark Rylance (multi-Tony Award and Academy Award winner) explains the early part of his process: "I like to do all this work before, which to my mind is like turning the soil in a garden . . . [Then when rehearsals start] the soil is all very turned, it's all bouncing around in my psyche."[1]

My grandfather was a farmer and I remember helping him as a kid (as much as a five-year-old child can help an adult) while he worked the fields. He was unbelievably patient as he explained how a single kernel of corn could grow into a 7-foot-tall cornstalk bearing many ears of corn. He told me, "First you've got to turn the soil. You got to break it up so when you plant the seeds they have a better chance of growing." And that is what this process is about: tilling the soil, laying the groundwork so your crop—acting, developing a character—has a better chance of succeeding.

WHAT IS ACTING?

Ask any actor, or acting teacher for that matter, and you will get a different answer. Some acting teachers think acting, especially acting for the camera, is reacting. And while I basically agree, there is much more to it than that. An actor's reaction happens because the character he/she created stands for something or desires something. So, before you can have an honest reaction you have to know, your character has to know, what he/she stands for or what he/she wants. That is what this work is all about: developing your characters so you know these things. You simply can't "react" without having first done the homework. This technique shows you how to explore your characters so that you'll know what they want and why they want it and how they plan to get it.

We will get into this later, but an essential component to every scene is that one character wants something, either from another character or from the situation. And the other character, or the overwhelming circumstances of the situation, works against that happening. This creates conflict and tension, two of the cornerstones for good storytelling.

Years ago, when I was first starting out, I stood in for Jeff Bridges (Academy Award winner) on a short film, *The Girls in Their Summer Dresses*. He likes to develop his characters by improvising his way through the script. Meryl Streep (winner of three Academy Awards with nineteen nominations), whom I have never worked with but would like to, does tons and tons of homework before the cameras ever roll. Mel Gibson (Academy Award winner) likes to wing it and not rehearse. I recently heard Robert Downey Jr. (multiple Golden Globe awards) tell a story about working with Mel on *Air America*, an action-based film about helicopter pilots flying illegal missions into Laos. Just before shooting the film's most harrowing scene, where their helicopter crashes, Mr. Downey, a more studied, traditionally trained actor, kiddingly said to Mr. Gibson, "I don't need to rehearse this. Let's just wing it, okay?" To his dismay, Mel said, "Yeah, great. Let's do it." Different strokes for different folks.

It's important, as you read the following chapters, to remember that the intention of this process isn't to restrict you to a set of choices but rather to open you up to the idea of making choices. Once you start working with your scene partner and a director, you will find yourself making new discoveries based on their input. You may also discover that what they brought to the party isn't as good as what you brought and, if that happens, you'll be very happy you did your homework.

WHY IS TECHNIQUE IMPORTANT?

Technique is the science that turns your acting into art. During the course of our careers we will all encounter a role or two that fits us like a glove. We don't have to do a lot to master those roles because they sing to us and instinctively we know what to do. The technique described in this book is designed to provide you with a foundation so you can successfully create the hundred or so other roles you will get to play in your life.

The information contained in this book gives you an array of tools that will help you at every phase of your career: from the very first moment you thought you wanted to be an actor to those early, often difficult days when you knew what you wanted to do but didn't yet have the skills to do it, to your first professional job and, finally, to the time we all strive for, when you've reached the point in your career where you've mastered the science of your craft and you're making a real contribution to the world through your art.

Anyone who has seen HBO's *Angels in America* knows what I'm talking about. The stellar cast, headed by Meryl Streep, Al Pacino, Emma Thompson, Jeffrey Wright, and Patrick Wilson, along with director Mike Nichols and writer Tony Kushner, not only created a masterpiece, but they also helped the world look at the global crisis of AIDS with new, more compassionate eyes. That is the power of art.

THE ROAD LESS TRAVELED

If you've made the choice to be an actor, to go on this very complex but rewarding journey, I salute you. Acting is an honorable and noble profession. It is also a profession that will test the limits of your courage and endurance. Along the way there will be laughter, tears, frustration, and great triumphs. In the end, however, you'll have the satisfaction of knowing you've done your part to make the world a better place. You've made this decision because there's a passion stirring inside you. You hear the beat of a drum few people hear. Celebrate that. It means you're alive!

Things Every Actor Should Know

THE THOUGHT PROCESS

There are probably as many definitions as to what acting is as there are actors. This is mine:

acting is the result of a thought process that ignites an emotion that provokes a behavior.

Everything discussed in this book is designed to enhance that thought process. What starts out as a thought in the actor's mind then ignites the actor's emotional center: the heart. Once the heart is engaged, it produces a series of behaviors that help define the character.

The original thought that results as the character's behavior comes from the actor's personal pool of information. But because the audience sees and hears the effect that information has on the situation the character is in, they assume the information originated with the character. It's only natural they would think that; in fact, that is exactly what we want them to think. Actors want to create fully realized, believable characters.

The camera may not know exactly *what* we're thinking but it certainly knows *if* we're thinking. In fact, what the actor is thinking—the material he/she uses from his/her "real" life in order to create the "reel" life of his/her

> One of the things that makes film acting so difficult is that the camera has the ability to see our thought process.

character—may have little, if anything, in common with the character's actual circumstances. But because the actor's thought process produces the desired emotions and behaviors in the character, the audience make the leap. In their mind, what the actor is thinking and how the character is acting are one and the same.

For many of us, the most difficult journey we'll ever embark upon is that eighteen-inch trek from our brain to our heart. Because of the nature of our work (our art) we're often called upon to repeat what we do, whether it is take after take or performance after performance. In order to do this, we need a technique (a science) that allows us to delve into the deepest depths of our souls without causing any irrevocable harm to our psyche and without interrupting the flow of the story.

This process should be so smooth and so clean that it's impossible for the audience to see the artist in the work. The only thing they should be aware of is the character living moment by moment. It isn't important for the audience to know what the actor did to get the results he/she got. What's important is that the characters are real and the emotions are genuine. Then, whatever the behavior is, it will seem as if it originated with the character.

The more we know about which thoughts produce which reactions in our emotional center, the easier it is for us to navigate our character's journey.

THE GOAL

In spite of what our ego thinks, the shooting schedule on a film set revolves around the lighting. As an actor you could spend anywhere from an hour to eight hours in your trailer while the gaffers are setting and adjusting the lights. Then, when you're called to the set, you have ten, fifteen, maybe twenty minutes to nail the scene. If the scene is difficult and you have to show a range of emotions, you can't afford to get stuck anywhere along the way. You need to be able to do your work quickly so the crew can move on to their next setup. Too often in our business, art is compromised by commerce. So, the faster and better you are at doing your job, the more attractive you become to producers.

Think of the shoot as being a well-oiled machine. You're one part—an extremely important part—but only one part of that machine.

The goal is to have your craft in such good shape that you can, without sacrificing any of your character's integrity or emotional honesty, plug yourself into whatever the situation is, do your job, then disengage and be ready the next time you're needed.

This may not sound glamorous, and it's certainly not very satisfying to the ego, but time is money in the film business and if you can save directors and producers either one or both of these two most precious commodities, you will work all the time.

DON'T LET THE LIMITATIONS OF OTHERS LIMIT YOU

As an actor, when you receive a film script you'll have at best 30 percent of the information necessary to create a fully realized character. The rest is up to you, and you'll need to fill in a lot of blanks. Even minor characters have major lives. We may not see the entirety of those lives played out on the screen, but that doesn't mean those characters don't have them. You must explore those lives so that, regardless of the amount of screen time your character has, we see a real, complete human being.

The better prepared you are, the better job you'll do. The better job you do, the better you make your director look. The better you make your director look, the more that director, and subsequently other directors, will want to work with you. And so it goes.

The amount of detail you provide determines how interesting your characters will be to watch and how much fun you'll have playing them.

The same is true for your fellow actors. If you set high standards for yourself they will rise to your level. If their standards are lower than yours, if they aren't prepared, don't get sucked into their vortex. If they aren't up to your level, you don't have to be a prima donna to make your point. Just do your work and the work will speak for itself.

Another benefit of this technique is, if you've done your prep properly, the instant you look into the other actor's eyes it will be immediately apparent to you if that actor is ready to play at your level. If not, then you'll know you need to stick to your game plan and execute the scene the way you prepared it.

If, on the other hand, you look into the other actor's eyes and you see they're ready to play at your level, that they're as prepared as you are, that's when magic happens. And it's those moments of magic we all live for.

Another advantage of this technique is that, because of its thoroughness and attention to detail, it provides you with the potential to create that magic, not just once or twice during your career, but every time you work.

YOU ARE YOUR OWN BEST RESOURCE

Nobody knows what makes you tick better than you. Every event you experience has an impact on you. Each incident sparks an emotion, and nobody knows better than you how that impact influences your emotions. Nobody knows what makes you truly happy or what makes you miserably sad; how you feel when you've been betrayed, or how jealousy eats away at you.

As an actor, one of your tasks is to categorize and store those emotional memories so you can use them in your work.

Emotions are our stock in trade, and your emotions, and the memories and events that sparked them, are money in the bank.

There may be some events from your life you can't use: memories that are too painful, scars that run too deep. Don't flog yourself by trying to make those memories work. Unlike other people who fight to repress their emotions, we as actors need to do a careful investigation of our lives so we can figure out which memories serve us and which don't. What memories can we call up that will allow us to tap into the most basic of emotions—joy, sadness, anger, fear, jealousy, betrayal, embarrassment, and confusion—so we can do our work? Once we determine which memories are safe, which ones produce the results we want, we can use them to develop our characters' realities.

Whenever possible you want to use the power of a real event. The goal is to extract the emotion you need from it as seamlessly as possible so you can move on to the next beat of the scene.

Knowing what the journey is and how you're going to accomplish it step by step does not diminish your effectiveness as an actor; it enhances it. True, you need to allow for spontaneity in your work but you also need to prepare for the emotional demands of each scene so you have a foundation from which to work.

THE WHAT IFS

If you're playing a mother who kills her children and is then racked with sadness, you don't have to kill someone you love to evoke that emotion. It's very possible you could duplicate the emotion by using an event from your real life, e.g., remembering how you felt when your puppy, Buster, was run over.

But what if Buster wasn't run over? What if you've dug into your memory bank and you can't come up with anything that approximates the

emotion you want? Then take the closest experience you do have and start adding a "what if" to it. "What if the day Buster ran out into the street he had been hit by a car and injured? Or what if he ran away and never came back? Or what if he got sick and died?" And so on and so on, until you have "what if'd" yourself into the emotional level you want to achieve for your character.

The "What if" game is something that should be used sparingly. It's like watching a tennis match instead of being in one—you're one step removed. It serves a purpose and can help you get over a difficult hurdle, but it's best to use "the real" stuff whenever possible.

ACTORS ARE AN ODD LOT

It's true; we are. We collect emotional memories the way other people collect coins or stamps. Charles Durning, a wonderful character actor and the recipient of a Screen Actors Guild Life Achievement Award, once told a story about being at his mother's wake. He was from a big Irish family and it was an emotional day for everyone in attendance. In the midst of the tears and sadness he was experiencing, he had the thought: "This is good. I'll be able to use this one day."

Being a professional actor is like being a professional athlete. You have to constantly practice to stay at the top of your form.

Whether the story is true or not, the sentiment is. We interpret stories other people create and our goal is to live inside those stories while we're telling them. To tell them honestly, to tell them truthfully, we need to make sure we're using the best resource we have: ourselves.

Like professional athletes, you have to know when it's time to practice and when it's time to play the game. If you've done your prep properly, investigated everything you need to know about your character, his/her history, his/her objectives, the facts surrounding his/her relationships and how he/she feels about the other characters, etc.—all that will be stored in your subconscious, ready to use. And like a baseball player who's done his prep, you won't have to think about how to catch the ball or what to do with it after you've caught it; you'll know.

Every time you work, your character is going to be called upon to take certain actions and experience certain emotions. It doesn't matter whether you're in a class or it's your first paid job or your hundredth; this technique will help you be a better actor.

The more you prepare, the more you hone your craft, the better your instincts will be. And the better your instincts are, the better you'll be at doing your job. And the better you are at doing your job, the more opportunities you'll have to work. And the more opportunities you have to work, the better your instincts become. That's the wonderful cycle that comes with preparation, and the good news is it all starts with you.

My sincere hope is that you will use this technique as a springboard that will catapult you into a long and fruitful career, filled with rich and rewarding experiences. Break legs. Break lots of legs!

The Basics

Since most actors start out on stage—in high school, community theatre, college—before they ever get a chance to work in a film or a TV show, one of the most important things they will have to adapt to is getting up to performance level with little or no rehearsal. Yes, you read that right, little or no rehearsal. In a play, it's during rehearsal we develop our characters and come to understand the nuance of the piece; heck, it's where a lot of us learn our lines. When you're working on camera you won't have that luxury. Why? Time and money. There is rarely, if ever, the budget for rehearsal. What does that mean to you? You have to learn to prep in a different way.

Several years ago I was a co-star in the mini-series *A Family of Spies*. Long story short, I played the love interest of Leslie Ann Warren (Academy and Emmy Award nominee, Golden Globe winner). We had several scenes together, but she was reluctant to engage with me, even to say hello. I didn't blame her; she didn't know me; we had never met before. Some actors are like that and it's important we honor each other's process. During the wide shot of our big scene, which was basically our rehearsal, she saw how prepared I was and was able to relax, and very quickly we developed the chemistry necessary for the scene. But that's the reality of working on a film or TV project. You won't have much, if any, time to rehearse!!

Okay, let's get some basic "film" terminology out of the way so we can dive into what this book is designed to do: give you a solid foundation so you can excel when working on camera.

SHOTS

There are seven basic shots (sometimes called camera angles or framing) that actors need to concern themselves with:

- **Master shot** (also called the **wide shot**): this is a wide-angle shot of the entire scene. Usually only a small portion of this shot is used in the final product. And many times the wide shot will be the only rehearsal you get.
- **Two shot** (also called a **double**): a tighter shot of the two (sometimes more) actors in the scene; usually framed from the lower portion of the chest to the top of their heads. Shooting tighter enhances the elements of storytelling by creating a greater degree of intimacy, conflict and/or tension.
- **Over-the-shoulder shot**: this shot includes the back of one or both shoulders and sometimes a portion of the back of the head of one actor, while capturing the other actor's face, framing the shot from his/her collarbone to the top of his/her head. Again, this is done to enrich the storytelling by boosting the level of intimacy, conflict and/or tension.
- **Reverse over-the-shoulder shot**: just what it sounds like; the reverse of the shot described above. This time the actor who had his/her back to the camera is now facing the camera.
- **Close-up**: a shot, from the neck to the top of the head of one actor. This and the ECU (see below) create the most intimate moments or add the most tension.
- **Reverse close-up**: again, exactly what it sounds like; the reverse shot of the other actor, making sure his/her size in the frame is the same as the actor in the first close-up.
- **Extreme close-up (ECU)**: directors use this shot to emphasize a moment. It could a bit of an actor's face, i.e., the eyes or mouth; it could be a person's hand or a single object.

The key thing to remember is that the tighter the shot, the less you have to do. That doesn't mean that what's going on inside of you is less, just your outward expression of it. Think of it like this: how would you communicate a message to someone standing twelve feet away? Now think how you would communicate the same message to someone standing a foot away? The tighter the shot, the less you need to do. But you always need to be fully engaged.

SHOOTING OUT OF SEQUENCE

In theatre, we're used to building stories that start at the beginning and go to the end, with the action mounting each step of the way.

It's possible the exteriors of the movie you're working on will be shot in New Zealand and the interiors on a sound stage in London. There are many and varied reasons why this happens; most of them have to do with budget, some with weather, some with star power or availability. Whatever the reason, it is highly unlikely that a project will be shot in sequence.

Rarely, if ever, does a film or TV project start shooting at the beginning and go straight through to the end.

This is why the film actor needs to be *über*-prepared. Don't get me wrong; you should be *über*-prepared if you are doing a stage role too, but film and TV offer a unique set of creative challenges that the stage doesn't.

Case in point: Tarah Nutter, a friend of mine, was hired to be Ron Howard's wife in a made-for-television movie titled *Bitter Harvest*. It's a story about a family of dairy farmers in central California whose cattle have been exposed to contaminated feed and the milk produced by those cows is causing cancer in children. She had several scenes in the film but the director decided to shoot her most emotional scene first. It's the scene where she realizes her own children may have been exposed to the cancer-causing milk. So, on her first day on set, armed with little except her own homework, she was thrust into her most difficult scene. If you see the film you'll see she does a great job expressing anger, fear, betrayal, and sadness.

Later, while talking to the AD (assistant director), she found out the reason they shot that scene first was because if she wasn't able to give the director the emotional depth he was looking for, the producers were going to fly another actress in to take her place.

What's important to understand about shooting out of sequence is how prepared you must be. You not only have to know where you're coming from emotionally but also where you're going—before those scenes have been shot.

MATCHING ACTION

Another wonderful thing about working on stage is how forgiving the audience is. My wife, the lovely and talented Marsha Mercant, was in the Los Angeles production of *Les Misérables*. One night the turntable, which was powered by a computer program, seized up. This brought the show

The camera, however, forgives nothing. Film is an exacting art form and any mistake, no matter how small, can pull the audience out of the moment.

to a screeching halt and for the rest of that performance the turntable had to be manipulated manually. But the show went on and the audience, who loved being a part of the "anything can happen" reality of a live performance, gave the cast a standing ovation.

We've all seen *continuity* issues in films. An actor is eating a plate of spaghetti and later in the scene when there should be less food on the plate, there's more. A guy is holding a drink in one hand and in the next cut somehow the drink magically appears in his other hand. We notice these things and they bring us up short. People are hired to keep an eye on continuity and for the most part they do a good job, but actors also need to be aware of and responsible for their matching action so those mistakes don't happen.

Whatever you do in one shot you will have to repeat in subsequent shots. If you're applying lipstick in one take, make sure you do it the same way, with the same hand, in the other takes. If you sit down or stand up, make sure you do it in the same place every time.

It may not seem like a big deal, but the problems it causes could cost you something quite valuable: your camera time. Why? Because if you don't match your action, you have limited the amount of coverage the director can use . . . of you. The director may have to cut to another actor when it should be your shot because you bowed your head when you lit your cigarette instead of lifting your head up like you did in all the other takes. Simple rule of thumb: keep whatever you do simple. The rule of KISS ("keep it simple, stupid") should be applied at all times.

OTHER HELPFUL TERMINOLOGY

Every industry has its own lingo and here are a few terms that will be helpful once you get on set.

- **Action**: this is pretty self-explanatory. What the director or the AD calls at the beginning of each take to cue the actors to start the scene.
- **Camera rehearsal**: just what it sounds like; a rehearsal for any moves the camera needs to make. Sometimes with the actors, sometimes with stand-ins; sometimes it's just the camera.
- **Continuity** (aka **Script Person** or *Scriptie*): the person who makes sure all the "business" actors do (e.g., smoking, drinking, standing/ sitting) in a scene is done in the same place at the same time on each take of the sequence being shot.

- **Coverage**: the collected shots and angles the director has filmed in order to capture all the facets and nuances of the scene.
- **Cut**: the verbal signal the director calls out to stop the acting and shooting of a scene. Keep in mind, actors should stay engaged in the scene, even if the dialogue is over, until the director calls, "Cut."
- **Director**: The person in charge of the vision of the project; the master of the ship.
- **Dollying** (aka **tracking shot**): a shot where the camera is set up on tracks and moves, usually toward the actor or an object the director wants to highlight. It can also be used to pull away from an actor or object.
- **DP—Director of Photography** (aka **Cinematographer**): the second most important person on the set. The DP figures out the camera angles, lighting and what lenses to use to capture the director's vision.
- **Editor** (aka **Cutter**): the person who assembles the various shots the director chooses into the final product, e.g., the movie.
- **Establishing shot**: a shot, usually an exterior, at the beginning of a scene that lets the audience know where the action that follows will take place.
- **Hot set**: same as in the theatre. It means everything (props, set pieces, etc.) is ready for the scene and should not be disturbed.
- **Mark**: a place where an actor stands or a place an actor moves to.
- **Martini shot**: my personal favorite. The last shot of the day.
- **Number one**: the positions the actors return to at the end of each take in order to get ready for the next take. When the AD says, "Back to one," you go back where you were when the scene started.
- **Pick up**: when a mistake is made—an actor messing up a line, a bump in a camera move—the director, without stopping the camera, will tell the actor to "pick up" the line or have the DP repeat the camera move.
- **Reaction shot**: a shot of an actor giving a non-verbal response, doing an action or thinking about something, when another actor is talking or when a planned action is taking place.
- **Running order**: the order in which the scenes will be shot.
- **Shooting script**: after many, many drafts, the final script.
- **Take**: a single, continuous recorded performance of a scene.
- **Wrap**: the end of the day's work or the very end of shooting of the entire film.
- **Zoom**: the camera changing the focus of the scene by manipulating the lens instead of using a dolly to "zoom" in or out of a scene.

Okay, that's it for the basics. Now let's dive in.

The Bones

The homework is everything.

Meryl Streep

Part of being human is that when we witness or participate in an event (e.g., a wedding, the birth of a child, a car accident, being mugged), those events become imbedded in our subconscious. And most of us, without too much difficulty, can recall those events and the emotions that went along with them. As actors we face a far more difficult task. Our characters, when first presented to us, are flat, one-dimensional entities that exist only on a piece of paper. In order for the story our characters are involved in to seem real they too are going to have to experience a series of events and the emotions that go along with them.

To express these events dramatically actors will break down an event into a series of beats and each beat is designed to articulate a particular part of the event (see Chapter 10, "Beats, Tactics, and Actions").

As actors we have to create a "subconscious" for our characters so that as these events are occurring, the emotions relating to these events come from an honest and truthful place. That's what this chapter is about: you breathing life into your character so you can lift him or her off the page and make him/her real.

There's an expression: "If you have to swallow two frogs, swallow the big one first." This is the big frog. This part of the technique will take up at least half of time you spend preparing each scene. It is without question

On average, film and television scripts supply actors with only about 30 percent of the information they need to create their characters.

the hardest part of the work, yet in many ways the most rewarding. It's the area where you get to engage your imagination, the place where you get to be your most creative. Enjoy it; relish it. The more time and effort you put into this part of the process the more rewarding your work will be.

The populations that inhabit these scripts are mere skeletons with little meat on them. It is up to the actor to provide not only the flesh and the muscle but to give each character a soul as well.

In a screenplay, the writer is more concerned with structure than character development. One of the biggest dilemmas actors face is how to take the little bit of information they are given and use it to create fully realized characters. I pondered that dilemma for a long time until I stumbled across Lajos Egri's book, *The Art of Dramatic Writing*.[2] In the second chapter Mr. Egri presents a step-by-step outline that helps not only writers, but actors as well, to create authentic, multifaceted, three-dimensional characters. Ironically, Mr. Egri calls this section of his book "The Bones." As far as I'm concerned it should be called "The Mind, The Body, The Soul—The Whole Salami," but in deference to him, we, too, call it "The Bones."

Often when you're working on a scene in class, or sometimes even when shooting a film, you won't have the entire script. In class a friend hands you a scene and says, "Let's work on this." Or, quite possibly, when you're working on a project, the script is being rewritten as you're shooting. Oh, yeah, that happens; more often than you think. This, however, shouldn't keep you from doing the work you need to do—creating genuine, believable characters—with the material you have.

Part of your job as an actor is to take whatever information you're given and use that as home base, a place to start creating not only a life for your character but a history as well. If you do this, your character will show up as a fully realized human being. If you don't, you run the risk of your character coming across as a one-dimensional stick figure.

It is important to note that a good deal of the information you come up with while doing The Bones for your character will not be in the script.

The information comes from you; you using your imagination, connecting the dots, filling in the gaps that the screenwriter left. If writers put everything into the script that you and the other actors needed in order to develop your characters, their scripts would be huge, ponderous tomes.

The Bones consists of three sections. After you've done the homework, after you've addressed the items in each category, you will have created a complete character. A character who is not merely a description of someone bound to the page but a living, breathing human being, a person with good and bad traits, a person who, because of his/her detailed past and because of his/her dreams for the future, is fully engaged in the present.

There are two critical aspects when it comes to creating The Bones. One, don't omit any of the categories. Some seemingly insignificant piece of information—the character's height, for example—could prove to be an important key that unlocks the character for you. Two, write everything in the first person. Using the first person helps you establish "ownership" of the character.

Physiology:

1 Gender
2 Age
3 Height and weight
4 Color of hair, eyes, skin
5 Posture—How do I stand? How do I carry myself?
6 Appearance—How do I dress for work? Leisure?
7 Defects—Physical faults
8 Heredity—Inherited physical traits; the good, the bad and the ugly

Sociology:

1 Class—Upper, middle, lower
2 Occupation—Type of work, hours, union/non-union, conditions
3 Education—Kindergarten through grad school, or none at all
4 Home life as a child—Who are/were my parents and what did they do? Number of siblings? Position in the family? Was I adopted?
Home life as an adult—Do I have a spouse, a partner, children, etc.?
5 Religion
6 Race, nationality
7 Place in community—Leader, follower, whatever
8 Political affiliations, beliefs
9 Amusements—What do I do for pleasure or fun?

Psychology:

1 Sex life—Moral standards, fantasy, and romance
2 Personal premise/ambition

3 Frustrations, disappointments
4 Temperaments
5 Attitude toward life
6 Complexes, obsessions, inhibitions
7 Extrovert/Introvert—A little of both?
8 Abilities—Languages, music, other talents
9 Qualities—Imagination, judgment, poise
10 IQ—Street smarts, book smarts, people smarts[3]

For the first section, **Physiology**, your answers should be as short as possible, a few words, a sentence at the most. Try not to stray too far from your own physical reality. Usually one of the reasons you've been hired is because your body type and physical traits coincide with the writer's and director's visions of the character. Of course, if the script says you're blonde and you're not, hair and make-up will take care of that. If blue eyes are called for, and yours are brown, they'll give you contact lenses.

While we're discussing physiology and appearance let's interject a quick word about **typecasting**. While this is still a "thing" in our business it is not nearly as much of a "thing" as it used to be. With the dismantling of the studio system the strictest rules regarding typecasting were forever altered. If those rules hadn't changed, Dustin Hoffman (two time Academy Award winner) would never have been cast in his breakthrough film, *The Graduate*. Gene Hackman and Jack Nicholson (both two time Academy Award winners) wouldn't have become leading men. The same is true for women. Think Frances McDormand (Academy Award and multi Emmy and Golden Globe winner), Bette Midler (multi Golden Globe winner), Melissa Leo (Academy Award winner): all of these actors, under the old definitions of "type," would have been relegated to smaller character roles. The take-away for you is this: typecasting, while not as pervasive as it used to be, still exists in our business and undoubtedly you will encounter it at some point during your career. What's important to remember is that talent, in the final analysis, is the most important component. Don't let someone else's narrow vision of how they "see" you look limit your aspirations.

In the Physiology section, one of the areas actors tend to gloss over is Defects. They often write, "None," but when I question them about their obvious physical traits—"Does your receding hairline bother you?" "Are you concerned about your teeth?" "Feet too big?" "Hands too small?"— they answer, "Oh, yeah, right. I forgot about that." They don't realize how much time they've spent thinking about their own hairline or their teeth

and how those thoughts have shaped them as human beings. If their teeth aren't perfect they may not have smiled as often as they would have if their teeth had been perfect. And because they didn't smile they didn't get the job they wanted as the hostess at that fancy restaurant. The same is true for the characters we play; they, too, have spent time thinking about their physical defects and those defects have had an effect on how they perceive themselves.

Heredity in this section does not mean what country your character's forebears came from; it means what physical traits the character inherited from them: the good, the bad, and the ugly. "I got my mother's cute nose and my dad's bad complexion."

In the second section, **Sociology**, you want to let your imagination fly. Let this be a stream of consciousness and write, write, write. Don't edit yourself. The things you aren't aware of, the things that just come out, will give your characters the complexity and texture that will free them from the page. The key here is not to write perfect prose but to plumb the depths of your character. In this section you probably won't be using your own personal information as the basis for your answers, not like you did in the Physiology section. Here you will be using the information the writer provided, regardless of how much or how little detail he gave you, *and* your imagination to fill in what he left out. However, if your real life parallels your character's reel life, and you're comfortable using that information, then use it.

In film, the general rule for actors is "less is more." In this section, however, more is more.

There is no maximum as to how much information you can create for each component in this section, as long as what you write helps you develop your character.

Think of this as prospecting. The more you dig around, the more likely it is you'll find the gold nuggets you're seeking.

The more you write, the more details you come up with, the more life you breathe into your character, the better your chances are of making the character real.

Don't let the fact that the writer didn't provide your character with a rich history prevent you from coming up with one of your own.

The same is true for the next section, **Psychology.** More is more. Don't be skimpy with your answers. You want your characters to be as alive as possible. The more life you give them, the more alive they'll be.

The following is an example of how The Bones works, using a scene from the brilliant film *Absence of Malice*.[4]

Synopsis

Megan Carter is a hard-nosed reporter for the *Miami Herald*. Three months ago she wrote an article that put Michael Gallagher in jail. Teresa Perone is an old friend of Michael's and has asked Megan to meet her, claiming that she, Teresa, can prove Michael's innocence. Megan is reluctant to go to the meeting but because of her journalistic integrity, she agrees. Time—early 1970s. Place—Miami, Florida.

<div align="center">

TERESA
I'm Teresa Perone.

MEGAN
I guess we know I'm Megan Carter.

TERESA
Thank you for meeting me like this. Would you like a
cigarette?

MEGAN
No. I'm trying to quit.

TERESA
Michael hates it. I have a story for you.

MEGAN
Michael Gallagher is innocent, you were with
him the night they got Diaz,
you'll swear to it in court. I'm used to dealing
with girlfriends.

TERESA
Why do you think I'm a girlfriend?

MEGAN
Just a hunch.

TERESA
No. I've never been Michael's girlfriend.
I've known him since
childhood; we're friends.

</div>

MEGAN
Of course you think he's innocent.

TERESA
No. I know he's innocent.

MEGAN
How?

TERESA
Well, because I was with him at the time. But I
don't want you to say it was me.

MEGAN
I see. Where were you?

TERESA
I can't tell you that.

MEGAN
How do you remember this? I mean it was ten
months ago.

TERESA
Do you remember where you were the day Kennedy
was shot?

MEGAN
Can you prove it?

TERESA
I don't know.

MEGAN
Miss Perone, you're very loyal, if that's what it
is. But I can't write a story that says someone
claims to know Michael Gallagher is innocent and
won't say how or why or even give her name.

TERESA
I am assistant to the principal at St. Ignatius
School and the publicity
would kill me . . . I just can't.

 MEGAN
 Suit yourself.

(Megan stands to leave)

 TERESA
 But you printed that other story.

 MEGAN
 That was different. I knew where it came from.

 TERESA
 You don't believe me?

(Megan sits)

 MEGAN
Miss Perone, I've never met you before in my life.
 You want me to write a story that says Michael is
innocent and then you tell me I can't use your name.
 You say that you were with him but you won't
 tell me where. Now what would you do?

 TERESA
 If I told you, just you, would it have to
 be in the paper?

 MEGAN
 Probably.

 TERESA
 Why? If it had nothing to do with Diaz . . . I mean
 it's private . . .

 MEGAN
 Look, I can't promise you anything. I'll speak to my
 editors about it but I
 can't promise you anything.

 TERESA
 But I don't understand. Couldn't you say that you
 spoke to someone who
 was with him the whole time?

 MEGAN
 I'm a reporter. You're talking to a newspaper right
 now, do you understand?

 TERESA
 You said you could keep it out.

 MEGAN
 I did not say that. I said I would discuss it with
 my editors. Look, if you have some information about
 where Michael Gallagher was that night
 and you want to help him . . .

 TERESA
 You don't understand. There was this
 guy . . . Michael hates him . . . maybe
 he's not so hot . . . but you see I'm Catholic . . .

 MEGAN
 Look, Miss Perone, I don't want to be rude but I
 don't understand what you're
 trying to tell me and I do have a deadline. I have
 to get back to the paper.

 TERESA
 I had an abortion. I got pregnant and I didn't know
 what to do. I got a name in Atlanta. It was three
 days. He stayed with me every day, every hour, and
 that's what happened.

 MEGAN
 That's not such a terrible thing. Have you told
 anybody else this?

 TERESA
 Oh, God. Ah . . . you're not Catholic.

 MEGAN
 It's the 70s, people will understand.

 TERESA
 Are you crazy? Not my people, not my father. I don't
 even understand it.

MEGAN
How old are you?

TERESA
You believe me, don't you?

MEGAN
Yes, I do.

TERESA
Well, then don't write this.

MEGAN
You're a friend of Michael Gallagher's. He's in
trouble. You've told the truth
about something that will help him. No one is going
to hate you for that, really.
Really. Now, do you have any ticket stubs or
receipts or anything that will
prove that what you're saying is true?

That's the scene. Wonderfully written, beautifully structured, rich with possibility but short on the who, the what, or the why behind the words. Those details are the very things that can make or break an actor's performance. Example: Teresa says, "There was this guy . . . Michael hates him." Who is this guy and why does Michael hate him? Those are the specifics, the details the writer left out that the actor needs to fill in.

The actor who played Teresa in my class created the following Bones for her character. She took the information the writer had given her, the skeleton, and added the meat and the muscle necessary for her to bring the character to life. It is important to note that this actor only had this scene and the brief synopsis to work with. She had not seen the movie nor read the rest of the script.

THE BONES—TERESA PERONE

Physiology

1 **Gender**—I am female.
2 **Age**—I am 28 years old.
3 **Height**—I am 5'10" tall and weigh 150 lbs.
4 **Color hair**—I have blonde hair.

Eyes—Blue eyes.

Skin—Fair skin.

5 **Posture**—My posture is mostly good. Sometimes I slouch (bad habit from grade school when I was taller than all the boys) but I try to pay attention and stand up straight, especially when I'm at work.

6 **Appearance**—I am always neat. I dress formally for work, in conservative skirts and nice blouses. When I'm not working I dress stylishly, but casual. I never wear jeans. I like to wear solid colors, like navy blue, black, or beige—rarely do I wear bold or bright colors, but rather colors that blend. Bold and bright colors make me appear taller than I already am. I care a great deal about my appearance. I think the way a person presents herself says a lot about that person. I keep my hair neat, cut short. I wear a minimal amount of makeup. One luxury I allow myself (even though I really can't afford it) is that I get a manicure once a week.

7 **Defects**—I broke my left arm when I was eight. The cast was put on too tight and my left arm is now thinner than my right. Nobody really notices it, but I do. I am still taller than a lot of men but it's not as bad as it was when I was in grade/high school.

8 **Heredity**—I have my father's big hands and my mother's coloring—blonde hair, blue eyes, and fair skin. She is from Northern Italy.

Sociology

1 **Class**—My family is middle class; at least we are now. When I was younger we were lower middle class. My father is a blue-collar worker who worked construction off and on until he got a job with the parks department in the city. After that we bought our first house, in a not-so-great neighborhood, and then five years later, we sold that house and bought another house in a middle class neighborhood. We're still very "old world," as both my parents are immigrants. I am the youngest child and still live at home with my parents.

2 **Occupation—type of work, hours, union, non-union, conditions**—I work as the assistant to the principal of St. Ignatius Catholic School. My job is interesting; I get to meet a lot of interesting people as I arrange and organize Father Christopher's (the principal's) schedule. St. Ignatius is grades 9 through 12 with a very impressive academic standing. Children from all over Miami come to our school because they know if they do well with us their chances of getting into a really good Catholic university (Norte Dame, American U., like that) are

much better. The job is fairly stressful as I have to run a lot of interference for Father Chris. I have been his assistant for four years after being promoted out of the small secretary/administrative pool of workers in the office. It was a big leap for me. The pay isn't as much as I could make if I worked somewhere else but I enjoy the comfort of being surrounded by the teachings and principles of the Church. It is also a fairly prestigious job as Father Chris knows a lot of influential people and because I work for him, those people know me. The other girls in the secretarial pool were jealous when I was first promoted but I have worked very hard and done a very good job and now after four years, I think they understand that I am qualified to do the job. Father Chris says that, without me, he would be lost. Another thing I like about the job is that I like working for an organization whose basic goal is goodness. I was raised in the Catholic Church and I believe that the work they do is good. I know that the education we are giving our kids is really superior. We are the number two ranked Catholic high school in the country academically. Sometimes I feel the Church is behind the times but Father Chris assures me that the Church is making strides. "Rome," he says, "wasn't built in a day."

3 **Education**—My parents, both immigrants, with maybe a sixth grade education between them, thought education was important. We (five kids) all went to Catholic schools, not St. Ignatius; we couldn't afford St. Ignatius. We were the poorest kids at school, maybe the poorest kids in our parish, but we all had our uniforms and we went to school. We all graduated from high school and the three boys went to college. I wanted to go to college too, but my parents didn't believe in spending that kind of money on a girl who was probably "just going to get married." In one way, they were right. My sister got married her first year out of high school. The boys went to college and I convinced my parents to send me to secretarial school. I learned to take shorthand, type, and do a little accounting. I worked for a real estate company for two years but didn't like the way they talked about their clients behind their backs. Then I heard about the secretarial pool at St. Ignatius and applied there. While working there I went back to secretarial school and got some additional training. Nights, I also went to community college and took a couple of courses. Those were more for my pleasure than anything else. English literature, courses like that. I have always loved to read.

1 **Home life as a child**—I am the youngest of five children. Two brothers, my older sister Gina, then Edwardo, then me. Antonio and Paulo,

my two older brothers, and Gina are all two years apart. Then there is a four-year gap before Edwardo was born, and I am two years younger than he is. Mama miscarried a couple of times between Gina and Edwardo and once more after she had me. I don't remember any of that, I was not born or was too young to remember, but the older boys and Gina say Mama was pretty sad about it each time. I also don't remember us being poor either, really poor, but Antonio and Paulo do and they remember fights with the landlord at an apartment my family used to live in, with the landlord threatening to throw the family out and send Papa to jail. The year I was born was the year Papa went to work for the Public Works Dept. in Miami. He still works there. Mama never worked, even when I went to school (St. Elizabeth's for elementary school, St. Mary's for high school). I think she was too embarrassed. Her English isn't very good and she doesn't read or write very well. She came from Northern Italy after WWII and has maybe a third grade education. Her schooling was interrupted by the war. She was sixteen when she arrived in America (Chicago) and went to work in a slaughterhouse, working on an assembly line making sausage. That is where she met Papa. They met, got married and as soon as they were married, Papa announced they were leaving, going to the land of opportunity, Florida. Mama is good with numbers though; she's the one who handles the family budget. Papa didn't have much schooling either but he is a strong man and a hard worker. After a lot of difficult times they were finally able to buy a little two-bedroom house. The seven of us lived in five rooms. We lived there until I was five. Then they bought a three-bedroom house in a better neighborhood. We still live there. I still live at home. It's expected of me; I'm the youngest daughter. And for the most part I don't mind. It was hard but my parents sent my brothers to college. Antonio is an attorney, Paulo is a chemist, and Edwardo is in his last year of medical school. He took a break and worked for four years before enrolling in U of Miami's Med Center. But Mama and Papa wouldn't send me to college. They didn't want to waste money on an education for a girl who was just going to get married and have babies. That was certainly true for my sister who got married right out of high school and has three kids. Three little girls who I love and adore. My parents, after a lot of pleading from me and my two older brothers, did concede and let me go to secretarial school. I have my own bedroom and bathroom and can come and go as I please. I have no doubt that my parents love me. They are both hardworking people and set a good example of what a family structure should be

like. They are both staunch Catholics. Mama goes to Mass every day; Papa at least twice a week. I go on Sundays. At school, I participate in all the assemblies and help the teachers (the Sisters) set the curriculum for their classes. Growing up, I never thought we were poor, but now that I have seen a little more of the world, I realize we were probably at best lower middle class. It is easier on my parents now. I pay rent, and my two older brothers chip in. Papa would never take money from them but they buy things for the house that my parents won't buy on their own—a color TV, dishwasher, like that. Growing up, my parents were stricter with me and my siblings than my friends' parents were with my friends. Being immigrants, my parents are still very concerned about fitting in, not drawing too much attention to themselves, afraid of being embarrassed, made to look foolish.

2 **Home life as an adult**—My home life now is pretty good. I make good money, not as much as a man, but my expenses are less, as I still live at home, and I am willing to make a little less in order to have the job I have. I like my job and I like feeling protected and glad not to be out there in the dog-eat-dog world. I am a little timid, or shy is maybe the best way to say it. Living at home is expected, and for the most part I am happy to be around to help my parents out. Ours is a loving family and my brothers and Paulo's wife (only Paulo is married; his wife is expecting their first child) and my sister and her family come to my parent's house for Sunday dinner every other week. We are very close. Papa still works and Mama runs the house, but her arthritis is bad now and she has a hard time doing anything with her hands. I pay rent, not very much, which helps me and it also helps them. I have a new car that I bought last year. Papa made a big deal out if it; he has never bought a new car, only used ones. I think he is very proud of me but he has a hard time saying it. He likes it when we go places and important people know who I am. They know me because of my job, but I see him stand a little straighter when people say hello to me and how nice it is to see me again. I don't date much. I did meet a guy I liked a year ago, but that ended badly, very badly, about four months ago. Neither of my parents nor any of my other family members met Phillip, the guy I was dating, which turned out to be a good thing.

3 **Religion**—I was raised Catholic, very Catholic. My parents and my brothers and sister and their families all go to Mass. The Church is important to our family. Until four months ago, I'd missed Sunday Mass maybe twice in my life. Mama has never missed it, even on the

days when it is hard for her to walk. Papa, unlike a lot of men who stand around outside the church while their wives are inside, goes in and takes Mass. He loves the ritual of it. I haven't been to confession in a while, or rather I have been but I haven't been completely honest, and the guilt of not telling the truth and of being Catholic, and knowing what I did, is tearing me apart.

4 **Race, nationality**—My family is Italian, my mother from northern Italy, a little town outside of Milan and my father is from Rome. They immigrated to America after WWII, met in Chicago, and then moved to Florida. They sought out the Italian community in Miami and are very entrenched in it. My mother's English still isn't very good and she prefers to speak Italian and do her shopping at stores where people speak Italian. Mama and Papa keep a very old-world home. Papa still makes his own wine.

5 **Place in community—leader/follower**—I am much more of a follower than a leader. At work I am thought of as a leader because of my job and its responsibilities, but once I am outside of the office, I don't feel that secure and I would much rather have someone else suggest what to do. If I am going to the movies with my girlfriends, I always let them pick what movie we are going to see. Same if we are going to dinner. I do, however, know the best places to buy clothes, and if we are going out shopping for clothes, then I am the leader. I don't have to make that many decisions about things outside of my job. I live at home. Mama makes the decisions of what we are having for dinner. I don't date very much, haven't gone out once since Phillip and I broke up. During the week I come home from work, have dinner with Mama and Papa and then watch television with them. If they are watching something I don't want to watch, I have my own TV in my room. I also read a lot and will often go to my room after dinner and read. Papa and I no longer smoke in the house. It bothers Mama, and she has developed a bad cough if we smoke near her.

6 **Political affiliations**—I am very conservative. My Catholic upbringing has strongly influenced my politics. My family is Republican, and I voted Republican in the last two presidential elections (the only two times I have been eligible to vote). I am against abortion but feel like an incredible hypocrite because I recently had an abortion. Having that abortion went against everything I was raised to believe and I am wracked with guilt. Having an abortion is murder and I am the one who did it. I have not been able to confess this horrible sin. I have

done everything I can to push it out of my mind. I keep wondering what I would do if my parents found out. I am sure the Pope knows and God knows. Still I am Republican and would vote for people who oppose abortion.

7 **Amusements**—For amusement I like to shop. I don't always buy but I like to look. I also read a great deal, romantic novels mostly, although I do like English literature, the classics. My girlfriends and I go to the movies and out to dinner on the weekends. I used to see Michael; we were never boyfriend/girlfriend, just friends. He and my brother Paulo used to play baseball together and they would let me hang out with them. Then when they got older, he and Paulo drifted apart. Michael and I remained friends. We would go for long walks in the park. We could and would just talk about anything that came up. There wasn't anything he couldn't tell me and vice versa. When I told him I was in trouble with Phillip, he helped me. But now that he is in trouble, I have been too scared to help him.

As you can see the actor has taken the black and white sketch the screenwriter provided and has added color, lots of color. There is some repetition in what she says but the repetition reinforces the most salient points of the character.

Psychology

1 **Sex life, moral standards, fantasy/romance**—At school (St. Mary's High School for Catholic Girls), everyone talked about sex. They talked about it all the time but I don't think I knew anyone who actually did it. I didn't. I didn't even date. The first two years of high school I was still taller than most of the boys and in my last two years, while the boys got taller, I wasn't interested in anyone who was interested in me. While in secretarial school I dated a couple of different guys. One worked at the drug store where I would get my coffee. We went out but the closest I had to having sex with him was some fumbling in the back seat of his car. It wasn't until I was working at the real estate office that I had my first real crush on someone. He was one of the salesmen from another office. He wined and dined me for a couple of weeks, swept me off my feet, and one night after our fifth date, he took me to a motel room. It was over before I even realized it had begun. I guess technically I was no longer a virgin but I didn't think I had had sex either. He never called me again and he

never came by the office again. If he had something to deliver to the office, he had someone else bring it. I was hurt, didn't know what I had done wrong, but that was it. My period, fortunately, was right on schedule and after a little while I stopped thinking about it. I had sex with a couple more guys. They were nicer than the first but not much more exciting. I didn't learn about orgasms, and certainly didn't have one, until one of the women who worked in the real estate office told me how to do it. She didn't come right out and say do this, do that, but she talked about masturbation a lot and I picked up enough pointers. I finally tried it. It was wonderful and I enjoyed it but always felt there was something missing. There was no one to share that good feeling with, no one to talk to afterwards. I masturbated once a week, usually on Saturday nights, for several years until I met Phillip. He was the district manager for the office supply company where we get our supplies. He was taking over a new territory and came by to meet all of the people who ordered supplies from his company. He was tall, funny, sensitive, and he read. We talked about books and movies and then he asked me out. We dated for six weeks and then one night he took me to the beach and we made love. I felt like I was in the movie *From Here to Eternity* with the waves crashing in around us. He was slow and took his time and made sure I was taken care of. He held me afterwards as if he was never going to let me go. I was completely head over heels in love. He sent me flowers to the office, and chocolates. It was wonderful. For a while. Every time we would get together we would make love. Whenever we met I would drive and meet him some place. Phillip would never pick me up at my house. He said it was because he lived so far away. He also said he lived with an invalid mother. So I would drive and meet him somewhere. But I didn't care. I was in love and if driving halfway to meet him was what it took to see him, I was more than happy to do it. I told my friend Michael about it. And then when I told him Phillip's name, Michael said he knew him and that I should watch out, Phillip wasn't the great guy I thought he was. I didn't believe Michael. Phillip and I continued to see each other in spite of Michael's warning and I thought life was great. Then Phillip starting breaking dates with me. We would agree to meet and then at the last minute he would call it off. Finally, I discovered that Phillip was married. Unfortunately, I didn't find that out until I realized I was pregnant.

2 **Personal premise, ambition**—My personal premise is that *God sees all and knows all*. Once I got pregnant, I realized that God knew

that too and that I had committed adultery and then murder by having an abortion, and I was deeply fearful and sad. My ambition before all of this happened was to be a good person, a good daughter, and hopefully, maybe a good wife and mother. Now I don't know if that is possible. I feel despondent, adrift.

3 **Frustrations, disappointments**—My biggest disappointment is for being so stupid. Michael warned me about Phillip but I didn't listen. I was so foolishly in love that I couldn't believe my best friend. Shortly after I found out that Phillip was married, I also found out that I was pregnant. My Catholic guilt clicked in big time and out of desperation I did something that I had condemned others for doing. I had an abortion. In essence I took a life, murdered a child. Michael went with me, stayed with me, held my hand through it all. I was a wreck when we came back from Atlanta. My folks thought something had happened but they never knew what. Nor did they ask, nor did I tell them. In the first month afterward, I thought several times about taking my life. Somehow I thought that would only make things worse. That entire experience was the worst thing that ever happened to me. Slowly I began to pull out of it. And things were going okay until Michael got arrested. Now my biggest disappointment is that I am Michael's alibi—he was with me while I was having the abortion when Diaz was killed—but I haven't been able to bring myself to tell anyone. I feel like such a loser. Not only did I commit adultery, I had an abortion, and now I can't even help the man who helped me when I needed help the most.

4 **Temperament**—I think a lot of people think I am pretty happy-go-lucky, that not much phases me, and to a certain extent that is true. I am great at maintaining my poise, playing my cards close to the vest. Outwardly I never appear to be rattled, but inwardly, especially the past few months, I am a nervous wreck. No one has said anything and I think most people don't know. They may think it is some sort of hormone swing but I am testy now, jumpy, and I didn't used to be. I am so angry at myself for failing to live up to the standard of life that I set for myself. I am now smoking two packs of cigarettes a day in place of the five to ten cigarettes I used to smoke.

5 **Attitude toward life**—I'm like two different people. There is the Teresa before she met Phillip and had an abortion, and then there is the Teresa who is hiding in the shadows, afraid that someone will find

out my ugly secret. If my parents did find out, especially my father, he would kick me out of the house. He would be so disappointed with me. As an immigrant, he learned a long time ago to keep his head down, not to make waves. This would draw too much attention, negative attention, to the family. And my job, I couldn't stay there, the scandal would be too much. I am the assistant to the principal, everybody knows me and whatever I do is a reflection on the school and Father Chris. I was brought up to believe in the teachings of the Catholic Church, and what I have done is a sin. And that sin has been compounded because I am too afraid to speak out and help my friend Michael. One word from me and he would be released from jail but I am too scared of what will happen to me, so I keep my mouth shut. If I had to say one thing, I would have to say I am scared. Life used to be so simple and now it has gotten so complicated.

6 **Complexes, obsessions, inhibitions**—I am a neat freak. Even while my life is crumbling down all around me, I am compulsively neat. At the end of every workday, my desk is clear, cleaned off. My closet at home is arranged by color and then style of garments. In the kitchen I clean up as my mother cooks. It drives her crazy but I know she puts up with it because she likes having me in the kitchen to talk to when she is cooking. I'm a smoker. I have tried to quit several times but I can't. I am very conscious of my smoking. I don't smoke at my desk; Father Chris doesn't allow any of us to smoke in the office but I take a break every hour and go to the teachers' lounge or outside and light up. All my brothers smoke; so does my sister and her husband and my sister-in-law. Mama is the only one who doesn't smoke in the family. I am even neat when I smoke and have a little portable ashtray that I carry with me. I don't just flick my ashes anywhere.

7 **Extrovert, introvert—little of both**—I am more of an introvert than an extrovert; that is for sure. I basically like quiet things: reading, walking, going to the movies (romantic ones especially). When it comes to shopping, however, watch out! I am like a fury unleashed. I make it a habit of knowing who is having what sale, when. I think that comes from when I was very young and my parents were still struggling. Mama taught me how to find a bargain. My friends love taking me shopping. I am like a general preparing a battle plan. When we are done, though, and the dust has settled and we are having lunch afterwards, I revert back to my quiet, normal self.

8 **Abilities—languages, talents**—Something almost nobody knows is that I write poetry. I don't know if it's an ability or not. I don't even know if I am very good at it. I have never shown anyone any of my poems. That is not true. I showed a few to Phillip and he said he liked them but I don't think I can trust that, not now, not after everything I found out about him. I keep the poetry to myself, for myself. I love to read and have read every classic in English literature. I don't know if that is an ability either. I have never used that information except to get A's in my community college lit classes. I speak Italian. In my house, it is my parents' first language, and sometimes I speak it at work. I am good with kids. Not little kids, but when they get to be about five or six I really connect with them and they seem to connect with me. I also speak Spanish. We have many wealthy Cuban children that attend our school.

9 **Qualities—imagination, judgment, poise**—Until all of this with Phillip, I would have said that I have excellent judgment but I obviously don't. Other people, however, depend on me often for my judgment: at my job, in my friendships. My poise, if that means being able to hide what is really going on with me, is also very good. Nobody really knows what has happened to me. If it wasn't for Michael being in jail, I could, at least outwardly, pull this off. I don't know if I would ever be the same again, but nobody else would ever know. I don't rattle easily in social situations. I am often the hostess for many of the social functions Father Chris has at the school. I have a good imagination. I think one of the places it comes alive is in my poetry. Of course, that could just be me thinking that. No one else has ever really seen anything I've written. But I like the way I rhyme things, my word usage, and the alliterations I come up with.

10 **Intelligence—book or street**—My IQ is very high. I am not a genius but I am smart. I often feel as if I should have gone to college. I know I am smarter than many people who have gone to college. Guess I am a little naïve too. If I weren't, I wouldn't find myself in the situation I'm in now.

These are The Bones the actor came up with for Teresa. It's the same character the writer gave us a skeleton sketch of in his screenplay, but the actor who played Teresa in class has added meat and muscle. When Melinda Dillon created this character for the screen, she also presented a fully realized character. I don't know what process she used but the young

woman who played this role in class used the guidelines set forth in this chapter and, because of the details she came up with, we can easily see what motivated her behavior. The genesis of this information, the home base, came from the material the writer provided. The rest of it came from the actor's imagination.

Many of the things the actor put into The Bones raised the stakes in the scene: her parents being immigrants, her relatively sheltered life (e.g., the fact that she still lives at home), even her height. Because the actress who played Teresa in class really is 5′ 10″ tall, she used that to her advantage. She mentioned several times she had been taller than boys most of her life. This, along with a few other things, led to her character's awkwardness around men, which in turn created a certain naïveté that made her vulnerable when Phillip arrived on the scene.

You can see why this is the Big Frog. Doing a full set of The Bones is a lot of work.

This gave the actor a tremendous advantage over other actors working on the same scene. Incorporating this process into your preparation will give you the same advantage.

However, because this actor put in the time and the effort, she was rewarded with a fully realized character instead of a flat, unexciting, one-dimensional caricature, hopelessly bound to the page.

I can hear you groaning already. "*Are you saying I have to do a set of The Bones every time I break down a scene?*" Look, think of this like cooking. When you first try a new recipe you follow the instructions to the letter, adding the exact amount of ingredients, using the right pots or pans, and timing every step perfectly. But after you've cooked the recipe a half dozen or so times you start to experiment in order to get the dish to come out just the way you like it. You add a little more of this, a little less of that, cook it for shorter or longer period of time, etc.

It's the same way with this technique, not just The Bones but for all of it. Do each step exactly the way it's laid out at first and once you've mastered it, once you really own it, then start to experiment. After a while you'll know which elements of the technique you need to use to help you create fully realized characters.

There are going to be times, especially if you're working in television, when you simply won't have the time to do all of the homework. You might audition in the morning and have to be on the set that afternoon. It's happened to me, more than once. But I have learned, and so will you, how

to do the use this technique in a timely manner and still reap all the benefits. However, I caution you, don't attempt to short cut this step or any of the other steps until this technique is fully ingrained in your work.

Never once in the entire time I've been teaching have I had a student who, after crafting a successful scene, says, "I wish I had done less homework."

Ten Positive Attributes

In the previous chapter, The Bones, the goal was to create fully realized characters—warts and all. This chapter, "Ten Positive Attributes," serves as a safety valve for that process.

As actors we're often guilty of wearing blinders. Because a good deal of our work revolves around conflict (both drama and comedy depend on it), we often, in our desire to generate that conflict, tend to accentuate the negative and create an artificial "darkness" for our characters. This "darkness" can inhibit our work and we frequently find ourselves focusing too much on the negative aspects of the character's persona. When we do this, we run the risk of handicapping our characters, locking them forever in one dimension.

If you're playing a bad guy, the audience know he's bad because he's doing and saying bad things. If you play him solely as evil and/or mean, your behavior becomes predictable. When that happens, the audience will start to second-guess you. If the audience get ahead of you, you lose the element of surprise. If you lose the ability to surprise the audience, they will lose their willingness to participate and they'll resist going on the journey you're trying to create.

While creating a role it's important not to beat the audience over the head with any one aspect of the character.

The way to avoid this is to find, and then play, the truth about your character. The truth about all human beings is we are a mixture of good and bad. Good people do bad things and bad people do good things.

Even the most sinister character has good traits. Hannibal Lecter in *The Silence of the Lambs*, brilliantly portrayed by Anthony Hopkins, is an excellent example. He is bright, articulate, charming, cultured, and yet he eats people. He dines on their livers and chases it down with "a nice Chianti." Al Capone, the subject of numerous films, was a thug and a murderer, yet he could justify everything he did: "I have to feed my family." In most of the photographs you see of this Chicago-based gangster he's smiling. Hardly the behavior you'd expect of someone labeled Public Enemy Number One.

There is an endless list of films that have failed at the box office because the actors in those films failed to find their character's humanity. Even if the writer has written a drab, colorless character, it is the actor's job to round out the character by adding a few colors of his/her own. By playing only one aspect of a character, you risk turning drama (or comedy) into melodrama. And melodrama went out of fashion a long time ago.

Sometimes the character isn't "evil" but rather someone who, because of circumstances, real or imagined, is suffering from low self-esteem. The following is an example of what happened when an actor limited her focus to just the "apparent" qualities of her character.

The actor who portrayed Debby in the following scene in my class created a dark, lost, despondent person who was so down on herself she didn't think anyone could possibly find anything to like about her.

BAR SCENE[5]

Synopsis

Debby is an airline stewardess from a small town in Iowa. Last night she went out with a man she met on one of her flights. The evening started out all right, but then, as her date drank more and more, he became belligerent. Debby and the date ended up in a tavern on the outskirts of Chicago where Roger tends bar.

Fueled by alcohol, the date started putting some heavy moves on Debby. When she resisted, the date started to get verbally, then physically, abusive. Roger and the date struggled and Roger threw him out of the tavern. Debby's date then drove off with her purse in his car.

Roger, realizing Debby was stranded, offered her a place to stay. He lives two doors away. She accepted. He gave her the keys to his house. After closing the tavern, he returned home. She spent the night in his bed. He slept on the sofa.

It is the next day, Sunday. Roger is already awake, reading the paper. Debby woke up a few minutes ago and has been poking around his bedroom,

seeing what books he reads, looking at photographs of his family. When the scene starts, she is standing in the door of the bedroom watching Roger reading in the living room. He looks up and sees her.

 DEBBY
 Can I come in?

 ROGER
 Sure.

 DEBBY
 Good morning, even though it isn't morning.

 ROGER
 Good morning. Did you sleep well?

 DEBBY
 Yeah, okay. This is really nice of you. I mean, you
 don't even hardly know me.

 ROGER
 That's okay.

 DEBBY
 I thought maybe I could make some breakfast for us.
 What would you like?

 ROGER
 On Sundays, I usually go to the deli for lox and
 bagels.

 DEBBY
 Isn't that Jewish food?

 ROGER
 Yes, smoked salmon. You eat it with cream cheese.

 DEBBY
 Oh. I hoped I could cook something for you.

 ROGER
 There are some eggs in the refrigerator. You can
 scramble some and make coffee.

DEBBY
I hope your girlfriend won't be upset when she finds
out I'm here. Just tell her
I won't be here long.

ROGER
But I don't have a girlfriend.

DEBBY
No?

ROGER
No.

DEBBY
Don't you get lonely all by yourself?

ROGER
I keep busy.

DEBBY
What do you do?

ROGER
Read newspapers and watch television.

DEBBY
May I ask you a personal question?

ROGER
Go ahead.

DEBBY
Your parents? They been gone for a long time?

ROGER
My mother died about five years ago, and my father
died a year before her.

DEBBY
Is that them in the picture on the dresser
in the bedroom?

ROGER
Yes.

 DEBBY
 Your father was wearing one of those little black
 hats. Was he a rabbi?

 ROGER
 No, but he was an Orthodox Jew. He always kept his
 head covered.

 DEBBY
 The Orthodox are the really strict ones?

 ROGER
 Very strict.

 DEBBY
 Did you two get along?

 ROGER
 No. No, we fought a lot. When I started tending bar,
 he stopped talking to me.

 DEBBY
 And your mother? Was she strict too?

 ROGER
 She was worse than him. She used to tell me, Jews
 don't work in barrooms selling drinks to goyim.

 DEBBY
 My father was the president of the chamber of
 commerce in my hometown one year. I'm from a small
 town in Iowa. Ottumwa. Ever hear of it?

 ROGER
 No.

 DEBBY
 It was in the news when I was a little girl.
 Khrushchev stayed overnight when he visited America.
 Remember when he came here? We also had a Miss
 America a few years ago.

 ROGER
 They grow corn in Iowa.

DEBBY

And hogs. But my father wasn't a farmer.
He owns a men's clothing store in a big shopping
center. I used to work for him before I went
with the airlines.

ROGER

Small town girl makes good, huh?

DEBBY

My father still hasn't forgiven me for leaving.
He thinks all airline stewardesses are whores,
and I have to admit, he isn't far off.

ROGER

Stewardesses are okay.

DEBBY

Sometimes I get disgusted with myself. I wonder what
I'm doing with my life.

ROGER

You can't be a stewardess forever.

DEBBY

God, that's depressing. Can . . . can we talk
about something else?

ROGER

Did you have any plans for today? Would you like to
go see a movie?

DEBBY

I'd love to.

ROGER

I got the paper right here. Let's see what's
playing.

DEBBY

Thank you. Thank you very much.

There are ample reasons to see why the actress got stuck on the "dark side" with this material. The synopsis and the script tell us she is disgusted with herself, her father thinks she's a whore, and she doesn't feel she has a future.

The first time the actors performed the scene it dragged on and on, only to end with an unsatisfying conclusion.

However, when I asked the actor playing Debby to consider what was good about her character here's what she came up with:

My character is: Ambitious—she wants more for herself than her small home-town has to offer; Smart—she has the intelligence to get a job with the airlines; Sensitive—she is aware of someone else's troubles besides her own, i.e., Roger's troubled relationship with his parents; Compassionate—she is willing to share stories of her difficulties with her father to ease some of Roger's pain; Inquisitive—she looks around Roger's room, hoping to find out more about this man who rescued her, and is willing to ask questions about Roger's life; Funny—she is willing to make fun of herself; Honorable—she offers to make breakfast as a way to pay back the favor Roger did for her; Grateful—she recognizes and acknowledges that Roger helped her out of a jam; Attractive—she is pretty (the actress playing Debby was, so there is no reason to think the character wouldn't be); Innocent—her comments about lox and bagels and not knowing what it means to be an Orthodox Jew indicate a certain unthreatening naïveté.

After making these adjustments the scene changed from being about a woman who was unhappy and condemned to failure to a scene about a woman who, despite a number of disappointments, despite being denounced by her father, still had the confidence and the desire to give life another shot.

It's true that all the negative things about the character are in the scene, but so are the positive things. One of the big tip-offs that these positive traits exist in Debby's character is that at the end of the scene Roger asks her out. If he only saw the gloom and despair that the actress playing Debby portrayed the first time she did the scene, Roger would have to be a masochist to ask her to do anything but leave. But he does ask her out. It's a part of the scene and in order to make that action plausible the actress playing Debby needs to find and play the positive traits of her character. Otherwise, the end of the scene doesn't make any sense. Roger asks her out because he saw those good traits; the actor playing Debby needs to make sure she sees them as well.

The second time the actors did the scene, not only were they transformed, but the energy in the classroom changed as well. By the time the scene was over there was a charge in the air and the other students in the classroom were sitting on the edge of their chairs, completely wrapped up in what was taking place in front of them.

As actors you have to remember all the "bad" things about your character are going to be written into the script. That's pretty much guaranteed—it's one of the ways the writer creates conflict. What's usually left out or

An audience can't, and never will, root for a character who doesn't root for him-/herself.

understated are the "good" traits. However, in order to build a genuine character, you have to find and play both.

Building a character is a delicate operation and all the aspects, positive and negative, need to be explored and incorporated into your work. Finding *Ten Positive Attributes* that describe your character will keep you from falling into the trap that ensnares so many actors. As artists you need to learn to paint with all the colors at your disposal, not just the apparent ones.

Relationships

Every acting teacher I ever studied with had an impact on my work, some more than others. The three that influenced me the most were Aaron Frankel, Nikos Psacharopoulos, and Michael Shurtleff—all different, all brilliant in their own way. There were many other acting teachers that came before them, teachers that influenced not only these three men but countless numbers of actors as well. People like Constantin Stanislavski, Lee Strasberg, Stella Adler, Uta Hagen; the list goes on. They all had a huge impact on the "American" style of acting. Some of the ideas they espoused and the language they used are still being used today and you'll encounter a few of those ideas and some of that language in this book.

Michael Shurtleff was a brilliant casting director who helped launch the careers of such superstars as Dustin Hoffman, Barbra Streisand, and Robert Redford. He also wrote a wonderful book, *Audition*.[6] Several of the concepts I gleaned from Michael (and Aaron and Nikos) are in this book. In fact, one thing all three of these gentlemen told me, told everyone studying with them (and I paraphrase here): "Take this information and put your own twist on it." That's exactly what I've done. And that is exactly what I hope you will do.

I once heard Uta Hagen say this about relationships: "Some performers are so eager to start acting they begin reading their lines aloud 'with emotion' before knowing what the story is about."

Unfortunately, it's true. The thing that makes a play or a movie work, the thing that makes us believe or not believe the story, is how the characters relate to each other.

If actors create relationships that are honest and truthful, we will buy into the story no matter how fantastic it is.

If actors don't create these relationships we won't buy into the story. Who would have believed that a man would team up with a huge, hairy creature, half man/half lion, and together they would fly a beat-up rocket ship across a zillion light-years to save a peaceful civilization from a vile aggressor in a galaxy far, far away? But after seeing *Star Wars*, we all accepted as fact that Han Solo and Chewbacca were not only friends but comrades as well, fighting side by side to overcome an oppressive regime.

That whole movie is a fantasy, yet because of the honest and truthful relationships George Lucas and his actors created, we believed. We even believed the relationship between C-3PO and R2-D2. We sat perched on the edge of our seats, fearful whenever these two robots got into trouble, and rooting them on as they played out their parts in taking down the bad guys.

If you don't know who your character is you can't properly relate to the other characters. If you can't relate to the other characters the story won't

Building solid, strong relationships is essential to good storytelling.

develop. Doing "The Bones" (Chapter 3) will fix the first part of that problem and this chapter, "Relationships," will help you get a handle on the second part.

When figuring out your relationship with another character, the first thing you need to address is the fact of the relationship. Are you brothers? Brother and sister? Husband and wife? Co-workers? Enemies? Long lost friends? The facts that determine relationships can be many and varied.

One of the most powerful relationships, and one that is constantly undervalued, is two people meeting for the first time. Why is this dynamic so important? Because when two people meet for the first time there is a charge to that encounter that is rarely duplicated at any other moment in their relationship. Think of two lovers, Romeo and Juliet, meeting for the first time. Think of sworn enemies coming face to face for the first time. A mother and child reunited after being separated at birth. Don't discount the fact that when two people meet for the first time, especially in a play or a film where time is compressed and reality is intensified, it's most likely going to be the most important meeting of their lives.

The facts, however, while important, are merely a jumping-off place when it comes to determining the depth of a relationship. For the most part

the writer will have spelled out the facts for you. The difficult part is figuring out how you feel about the other person. Say you're brothers. Do you like your brother? Did he treat you well when you were children? Or do you resent him? Did he constantly belittle you in front of his friends?

There are six situations that govern the status of almost every relationship your character(s) will have with another character. This is true in our real lives as well.

I love him/her.

I hate him/her.

I admire him/her.

I resent him/her.

I want to help him/her.

I want to get in his/her way.

Take an honest look at any relationship you've had with anybody and see if that relationship didn't, at various times, fall into one of those parameters.

If the story you're trying to tell is so narrow in its scope that only two elk herders in Norway could possibly relate to it, you aren't going to have much of an audience. The reason Shakespeare's plays are still being performed, and the reason so many films based on his plays have been produced, is because of the universality of their themes. By using one of these six relationship possibilities when it comes to determining how we "feel" about the other

This may all sound simplistic, but one of the things we need to be aware of as actors, even while we're trying to create unique characters telling unique stories, is that there also needs to be a universality to the work, a chord that resonates with as many people as possible.

characters, we keep things simple and are more likely to strike those chords of universality. And the more often we strike those chords, the more impactful our work will be.

What's important when determining how you "feel" about the other character is how you "feel" at that moment in the scene. How you felt about him/her yesterday, while it may have a bearing on the scene, isn't as important as how you feel about him/her now. And how you might feel about him/her tomorrow is unpredictable. What really matters is how you

feel about him/her now. Do you love him/her? Do you resent him/her? Do you want to get in his/her way?

Let's use the older brother scenario. Your father died when you were both young. Your brother stepped up, took charge of the family, worked three jobs, amassed a good deal of money, made sure your mother was taken care of and sent you to college. Sounds like a great guy. He is. And you love him. And if you stop there you may have left out an important part of the equation.

Once you've figured out the facts of the relationship and how you feel about the other character, the next thing you need to determine is the conflict you have regarding those feelings. Conflict is the component that drives drama and comedy. When we're making films or staging plays we're working with an advanced form of storytelling. The more advanced the storytelling, the more intensified the reality should be. A situation that may take a year to play out in real life, where the people involved are doing everything they can to minimize the conflict—which is what we do in real life—will play out in less than two minutes on the screen or on stage where everything is being done to maximize the conflict, to increase the tension.

Why? Because if we don't create conflict, if the reality isn't intensified, if we're too successful in keeping the lid on the situation, then the excitement wanes and the audience loses interest.

In our personal lives we'll do almost everything we can to avoid feeling any emotion other than joy. But as actors we have to ride the roller coaster of emotions, hit as many of them as we can to develop our characters. The ride is vital to our work. We are re-creators of life, the interpreters of stories, and in order to tell an engaging story, our characters have to be pushed to the edge. They are either in a crisis, about to be in a crisis, or just coming out of a crisis. They live a reality that most of us, given the choice, would avoid.

However, this is the nature of our brand of storytelling, and if we want to participate in those stories then we need to, metaphorically, run into the burning house to rescue the three kids and the puppy trapped on the top floor. Or stand up to the schoolyard bully. Or have that serious "talk" with our significant other.

Indeed, one of the great joys of being an actor is we get to engage in scenarios we might never have the nerve to do in our real lives. You can yell and scream at your scene partner, say things you would never dream of saying to your spouse, and then, when the scene is over, you and your scene partner can go have a drink and congratulate each other on how well the scene went, how much you cried, how much emotion you showed.

Back to the scene with your brother. He's a good guy. He took charge of the family, bought your mother a house and put you through college. And you love him. But what if he drinks too much and when he does he's verbally abusive to his wife, a woman you admire and respect? Is it possible

that you might hate him, too? Just a little bit? And is it possible that little bit of hate could add an element of conflict to the relationship that would alter your thought process for a couple of seconds? Because, by altering your thought process slightly, it might give one of your lines a different spin. And by spinning one of your lines in a different direction, you create variety. And variety, my friends, is one of the elements that transform good work into great work.

An actor's worst nightmare is that he'll be boring. (Equaled only by the nightmare of being naked on stage and unable to remember your lines.) The way to avoid that, the way to make sure the scene doesn't remain static, doesn't get tedious, doesn't send the audience spiraling into a deep slumber, is to seek out and embrace the opportunities for conflict.

You want to generate as much conflict as you can and there is no better place to start than by being conflicted about the feelings you have regarding another character. It works the other way, too. Let's say the other character was a man who cheated your father. You hate him. But he also donated a huge sum of money and built a hospital for the poor. You admire that. It may not be your primary feeling, but somewhere, for a brief moment, your admiration for him will be strong enough for you to deliver a line or react in a different way.

APPLICATION TO A SCENE

The following is a scene from an Australian film, *Lantana*,[7] written by Andrew Bovell, directed by Ray Lawrence, and starring Anthony LaPaglia (Tony and Emmy Award winner) and featuring Rachael Blake.

Leon is a police detective who's having a difficult time in his marriage. He feels numb, passionless. He meets Jane at a Latin dance class he and his wife are taking. Jane has recently separated from her husband and is lonely. Leon and Jane start an affair. They meet one night for dinner at a restaurant.

LEON
So, why did you and your husband split up?

JANE
Um . . . I dunno. I just turned around one day and
realized that I was living with
a man that I didn't love anymore.

LEON
It was that simple?

JANE

(laughs)

No.

LEON
But you knew that much?

JANE
Maybe my expectations were too high.

LEON
You're a brave woman. You are. Most people
settle for less.

JANE
I really like you, Leon. Maybe a little too much.
But I'm . . . I'm starting to wonder
just where this might go.

LEON
I'm still in love with my wife, Jane.

JANE

(laughs)

Right.

LEON
I'm sorry.

JANE
So. I mean what . . . why . . . then why are you
off seeing me if you're still
in love with your wife?

LEON
I don't know. It's not something I planned.

(Jane laughs but doesn't speak.)

> LEON
> Look, Jane. This doesn't have to end badly.

> JANE
> Just go. Just go. Go.

The actor who played Leon in class created the following narrative for his relationships with Jane and the other characters mentioned in the scene.

Leon's relationship with Jane

Facts: she's a woman, a married woman I'm having an affair with.

Feelings: I love her, certainly in a sexual way. And I want our relationship to continue. I feel alive when I am with her.

Conflict: regardless of those feelings, I resent her. I resent the fact that she doesn't want to continue our relationship, that she was strong enough to leave her husband and now me.

Leon's relationship with his wife

Facts: she's my wife, the woman I'm married to.

Feelings: I love her. She is the mother of my children.

Conflict: regarding those feelings, I resent her. I resent what our relationship has evolved into. The excitement is gone and I blame her.

Leon's relationship with Jane's husband

Facts: he's the husband (although separated) of the woman I am having an affair with.

Feelings: I don't know this guy, I've never met him, but I want to get in his way. I want Jane to myself and if he is out of the picture, completely out of the picture, it makes things less complicated.

Conflict: regarding those feelings, I admire him. They may be separated now but at one time she loved him, probably deeper than she could ever love me. He must have some very good traits for her to have loved him like that.

Jane's husband and Leon's wife aren't even in the scene but they're very much a part of the scene and their presence needs to be felt.

Because the actor who played Leon in class included them in his relationship work, their presence is guaranteed. Now, instead of just two people who are casually mentioned, these two characters can and will have an impact on the scene.

When doing the work in this section it's important to use the first person: *I love her*; *I resent her*; *I want to get in her way.* It helps make the situation more immediate and helps you establish ownership of your character.

This is the most important lesson I learned from Michael Shurtleff: ask, "Where is the love?"

There is one more important aspect when it comes to figuring out your character's relationships to other characters in a scene. You need to always ask where the love is.

Not every scene is a love scene but there is love in every scene. Love isn't always pretty; it doesn't necessarily guarantee a happy ending. But by looking for the love, and hopefully finding it, you maximize your emotional involvement in the scene, and by maximizing your emotional involvement, you automatically raise the stakes.

The annals of drama are filled with tragic love stories. Why tragic? Because love stories that end well don't have the same impact as those that end . . . well, not so well. *Romeo and Juliet* is the classic version but there are many, many others.

The film *Longtime Companion*[8] is both touching and horrifying as it chronicles the early days of the AIDS epidemic. In this tender, compelling film David (Bruce Davison) and Sean (Mark Lamos) are the Longtime Companions. When Sean becomes ill he and David are forced not only to deal with the indignities of the disease but also the ignominies of a society that cannot, will not, accept their love. This film, although it ends tragically, is filled with love.

Carol[9] is another example of how societal values threaten the lives and happiness of title character, Carol (Cate Blanchett), and her lover Therese (Rooney Mara). Although these lovers end up together Carol pays the terrible price of having to give up custody of her daughter and can only see the little girl on supervised visits.

La La Land[10] is yet another example. This exquisite story of star-crossed lovers was written and directed by Damien Chazelle and stars Ryan Gosling and Emma Stone. We watch these lovers meet, fall in love and then eventually, as much as we don't want it to happen, grow apart. Filled with many, many joyous moments the story ends with them going their separate ways and leaves the audience (at least me) with a big hole in our hearts.

Not all love is idealistic or altruistic. In "Cat On A Hot Tin Roof", the dynamic between Maggie and Brick is hardly romantic; he can barely stand the sight of her. Yet the feeling between them started out as love, and because of a betrayal, done in the name of love, their relationship is strained to the breaking point.

Not all love is admirable. Envy, jealousy, revenge, greed—these are all conditions that began as love and then became twisted somewhere along the way.

If you don't look for the love, if you don't attempt to elevate the human condition to its highest possible level, then what you are likely to end up playing is indifference, and indifference is not only hard to play but it is extremely boring to watch.[11]

As actors we're the people that bring the writer's words and the director's vision alive. In order to tell the best story it's important for us to explore the depth and profundity of the relationships between our character and the other characters in the story.

You need to extract as much information as you can from the material you're given. You must not only be willing to ask where the love is in a scene but you must also be willing to accept that the love you find may not be as "attractive" as you would like it to be. You have to train yourself not only to look for conflict but also embrace it once you have found it.

This can be difficult. It's like reaching into a fireplace, pulling out a burning log, and wrapping your arms around it. Yet, in order for you to do your job, it's something you have to learn to do.

The presentation of the information in this chapter isn't meant to be formulaic. Rather, the goal is to help your character figure out how he/she feels about the other characters in the scene. Things will change once your scene partner gets involved, once you're on the set, once the director gives you input. The purpose here, and in the chapters to follow, is to help you establish a base line for your character, one that is both solid and flexible at the same time.

As actors, as re-creators of the human condition, we need to expand our concept of love to include the perverse shapes and forms love often takes in human relationships.

Once you have mastered the riddle of relationships, once you've explored their deepest depths, you will have developed an understanding of the human condition that eludes most actors.

Figuring out the complexity of relationships in a scene is like putting gas in your car before taking a trip. If you only put a couple gallons in the tank, you aren't going to get very far. However, if you fill up the car up, you will discover parts of the planet most actors never see. It's up to you; do you want to drive to the next town or around the world?

Main Objective

As stated earlier, there are a great many factors that can influence a scene—your choices, your partner's choices, the director's vision, and of course the material itself. If you have the luxury of rehearsing—not too likely in film or TV—you might be able to improv the scene or do some experimental work. And while these things are important and valuable they aren't always practical—not if you're on location and the light is fading and you only have five minutes to get the shot. Don't get me wrong, I'm all for doing whatever it takes to wake up our instruments but the realities of film and TV don't often allow for the same luxuries afforded you with a theatrical piece.

However, regardless of what the situation is—a play, a film, a TV show—an actor's goal should always be to serve the story/the scene and in order to do that you have to know what it is you want; what you're striving for. Sometimes you won't get what you want and other times you will get exactly what you want but despite which end of the stick you end up with you still have to serve the scene. The best way to achieve that is to make sure you have picked a strong *main objective*. Win or lose, make sure you know what you are fighting for!

I prefer using the term *objective* rather than *intention* because *objective* implies engagement whereas *intention* implies trying. Actors are goal-oriented people and in order to do our work we need to do much more than merely try. If we have an objective and we're fighting like hell to achieve it then regardless of whether we're successful or not, our work will be interesting.

Having a main objective is critical. If your character doesn't have an objective, if you aren't pursuing a goal, if you don't want anything from the other character or from the situation, if you aren't trying to influence the outcome of the encounter, then there is no reason to do the scene. The main objective is the engine that drives the scene.

Unlike the Sociology and Psychology sections of The Bones, where you are trying to breathe life into your character and you want to include as many details as you can, the main objective for the scene should be stated as simply as possible. *I want to charm her. I want to enlist him over to my side. I want to seduce her. I want to win his affections. I want to attack. I want to control. I want to manipulate.* There are a myriad of choices you can make, but whatever you choose, it needs to be simple, succinct and action based. The simpler the objective, the easier it is to pursue.

The main objective is your character's through-line, the one thing he/she wants to achieve in the scene. When you read a scene, ask yourself, "What do I want from the other character? Or what do I hope to gain from the situation? And why do I want it?" Knowing what your character wants and what motivates that desire makes your job easier.

Motivation is a buzzword with actors. We're constantly asking our directors or our fellow actors or ourselves, "Why am I doing this? Why am I doing that?" These are important questions. As actors we need to know what forces drive our characters, what the underlying causes are for our actions.

The order of their importance varies depending on individual personalities and the desires of our characters but these four fundamental needs are the main things that motivate our behavior. And because we, as humans, are motivated by one or a combination of these needs it's only natural that the same would be true for the characters we play.

> There are four fundamental needs that motivate the human race: love, sex, attention and survival.

What motivates Willie Loman in *Death of a Salesman*? What does he want? One thing he wants is **attention**, to be well liked; he even tells his sons that being well liked is the key to success. He spends his whole life harboring this misconception. What about *A Lion in Winter*? Henry and Eleanor are pitted in a desperate power struggle, each willing to use whatever is at their disposal, even their children, in order to **survive**. *Romeo and Juliet*? This story is filled with **love**, most notably the romantic love between the two title characters. In *Looking for Mr. Goodbar*, a craving for **sex** leads the protagonist, Theresa, into increasingly dangerous situations that eventually cost Theresa her life.

Each of these characters is striving to get more of what they need—more attention, more power (in order to survive), more love, more sex. And it's the conflict, the things that stand in the way of the character getting what he/she wants, that engages the audience. Would *Romeo and Juliet* be the compelling story it is if their parents liked each other? If they said, "Hey, kids, you're in love? That's fine with us."

Because drama and comedy depend on conflict, some or all of the other characters in the scene are invariably going to be saying "no" to what your character wants. Or you are going to be saying "no" to what they want. This is good. The "no's" force you, and/or them, to be persistent in pursuing your (and in the case of the other characters, their) main objective.

The need for conflict is one of the reasons why romantic love scenes are so hard to play. On the surface it may appear as if both people want the same thing. But if you keep in mind that every scene is really a struggle for power, for control, and that while the two people involved may seem to want the same thing, in reality they each want what they want in their own way. They each have their own agenda about how to get what they're after. These different agendas create conflict, and conflict is what keeps the story interesting.

The same thing applies to a seduction scene. Even if both of the characters use "to seduce" as their main objective, there is still conflict. Each character has his/her own idea of how the seduction should happen; each character wants to control the situation; and each character struggles, excuse the pun, to make sure he/she comes out on top.

Once you start analyzing scenes and breaking them down to their basic elements, you'll notice that almost every scene shares a similar pattern. Regardless of the length of the scene, regardless of the kind of scene it is, the progression of the scene is usually: conflict, conflict, conflict, resolution, end of scene. If the scene goes on for five pages, it's because: (1) the writer wants a certain amount of information revealed; and (2) the characters are pursuing different main objectives (or they're pursuing the same objective but hoping for different results). Then, somewhere toward the end of the scene, a resolution is reached, or they're interrupted, and the scene is over. If they're interrupted then the conflict is usually continued in a later scene.

If for some reason the screenwriter hasn't written conflict into the scene, it's the actor's job to create it. It's important that you be passionate about what you want and do everything in your power to get it. Especially when another character says, "No, you can't have it." In the end you may not get what you're after but you will have created an exciting scene because you fought like crazy trying to get it.

Scenes revolving around conflict are not only fun to play they're also exciting to watch.

Even bonding scenes are based on conflict. Two seemingly disjointed characters slog through their differences only to discover they have a common goal or value that ultimately unites them. The bulk of the scene is about the struggle caused by the differences. Then, when the characters discover the common bond they share, resolution occurs and shortly thereafter the scene is over.

Scenes about resolution are difficult to play and can be boring to watch. Playing a scene that is only about resolution is like going to a psychiatrist long after the reason you went in the first place has been resolved. The drama is over; there isn't much more to talk about.

Look at whatever scene you're working on now and ask yourself, "What is motivating my character's behavior?" Why is he doing or saying the things he says or does? Is he like Adrien Brody's character in *The Pianist*? Is his behavior motivated because he is doing everything in his power to **survive** a terrible situation? Or is it like William Hurt's character in *Body Heat*, whose **sexual** attraction to Kathleen Turner is so strong that he helps murder her husband? Or is it like the undying **love** that Meryl Streep's character feels for Ed Harris's in *The Hours*? Or is it the **attention** that Andy Griffith's character, Lonesome Rhodes, desperately seeks in the marvelous film *A Face In The Crowd* that causes his character to do the things he does?

Having a main objective is crucial to the success of any scene, whether your character achieves his/her objective or not. Knowing the underlying cause for your character's behavior (love, sex, survival, attention) provides you with the insight you need when it comes to choosing that main objective.

Remember, the other character(s) in the scene is going to be saying "no" to you for most, if not all, of the scene. Make sure your main objective is strong enough so you can pursue it throughout the scene. And make sure it is simple enough so that not only you know what you're trying to accomplish but the audience knows as well. And finally, make sure your main objective is action based and playable.

Stating your main objective in a sentence is good. Stating it in two words is even better: *to manipulate*; *to convince*; *to seduce*; *to overcome*. These and a thousand other action-based verbs will help you as you try to get what you want from the other characters in the scene. Having a main objective—knowing what your character wants—not only energizes your performance, it gives you a reason to be in the scene.

Opposites

Human beings are a study in opposites. Think of the burly construction worker who makes his living in an environment where gentleness is ridiculed, even scorned. Yet this same man weeps with joy at his five-year-old daughter's ballet recital. Think of a demur, bespectacled librarian who also happens to have a black belt in karate. This woman could annihilate an attacker before he could lay a hand on her. Or a boxer who does Transcendental Meditation. Or an accountant who skydives.

What you see isn't always what you get. And what you think you have isn't always the thing you thought it was. Think of your girlfriend, the woman you love. You just got through telling one of your coworkers that you love her and you want to ask her to move in with you. Then you see her walking down the street arm in arm with a man you don't know. How do you feel now?

Do you have children? Those lovely creatures you would give your life to protect? When was the last time you felt like wringing one of their necks because they did something stupid? Love, like so many other things, can turn on a dime.

This happens to us all of the time. We're headed in one direction when something gets our attention and we veer off to the right. We travel down that road for a little while only to realize it isn't going to get us to where we want to go. So we get back on the main road and eventually end up where we wanted to go in the first place. But by traveling away from where we

wanted to go, by going in the opposite direction for a short while, we have learned something—if nothing else we've learned that we didn't want to go that way—and then we correct our course.

Good writers do this as well. They know they need to present a certain amount of information in each scene in order to forward the story. By creating opposites, by taking the scene in an unexpected direction, however briefly, the writer can extend the scene and keep the audience's interest piqued at the same time.

Actors need to understand this concept, too. First of all, we might not always be fortunate enough to be working with good writers. And second, even good writers write bad scripts. Either way it's going to be you up on the big screen, and you need to make sure you're doing everything in your power to ensure the story's success. Opposites serve us because they help create variety.

Think of each scene as a piece of music. The screenwriter wrote the lyrics; you get to do the orchestration.

If you don't do this, if you simply pursue your main objective, you'll flat line your work, your performance will lack "color," and you'll be doomed to mediocrity.

It's possible the audience may know what your main objective is before the scene begins. Information from a previous scene might tip them off as to where the current scene is headed. By finding and playing an "opposite," you not only add an element of surprise to the scene but the conclusion of the scene, when you finally get there, is ultimately more satisfying. You've taken the audience along the scenic route with a lot of interesting twists and turns instead of just barreling straight down the interstate.

If your main objective in a scene is to seduce a girl then at some point, after she's rejected your advances enough times, you change direction and play your opposite. In trying to seduce her, your dialogue could be, "You want to go for a ride?" To which she says, "No." "What about dinner?" "No." "What about a drink?" "No." "It's a beautiful night. How about if we go for a walk down by the lake?" "No." And so on and so on until you finally give up and say, "I've got to get up early tomorrow morning. I'd better shove off," the subtext being "I don't care if I get you into bed or not." You're no longer pursuing your main objective; you've switched and are now playing an opposite. You've gone from wanting to seduce her to wanting to cut your losses.

If that's the end of the scene and the writer doesn't have any more information to impart, then the scene is over. You've played your main objective—*to seduce*—for most of the scene, using a variety of tactics (see Chapter 10, "Beats, Tactics, and Actions"). At the end of the scene, you play your opposite objective and the scene is over.

But if the screenwriter wants to use this scene to reveal more of his/her story, if he/she needs to develop the characters further, and the scene continues past this point, then an interesting thing happens. After you play your opposite, the other character may counter with, "I'm off work in ten minutes. Maybe we could get a cup of coffee," the subtext of that line being "I know I've been saying 'no' all this time but I don't want you to think I'm not interested."

The scene may continue on for several pages only to end up with the same results: your character still pursuing the girl and the girl still saying "no." But because the writer created this bump in the road and both actors played an opposite, the focus of the scene shifted enough to keep the audience engaged. Because this twist was interjected in the story line, the audience are not only willing to stick around to see what happens next, they're excited about the prospects. Now with the audience fully engaged, the writer can put in whatever additional information he/she needs in order to forward the story.

The above example is one in which the writer knew he/she had a lot of information to dispense. He/she wanted to keep the audience involved so he/she wrote an opposite; he/she created that bump in the road for the actors to play with. But what if he/she wasn't a good writer? Or if he/she's a good writer but was having a bad day?

If you don't apply the use of opposites to your work the scene will be tedious, lacking variety, and you could end up looking foolish. As actors we are the focal points. We're the ones the audience see and we're the first ones to get blamed if things go wrong. A member of the audience will often react, "I didn't think so-and-so did a very good job." Rarely does the audience member realize that so-and-so was working his/her ass off but was handicapped with inferior material. However, if you understand the concept of creating opposites, you'll be able to turn a bad scene into a good scene and a good scene into a great scene.

As an actor you need to train yourself to look for and then play opposites, even if they aren't written into the piece.

This is not a slam on writers. Writers, directors, actors—we all want the same thing. We want to tell the best story we can in the most interesting, exciting, and truthful way possible. In order to do that, we need to get from Point A to Point H. Going in a straight

line isn't the most interesting way to do that. Creating a roller coaster ride that starts at Point A, and then dips down, and then zooms up, and then whips around a sharp corner, and then plunges down again, and then zips up again, finally winding up at Point H is not only interesting but rewarding as well.

Use the concept of opposites to create that roller coaster ride, whether the writer has written any opposites into the scene or not.

Here's how this works. The following is a scene from *The Thomas Crown Affair*. The movie was first made in 1968, and then remade in 1999. Both films were fun and exciting to watch. This is from the 1968 version, starring Steve McQueen and Faye Dunaway (both nominated for numerous awards), written by Alan Trustman, and directed by Norman Jewison (multi Academy Award nominee).[12]

This scene is about attraction and danger and is filled with sexual innuendo. The two characters are drawn to each other like moths to a flame. They know if they get too close their wings will catch fire and they'll burn. However, like the moth, the temptation to be close to the light is difficult to resist and they continue to flit back and forth, getting closer and closer to the very thing that could consume them.

Synopsis

Thomas Crown is a wealthy businessman who robs banks (in the remake he steals art). He doesn't do it for the money but rather for the thrill of it. He's never been caught, but the insurance company that has had to cover the losses at several of the banks he's robbed believes he is the mastermind behind the robberies. The company hires Vicki Anderson, an expensive private investigator, to find out if Thomas Crown is the bad guy and, if so, to put him behind bars.

Vicki, instead of investigating Thomas from afar, decides to meet him. She "bumped" into him at an art auction a week earlier. At that auction they bid against each other for a painting by the artist Daumier. When the bidding got too high, Vicki stopped bidding and Thomas ended up with the painting. Despite the danger—her flirting with someone she is investigating and his flirting with a woman who could put him in jail—they are very attracted to each other.

The writer wrote a couple of obvious places where both characters could play opposites.

In class, the actor who played Thomas found several additional places to incorporate the use of opposites. In the following scene the actor wrote out his thought process to justify his shift from playing his main objective to playing an opposite:

MY MAIN OBJECTIVE—TO SEDUCE.
With my Opposites I will pull back, distance myself.

<div align="center">SHE</div>

<div align="center">Mr. Crown. I'm Vicki Anderson.</div>

<div align="center">HE</div>

Main Objective—she's attractive so I'll flirt
with her.
To flirt in order to seduce.

<div align="center">Hello. Where's your camera?</div>

<div align="center">SHE</div>

<div align="center">You remember?</div>

<div align="center">HE</div>

<div align="center">The Daumiers. May I give them to you?</div>

<div align="center">SHE</div>

<div align="center">Then why did you . . .</div>

<div align="center">HE</div>

<div align="center">Bid? Because I wanted to buy. Anyhow, it's for
charity, and five is the proper price. That your
Ferrari outside?</div>

<div align="center">SHE</div>

<div align="center">Why, yes. How did you know? I just bought it . . .</div>

<div align="center">HE</div>

This is my first Opposite—it's a small bump in the
road. I really have no idea who this woman is. I go
to all these charity events all the time and I've
only seen her that one time before. I want to find
out more about her before I make a stronger play.
I'm going to keep her at arm's length while I gather
more information.

<div align="center">On the other hand, you stopped bidding at . . .</div>

<div align="center">SHE</div>

<div align="center">Shall we have a drink, Mr. Crown?</div>

<div align="center">HE</div>

Still playing my Opposite Objective, still checking
her out.

<div align="center">What brings you out here? Charity?</div>

SHE
Not really. I've been reading about you.

(He points to a newspaper he has tucked under his arm.)

HE
Back to Main Objective—I'm flattered. I drop my
guard a little. I begin to flirt again, using
flirtation as a way to seduce.
Oh, this. I get around, I guess.

SHE
Not in the society pages.

HE
No? Where?

SHE
In a file.

HE
Opposite Objective—another small bump in the road.
I'm going to pull back a little. If she has been
reading about me, what is she up to?
Oh? No kidding? Who do you work for?
Vogue? Harpers?
Life? Look? Time?
By the time I get here, I have regained my sense of
humor. I am back to my Main Objective and am more
interested in seducing her than anything else, so I
make a joke.
I've got it. World Wide Polo.

SHE
Uh-huh. Insurance, Mr. Crown.

HE
Opposite Objective—big bump in the road. I've
been flirting with, trying to bed, an insurance
salesperson? I'm angry. I pull way back.
I'm amply covered.

SHE
I hope so. I'm an investigator.

 HE
*Still playing my Opposite Objective—still holding
her at a distance.*
 Anything in particular?

 SHE
 The bank, Mr. Crown. You wouldn't expect us to take
 the loss of over two-million dollars lying down,
 would you?

 HE
*Back to Main Objective—even though I now have an idea
who she is and what she does, it doesn't turn me off.
Plus the thought of seeing her lying down actually
turns me on. The attraction is strong, so I stay.*
 It's an interesting picture.

 SHE
 Not to some people.

 HE
*Still playing my Main Objective—lots of sexual
innuendo. I really look her over, visualize her
lying in my bed.*
 It's still an interesting picture.

(He points to her car.)

 HE
*I switch to an Opposite in the middle of this speech
and ask her for the facts about her job, the job
that could put me in jail.*
 They must pay you well.

 SHE
 Depends on the return.

 HE
 I get it. You're one of those headhunters, huh?

 SHE
 You could put it that way.

 HE
Main Objective—talk about innuendo.
 Whose head are you after?

 SHE
 Yours.

 HE
 Mine?

 SHE
 Yours.

 HE
*Opposite—I back away again, trying to put things in
perspective.*
 Interesting.

 SHE
 You really do amaze me, you know?

 HE
 How's that?

 SHE
 You've got to be curious.

 HE
 No. Not that curious. Although you have been saying
 some pretty wild things.

 SHE
 Wild?

 HE
 And a little ridiculous.

 SHE
 But only a little.

 HE
 Look, it's very enticing and all that, but you
 practically said I had something to do . . .

 SHE
 I said it, and not practically.

 HE
Back to Main Objective—in spite of the danger, I'm
still there. I'm still intrigued. I want to know
exactly what she has on me. Or thinks she has.
 Just what is it you've got?

 SHE
 Oh, I can't tell you, it would spoil the fun.

 HE
 Fun?

 SHE
 Fun. Yours, mine, your finding out just
 what I've got.

 HE
 What a funny, dirty little mind.

 SHE
 So put a bullet in my leg. It's a funny, dirty
 little job.

 HE
Opposite—even though I'm in pretty deep and I'm very
attracted to her, I want to stay clear-headed, so I
try to pull back a little, although not as much as
before.
 I suppose you think you're good at it. Your job.

 SHE
 I know I am.

 HE
 Always catch your man?

 SHE
 Of course.

 HE
Main Objective—back to flirting. I know how
dangerous she is to me but I think I'm smarter than

```
she is. I think I can have my cake and eat it too,
so I play with her.
          Do you think you're going to get me?

                         SHE
                 Mmm.  I hope so.
```

The challenge for the actors isn't to merely tell a story; the challenge is to create a story filled with human complexities.

The audience knows who each of these characters are long before this scene starts, but it's in this scene that these characters discover their mutual attraction. The actress in class also had a main objective, but if both actors only played their main objectives then the scene wouldn't be nearly as rich. Because the actors found and then played a series of opposites, the scene became an intricate dance and we watched with fascination as these two characters moved from Point A to Point H, going from adversaries to practically becoming lovers. In fact, a couple of scenes later, they wind up in bed together.

In order to do this, you need not only to know and play your main objective but to find and then play the opposites as well. The main objective is played for the majority of the scene; the opposites are momentary. Add excitement and flavor to your scenes by creating and then employing the opposite aspects of your character's life in your work.

There is one important caveat to this—another reality of the business. If you're hired as a "day player" (an actor contracted for one day, as the name implies) or as an "under-5" (a role with fewer than five lines) in a film or a TV project, the writer may not have created any opposites for your character. Nor is it likely you'll be able to create any. Those roles are in the script so that someone other than the main characters can forward the story. Unfortunately, those parts are usually where typecasting prevails and casting directors will tell you, "This role isn't about acting; this is about getting the story told. The stars will do the acting."

Having said that, though, it doesn't mean you shouldn't do your best work; it's just that these parts aren't going to provide you with the same opportunities to develop your character that larger roles will.

Moment Before

While it's important that you know what's happening with your character throughout the scene, it is equally important to know what's happening with your character before the scene begins. If you don't know what led your character to the state he/she's in when the scene starts, your job's going to be much harder. Your character needs to be fully engaged in his/her life before the camera starts to roll or before you step on stage. You can't start at 70 percent; you have to be charging on all cylinders, 100 percent engaged. Your emotional state may change during the scene (and it should), but like a bull ride in a rodeo, it starts in the chute before the gate opens.

The Moment Before is the preparation you do to ensure that your character is completely immersed in his/her life—mentally, emotionally, and physically—before the scene begins. Even Act I, Scene I has a Moment Before.

It took me a long time and cost me many—too many—good roles before I finally grasped the importance of creating a strong Moment Before. One of the more painful memories was losing out on the lead role in *Moonlighting*, a TV series that went on to star Bruce Willis and Cybill

> The more specific you are with what's happening in the Moment Before, the better your work will be.

Shepherd. Casting director Kris Nelson told me I was her choice when I auditioned for the show. Before going in for that audition, I had done my standard prep work—I learned the words, knew what my main objective

was, figured out what emotions I wanted to highlight. What I didn't do, what I didn't know then, was how to create a Moment Before.

Another incident happened shortly after that. I had the chance to meet and read for the casting director, Mali Finn. Ms. Finn cast over fifty films including such mega-hits as: *The Matrix*, *Titanic*, *The Untouchables*, *Terminator 2: Judgment Day*, *The Green Mile*, *Running with Scissors*.

I did my standard prep—learned the words, worked on the emotions, knew what I wanted in the scene—and once again I didn't get the role. But my agent did get some feedback. The word came back that Ms. Finn felt I wasn't as prepared as I could have been. I told my agent what my process was, how I prepared, and my agent suggested I get in touch with Michael Shurtleff; he was forming a new class.

Michael's class was geared toward the audition process and it was there that I learned about the Moment Before. After that class my booking rate went up, way up. Not only was I booking a lot of episodic work but I landed a ton of commercial work too.

The Moment Before, like The Bones, is part of the technique where more is more. The more detail you put into it, the more you'll get out of it. And, like The Bones, you may have to go outside the script to get the information you need. Never forget that the actual script you're given only provides you with about 30 percent of the information you need to create a fully realized character.

A lot of actors are keen on doing improvisation. In improv, if you aren't present, the story comes to a screeching halt. The advantage actors have over improvisers is actors know where the scene is going before it starts. Improvisers not only have to make up the story, they also have to fill it up while performing it. Since much of what we do as actors is already made up before we get involved in a project, our focus is on filling up what we're given. Starting full, with characters that are completely engaged before a scene even begins, is the best way to guarantee that.

The Moment Before consists of three parts: *the scenario*, *the positive expectations*, and *the negative expectations.*

The scenario: This is the mini-scene that happens just before the real scene begins. In The Scenario it's a good idea to start with a few sentences that describe how and why the character is in the situation he is in, and then a couple of sentences to set up what is about to happen. Here's an example of how this works using the *Absence of Malice* scene from Chapter 3.

The actor has already done the backstory (The Bones) for Teresa's character, so we know the situation she's in didn't develop overnight; it

started years ago. Growing up in a lower middle class, old-world family, going to an all-girls school, and being sheltered from any real experiences with men, Teresa ended up having an affair with a married man, got pregnant and terminated the pregnancy with an abortion.

Here, from Teresa's point of view (POV), is The Scenario that leads up to the beginning of the scripted scene:

I am sitting on a park bench waiting for the reporter I spoke with on the phone to show up. She wrote an article that put Michael in jail for a crime, a murder, he didn't commit. I know he didn't do it because he was with me at the time. I got an abortion and Michael saw me through it; he never left my side. I was too scared to speak up when Michael was first arrested, and I hoped he would be set free without me having to say anything. But he wasn't, and if I don't do something now, he's going to be in jail for a long time. I am sitting, smoking, checking out each person who enters the park. That woman there, she's looking back at me. She starts walking toward me. I stand.

The Scenario doesn't have to be any more complicated than that, and yet you would be surprised how many actors don't even do this; they just plunge in. Please, take it from someone who learned the hard way and do us all a favor, don't be one of those actors. Know how and why your character got to where he/she is before the scene starts.

The next two parts of the Moment Before are to assist you in getting your character into the proper emotional state to begin the scene.

Positive expectations: this is how you're hoping the scene will play out. These are the good things, the things you want to happen:

I am excited, hopeful. The reporter is here. That's already a good sign. Maybe it will work out, she'll believe me and I won't have to tell her everything. And she'll write another story, a story that will set Michael free so I can stop feeling so guilty about not helping him earlier.

Negative expectations: these are the bad things that could happen. Why are the bad things important? Because we want to maximize the conflict in the scene. For the most part our characters are either in a crisis, about to be in a crisis, or just coming out of a crisis. Crisis creates conflict. Conflict is the component that drives storytelling. Knowing the bad things elevates the stakes. It not only puts the character in peril, it also makes the story worth telling:

I'm scared. What if she says no? What if she refuses? What if she won't write another story? I can't let Michael go to prison for something he didn't do. But I can't tell her everything. It's too horrible what I did. I had an abortion. I killed a baby, my baby. I'm the one who is guilty of murder.

Now, before the scene even starts, you have a character that is not only excited, she's also nervous and fearful—probably just how you would be if you were in her situation.

The same thing is true for Debby's character from the scene in Chapter 4 ("Ten Positive Attributes").

The scenario: this is what is happening from her POV up to the very first line of the piece:

I ended up in a bar last night with a guy I didn't really know, a passenger from my flight. He got very drunk and started being abusive. I keep ending up with guys like this, all flash and no substance. It's like I'm looking for love in all the wrong places. When my date started getting physical, the bartender, Roger (I think that's his name), stepped in and threw my date out. I've never had anyone defend my honor before. I didn't have any money for a cab so this guy, Roger, said I could crash at his place. I was a little reluctant to go, but somehow I felt safe so I went. He gave me his bedroom. I am not sure where he slept but it wasn't with me. I woke up about a half an hour ago and I have been looking around Roger's room, trying to figure out who this knight in shining armor is. I can hear him in the living room. I crack the door open and peek in and see him reading the newspaper. He looks up and sees me.

Positive expectations:

I don't know much about this guy, but what I do know, I like. He didn't take advantage of me last night when I was in a very vulnerable position. I feel happy. Maybe there could be something there. God knows I would like to have a real boyfriend.

Negative expectations:

Who am I kidding? I'm so embarrassed. Plus, I don't have any idea who this guy really is. I could be worse off than I was before. Nobody knows I'm here with this guy. I need to tread very carefully, make sure I'm safe.

Now we have a character that is not only fantasizing about having a relationship with a man she doesn't know, she's also embarrassed and fearful. She doesn't know if she's safe or not.

The result: we get a character that is fully engaged, emotionally charged and involved in an active thought process before the scene even begins. What more could we ask of an actor who has yet to say a line?

The Moment Before is like jump-starting a car: you've got to get the car up to a certain speed before you pop the clutch. If you don't, the car won't start. Make sure you create a moment before that gives your scene the juice it needs to get going.

Discoveries/Emotions

One of the biggest obstacles actors face is staying "in the moment." While we're working on a scene we live a very schizophrenic existence. We know everything that's going to happen before it happens. We know the beginning, the middle and the end of a scene before the scene starts. We know who wins and who loses each battle long before the first shot is fired, and then we have to pretend we don't know what we know.

This is hard. It goes against every natural instinct we have. One of the advantages humans have over animals is our ability to reason. We take what we've learned from life's lessons and move forward. It's not natural for us to repeat the same unpleasant experience over and over again, especially when we know the outcome. Yet as actors, in order to fulfill the obligations of the story,

> We know everything that's going to happen before it happens. We know the beginning, the middle and the end of a scene before the scene starts. We know who wins and who loses each battle long before the first shot is fired, and then we have to pretend we don't know what we know.

that's what we do. Staying present, being "in the moment," night after night or take after take can be difficult when we have so much prior information.

Most of us are pretty good at being in the moment when our character is talking, but when another character is talking we tend to drift off. Unfortunately, this means we're only present for about half of the scene. That isn't enough.

While we're acting, we're dealing with heightened moments of reality. When the stakes are that high we need to be present 100 percent of the time.

The best way to accomplish this is to learn how to be an active listener. Being an active listener doesn't mean you move around a lot or make facial expressions or tilt your head from side to side. It means, when the other character is speaking or engaged in an activity, you're making a series of discoveries about what he/she is saying or doing. If you make honest, interesting discoveries, you become interesting to watch. The more interesting you are to watch, the more the audience wants to engage in your character's journey.

A wonderful example of this is almost any film starring Jimmy Stewart. Watch those old movies and you will see, scene after scene, when another actor is talking, and the camera should be on that actor, it's on Mr. Stewart. Why? Because he's listening, making a series of discoveries. It's not that the other character's information isn't important; it is. It's just that the visual of Mr. Stewart listening is more engaging than the visual of the other actor delivering his lines. Film directors and editors (and, to their dismay, many actors who worked with Mr. Stewart) realized that some of the best work in the film was Mr. Stewart listening. That footage made the final print while the footage of the other actor ended up on the cutting room floor. You need to make sure this doesn't happen to you.

What is the key to listening? Listening is about evaluating. For a scene to be successful you have to want something. That's your Main Objective. Let's say your Main Objective is to win the other character over to your cause, whatever that cause might be. Every time he/she says or does something, you need to evaluate that information and figure out if you're getting closer to what you want or if it's taking you further away.

This really isn't any different than what happens in real life. You want something, you need somebody else to help you get it and as you engage with him/her, you discover whether he/she's helping you get it or not.

The second part of the equation is figuring out how you feel about what you've just discovered. You want something in the scene and how you feel about getting it or not getting it will have an impact not just on your character but on the audience as well.

Don't forget, a huge part of your job is to go on an emotional journey.

You are the audience's guide and as you go through the process of making discoveries and then figuring out how you feel about them, those feelings, those emotions, will impact the audience. The discovery aspect of the equation alone is not enough. You must add the emotional component.

There are hundreds of emotions. The important thing is to make sure you're using a real emotion to describe what your character is feeling. Oftentimes, when I ask students how they feel about something they just discovered, I'll get some very strange responses. Here are two I heard the other day. The first actor said, "I feel overheated. I don't like the way my husband in the scene treats our child and I get so overheated that my skin is actually hot." Overheated is not an emotion; it's a result of an emotion—anger. Or this one, "I don't feel welcomed by my parents. They've rejected me since I told them I was gay." Two things are troublesome here. First, what you *don't* feel isn't nearly as important as what you *do* feel. So focus on what you do feel. Second, the "not feeling welcome" issue comes from being sad, or feeling betrayed or embarrassed, or all three. These are real emotions. Those are things you can play and the audience can follow. That's what you want: emotions that are easy to play and easy to follow.

When I'm breaking down a script, either for myself or when I'm showing other actors how to do it, I try to limit my choices to eight emotions. Not only are these emotions clear and easy to follow but, whether standing alone or combined with one of the others, they pretty much cover every emotional state we'll be called on to experience. Here they are:

- Joy
- Sadness
- Fear
- Anger
- Jealousy
- Betrayal
- Embarrassment
- Confusion

If you choose to expand on this list, it's up to you. However, what's important is that you make sure you're using genuine emotions and not stating a condition. The primary way an audience connects with actors is through emotions. You're going to be their guide and if you're clear about what the emotional journey is for your character, it will be easier for them to track. Emotions like anger and sadness are easy to distinguish and follow; conditions like being overheated or unwelcomed are ambiguous and a lot harder to play!

Here's an example of how the Discoveries/Emotions aspect of this technique works. The scene is from *Body Heat*.[13] Not only was it a breakthrough film for the two leads, William Hurt (Academy Award winner) and Kathleen Turner, it also put writer/director Lawrence Kasdan (four time Academy Award nominee) on the map.

Synopsis

Ned Racine is a young lawyer in a small Florida town. A bachelor, his sexual appetite often outweighs his ability to reason and think clearly. He tried several times to pick up Matty, a young woman married to a wealthy, older man. They had short conversations in an earlier scene and he tried to pick her up, but she rejected him. In that conversation she mentioned the town where she lived. Cruising in his car one night, he sees her car parked outside a bar. He goes in.

INT. COCKTAIL LOUNGE—PINE HAVEN—NIGHT
Dark. Almost classy. The place is half full. Matty
is drinking at the end of the bar, her cigarettes
next to her glass. The bar chairs near her are empty.
Racine comes in, looks around, walks over and sits in
the seat next to her. She looks up, surprised.

MATTY
Look who's here. Isn't this a coincidence?

(Racine looks at her, almost as though he can't
place her. But he doesn't push that effect hard.)

RACINE
*I discover, even though I pretend I don't, that she
remembers me. I feel* **joy.**
I know you.

MATTY
You're the one that doesn't want to talk about the
heat. Too bad. I'd tell you about my chimes.

RACINE
*I discover that not only does she remember me, she
wants to engage me in conversation. This makes me
even happier.* **Joy.**
What about them?

MATTY
The wind chimes on my porch. They keep ringing and
I go out there expecting a cool breeze. That's what
they've always meant. But not this summer. This
summer it's just hot air.

 RACINE
 I discover a hint of sarcasm. Not sure what that
 means. **Confusion.**
 Do I remind you of hot air?

(The bartender has come up.)

 RACINE
 Bourbon, any kind, on the rocks.

(to Matty)

 Another?

(She thinks, then nods her agreement. The bartender
moves away.)

I discover she's willing to let me buy her a drink.
Whatever the sarcasm was about before, it seems to
be gone. **Joy.**

 MATTY
 What are you doing in Pine Haven?

 RACINE
 I discover she's curious. She's the one asking
 questions and that's a good sign. **Joy.**
 I'm no yokel. Why, I was all the way to
 Miami once.

 MATTY
 There are some men, once they get a whiff of it,
 they'll trail you like a hound.

(The bartender brings their drinks and leaves.)

 RACINE
 I discover that she's got my number. **Embarrassment.**
 I'm not that eager.

 MATTY
 What is your name, anyway?

 RACINE

(offers his hand)

 Ned Racine.

 MATTY
 Matty Walker.

(She takes his hand and shakes it. Racine reacts
strangely to her touch and doesn't let go right away.
She gently frees it and then picks up her drink.)

 RACINE
I discover her body temperature is high. **Confusion.**
 Are you all right?

 MATTY

(laughs)

 Yes. My temperature runs a couple degrees high.
 Around 100 all the time.
 I don't mind it. It's the engine or something.

 RACINE
*Again, I discover this is normal for her. But I also
discover, or I think I do, a hint of innuendo.* **Joy.**
 Maybe you need a tune-up.

 MATTY
 Don't tell me—you have just the right tool.

 RACINE
*I discover I might have been wrong about the
 innuendo.* **Embarrassment.**
 I don't talk that way.

 MATTY
 How'd you find me, Ned?

(Racine gives her a look.)

 RACINE
I discover she's being direct, calling me out in a
way. I feel a twinge of **anger.** *I mean, she told me*
where she lived. Why do that if she wasn't thinking
 about a possible hook-up?
 This is the only joint in Pine Haven.

 MATTY
 How'd you know I drink?

 RACINE
We're still talking, so the game isn't over. **Joy.**
 I even make a little joke.
 You seemed like a woman with all the vices.

 MATTY

(smiles)

 You shouldn't have come. You're going to be
 disappointed.

(Racine looks around the bar. Several of the men in
the place are looking at them.)

 RACINE
Again, I am getting mixed signals—she's encouraging
me but then says I shouldn't have come. **Confusion.**
 I also discover that I am getting the evil eye by
 several guys in the bar. **Fear.**

(referring to the men)

 What'd I do?

 MATTY

(indicating Racine's chair)

 A lot of them have tried that seat.
 You're the first one I've let stay.

RACINE
I discover she's rejected a lot of the guys who are staring at us but I also discover that I'm special. **Joy.**

(spotting a few more men)

You must come here a lot.

MATTY
Most men are little boys.

RACINE
I discover her attitude toward men. **Confusion.**
Maybe you should drink at home.

MATTY
Too quiet.

RACINE
I discover for all of her complaining she still likes to be out. **Joy.**
Maybe you shouldn't dress like that.

MATTY
This is a blouse and a skirt. I don't know what you're talking about.

RACINE
I discover she's fishing for a compliment. **Joy.**
Happy to supply one.
Maybe you shouldn't wear that body.

(Matty leans back in her seat and glances down at herself. She's magnificent.)

MATTY
I don't like my body much. It's never been right.

(Racine has been looking at her body too. With her line, he just laughs. Matty watches him, then leans over her drink. Her tone is different.)

 MATTY
 Sometimes, I don't know. I get so
 sick of everything, I'm not sure I
 care anymore. Do you know what I
 mean, Ned?

 RACINE
 I'm **confused,** *not really sure what she means, but it*
 doesn't stop me from playing along, still trying to
 score points that will get me in her bed.

(he's not sure)

 I know that sometimes the shit comes down so heavy
 I feel like I should wear a hat.

(Matty laughs, studies him)

 MATTY
 Yeah, that's what I mean.

(Matty drains her glass and stubs out her
cigarette.)

 MATTY
 I think I'll get out of here now.
 I'm going home.

 RACINE
 She's about to bolt. Slight **fear,** *anxiety really.*
 Don't want to let this go.
 I'll take you.

 MATTY
 I have a car.

 RACINE
 She's rejecting me. **Sadness.** *Got to come up with*
 something to get the game going again.
 I'll follow you. I want to see the chimes.

 MATTY
 You want to see the chimes?

RACINE

Good, the chimes line got her attention. **Joy.**
I want to hear them.

(she looks at him a long time)

MATTY
That's all. If I let you, that's all.

RACINE

This is working; good. Really good. **Joy.**

(gestures his innocence)

I'm not looking for trouble.

MATTY

(very serious)

I mean it. I like you. But my life
is complicated enough.

*I discover she's trying to set conditions of my
visit. I'm thinking once I get there, I'm in.* **Joy.**
(Racine nods his acceptance.)

MATTY
This is my community bar. I might have to come here
with my husband sometime. Would you leave before me?
Wait in your car? I know it seems silly . . .

RACINE

I discover she's being naïve. I feel **confused.** *Who
does she think is going to fall for that?*
I don't know who we're going to fool. You've been
pretty friendly.

(She gives him a look and then slaps him hard!
Everyone turns toward them.)

 MATTY

(steadily)

 Now leave me alone.

(She stands up, takes her purse and her cigarettes,
and walks to the other end of the bar, where she
sits down. Racine watches her with amazed eyes. He
stands up and throws some money on the bar.)

 RACINE
*I discover a malicious side to her that I didn't see
 before. I am* **confused** *and* **angry**.

(angry)

 Lady, you must be some kind of crazy!

(He stalks out of the bar.)

Ned ends up following Matty home, they end up having a relationship, and he ends up helping her murder her rich husband. But the character doesn't know any of that in this scene. He only knows what is happening in the moment.

The discovery process doesn't have to be a long, ponderous affair. In real life many of our discoveries are instantaneous; others take a while to figure out. The same is true of our emotional responses to those discoveries. Sometimes we flare up over something; sometimes we stew. If a scene requires a rapid pace, the discoveries have to be made quickly. But the scene, or parts of the scene, may need to move at a slower pace and the characters will take more time to figure out what is going on and the discovery process may take a little longer.

One more thing about emotions: whether you use the eight listed above or add others, each emotion can be played in a variety of ways. In the example above, when the other men in the bar were staring at Ned, the actor used fear. But the fear he felt wasn't the same fear you would experience if you were being chased by a grizzly bear. The point is to start making discoveries and then attach an emotion to each discovery. The degree of that emotion is up to you. You'll see how valuable this is when you couple it with the information in the next chapter.

The question to keep asking yourself is: what thought process does my character go through in order to arrive at the decisions he/she makes before speaking or taking an action.

Beats, Tactics, and Actions

Just so we're all on the same page, here's how these three terms apply to this technique: Beats (aka events) are specific moments where certain sentiments and activities are presented that propel the story forward. Tactics are the changes you make within the various beats. The tactics are determined by whether you're getting closer or further away from your goal as you strive to achieve your main objective. Actions are the words and/or physical actions you use to accomplish those tactics.

In the last chapter we discussed the value of making discoveries and figuring out what emotion(s) those discoveries produced. Those emotions will have an effect on you. If the discovery brings you closer to achieving your Main Objective, you'll probably feel some variation of joy. That feeling will influence how you deliver your next line or set of lines. If your discovery lets you know you're getting further away from your goal, another emotion will surface and influence you in a different way.

Let's say your Main Objective, like Ned's in the last chapter, is to seduce another character. Then as long as the other character is agreeable, you'll feel pretty good (joy) and that good feeling will be reflected in what you say or do. But what if, like Matty, she says, "No." Then you might feel sad, or confused, maybe even angry. And the way you deliver your next line or the next physical action you take will reflect that emotion.

Rarely will one character come right out and tell the other character what he/she wants. Ned doesn't say to Matty, "I want to bed you"—it's implied. He knows it; she knows it. And she spends a good portion of the scene

saying "No." She tells him, "You shouldn't have come. You're going to be disappointed. Most men are like little boys," etc. Nothing she says overtly suggests that Ned is going to get what he wants.

But Ned persists. He finds a different way of asking for what he wants. That's what tactics are: finding a different ways to pursue your objective.

We do this all the time as human beings. We're constantly evaluating, trying to figure out how to get what we want. Based on our Main Objective, we formulate various tactics and execute them through a series of actions.

If you have a beat that consists of eight lines then depending on the dance you have to do to in order to achieve your main objective, this beat, instead of being just one big beat, could actually be three or four smaller beats. And each of those beats may require a different tactic.

In theatre, actors are trained to find the beats of a scene. The same is true in film and TV. But because so much of what we do on camera is reacting, and because the camera can read our thoughts, we need to be aware that those microscopic conditions create beats within a beat. The tiniest gesture on the screen can replace a paragraph of dialogue.

You say your first three lines, you see the other character's reaction, and you make a quick assessment as to whether or not you're getting closer to what you want. If not, it would be foolish to keep using the same tactic, so you switch to another one.

You say your next three lines and make another assessment. If what you're doing is working, great, but if not, you switch to a third tactic. Each tactic will generate a different action or series of actions.

To give you an example of how this works, here is a scene from *Georgia*,[14] a wonderful film written by Barbara Turner, directed by Ulu Grosbard, and which starred Jennifer Jason Leigh and Mare Winningham.

Synopsis

Georgia, the older sister, is a successful singer/songwriter. She is well established in the business, has a huge fan base and lives in a big, wonderful home with an adoring husband and two young children.

Sadie, the younger sister, is also a singer, and perhaps the more passionate of the two. She is, however, not as grounded as Georgia and is tormented by her insecurities and her inability to live up to her own expectations. Sadie also has a recurring drug and alcohol problem.

Both girls have a rocky relationship with their father.

Down on her luck, Sadie recently left a difficult situation and has come to live with Georgia. Since Sadie has been at Georgia's, she has been clean and sober for the most part but lately she's slipped and is drinking and doing drugs again.

This isn't the first time Georgia has provided a refuge for Sadie. Georgia genuinely loves her sister but she also knows who Sadie is and what her faults are. Lately she's begun to suspect that Sadie is using again.

Sadie loves her sister but is also jealous of her. Georgia has everything Sadie wants.

Georgia comes home from a trip earlier than expected. When Georgia walks into the house, Sadie bounds down the stairs to greet her. Sadie is wearing one of Georgia's favorite blouses.

> SADIE
> I stripped the beds.
>
> GEORGIA
> You didn't need to do that.
>
> SADIE
> Yeah, well. Sure I did.
>
> GEORGIA
> It's pouring, Sadie.
>
> SADIE
> And you hang them out. How dumb to forget.
> Well, no harm done.

(Sadie notices Georgia staring at the blouse she is wearing)

> SADIE (cont'd)
> I borrowed this, okay?
>
> GEORGIA
> Whatever, it's fine. You don't need to clean
> my house, Sadie.
>
> SADIE
> I was cleaning motel rooms. Really. No, really.

"Oh, God, Sadie reduced to that." Or, "is there anything Sadie can't be reduced to?"

GEORGIA
You want to give me a break, Sadie?

SADIE
You want to give me one? I can feel what you're feeling.

GEORGIA
No. No, you can't, Sadie. No. You can't feel what I'm feeling. You aren't me.

(pause)

GEORGIA (cont'd)
I believe in you. I've always believed in you.

SADIE
I think we should not get into this.

GEORGIA
Fine. Better for me.

(pause)

GEORGIA (cont'd)
Oh, shit. Dad's coming to stay for a week, Friday.

SADIE
I won't be here.

GEORGIA
It gets really tense, Sadie.

SADIE
I won't be here, okay.

(pause)

SADIE (cont'd)
How's he doing?

 GEORGIA
 I think fine. I think all right. You need some
 money?

(long pause)

 SADIE
 Yeah. Yeah. Something to get started on. I'm good
 for it.

 GEORGIA
 I don't want you to be good for it. It pleases me to
 be able to give it to you. I love being able to give
 it to you.

 SADIE
 Okay. Things are going to break for me. There's not
 a doubt in my mind. This has all got to be about
 something. This whole adventure. Everything's stored
 for later use. There must be a pony.

That's the scene. Incredibly well written, full of possibilities, it's just waiting for the actors to fulfill its potential. The following is a breakdown of the same scene that the actor playing Sadie did in class, combining the Discoveries/Emotions with the Beats, Tactics, and Actions. As we go through the scene again, see how the work she did influences the scene.

The actor playing Sadie said her main objective is *to win* Georgia over. That's what she's trying to do for a good part of the scene. But there are several moments when she does just the opposite—she's flippant, disrespectful, and doesn't care what her sister thinks.

Sadie has the first line of the scene so she needs to make a discovery in the Moment Before (see Chapter 8). But before the scene begins, the actor playing Sadie has a big decision to make. Actually she has several decisions to make, but this one isn't as obvious as the others and yet it could have a huge impact on what happens. The actor has to decide if Sadie is high during this scene.

We know that Georgia is coming back from a trip sooner than expected. Did Sadie get high, thinking no one would be the wiser? If the actor says "no," she has closed the door on a wonderful opportunity. If, on the other hand, the actor says

As actors, you need to learn to say "yes" to possibility and keep the doors of opportunity open.

"yes," then the door is open and it can be opened as much or as little as she wants.

The choice to be high in this scene not only makes the scene more interesting, it's also logical. We know that Sadie has a drug and alcohol problem. We also know she's fallen off the wagon before so it's possible she could be high. Her being high adds an element of danger. Danger is good. It heightens the tension.

There's another reason it's a good choice to play Sadie high: Sadie's mood will be affected. Now, not only will it be much easier for the actor portraying Sadie to generate the emotional roller coaster ride that occurs during the scene, it will also make it easier to justify her mood swings. Sadie's behavior, which ranges from bubbling enthusiasm (**joy**) to bruising anguish (**anger**), will be unexpected but completely plausible.

Door open or closed? Whenever possible, keep it open.

The Moment Before (from Sadie's POV): *I'm in Georgia's room, in her closet, looking through her stuff. Feeling good. The 'lude is kicking in. Gosh, she has some beautiful things. Oh, wow, look at that blouse. I am totally trying this on. Oh, Boss, man. It looks great. What's that? A car? Shit, it's Georgia's truck. What's she doing back? Okay, okay, everything is cool. Let me check my eyes. Good, good. (Giggling) She'll never know I'm stoned. Okay, okay, pull it together. Go downstairs and tell her what a good girl her little sister is.*

I discover Georgia is home. I feel ***fear*** *(anxiety) because I'm high and I don't want her to know. And I feel* ***joy*** *because I'm smarter than she is and she'll never be able to figure out that I'm stoned. I also feel another type of* ***joy*** *because I did the laundry and she'll be pleased to see that I'm helping with some of the chores. I rush downstairs, pleased with myself, and I blurt out . . .*

> SADIE
> (*action—**to boast***) I stripped the beds.

> GEORGIA
> You didn't need to do that.

> SADIE
> *I discover, to my amazement, she isn't happy with*

*what I have done. I feel **confused**. I was sure my*
helping out would please her.
*(action—**to validate what I did***) Yeah, well.
Sure I did.

GEORGIA
It's pouring, Sadie.

SADIE
*I discover her disappointment with me. I feel **sad**.*
I was trying to prove how worthy I am.
*(action—**to acknowledge***) And you hang them out.
*(action—**to reprimand myself***) How dumb to forget.
*(action—**to shrug it off***) Well, no harm done.

(Sadie notices Georgia staring at the blouse she is
wearing.)

SADIE
I discover Georgia is staring at me. Are my eyes
dilated? Does she know I'm stoned? I know that look.
*She's angry. I feel **fear** and **embarrassment**. I need*
to change the subject, quick.
*(action—**to divert her attention***)
I borrowed this, okay?

GEORGIA
Whatever, it's fine. You don't need to
clean my house, Sadie.

SADIE
I discover that Georgia is disappointed with me,
*again. I feel **anger**. All I wanted to do was*
to be helpful.
*(action—**to shock**, playing an opposite*) I was
cleaning motel rooms. Really.
No, really. *(action—**to mock***) "Oh, God, Sadie reduced
to that." Or, "Is there anything Sadie can't be
reduced to?"

GEORGIA
You want to give me a break, Sadie?

SADIE
*I discover she is angry. I'm **angry** too. She has
no idea what I have been through, what my life
has been like.*
*(action—**to lash out**)* You want to give me one?
I can feel what you're feeling.

GEORGIA
No. No, you can't, Sadie. No. You can't feel
what I'm feeling.
You aren't me.

(pause)

GEORGIA (cont'd)
I believe in you. I've always believed
in you.

SADIE
*I discover that she is changing directions, taking
the argument in a different direction, telling me
how much she believes in me. I feel **betrayed**. If she
believed in me so much, why doesn't she help
me get my career going?*
*(action—**to deflect**)* I think we should not get into
this.

GEORGIA
Fine. Better for me.

(pause)

GEORGIA (cont'd)
Oh, shit. Dad's coming to stay for a
week, Friday.

SADIE
*I discover my father, who doesn't speak to me, who
threw me out of the house, is coming for a visit. I
feel **betrayed** and **jealous**. I'm supposed to be the
guest, the one who gets Georgia's attention. Now she's
spoiled that by allowing Dad to come for a visit.*
*(action—**to sulk**)* I won't be here.

> GEORGIA
> It gets really tense, Sadie.

> SADIE
> *I discover she is patronizing me. I feel* **anger.**
> *She's the one who screwed up and now she is trying*
> *to make an excuse for her mistake.*
> *(action—**to dismiss**)* I won't be here, okay.

(long pause)

> SADIE (cont'd)
> *In the silence I discover that, in spite of myself,*
> *I still have feelings for my father, I still care*
> *about him. I feel* **confused.**
> *(action—**to inquire, reluctantly**)* How's
> he doing?

> GEORGIA
> I think fine. I think all right.
> You need some money?

> SADIE
> *I discover that Georgia is trying to make up for*
> *what happened by offering me money. I feel* **sadness**
> *and* **fear.** *Sadness because what I want more than*
> *anything else is for her to love me, not buy me off;*
> *fear because I have nothing, I am dependent*
> *on her once again.*
> *(action—**to accept, with difficulty**)* Yeah. Yeah.
> Something to get started on.
> *(action—**to assure, myself mostly**)* I'm good
> for it.

> GEORGIA
> I don't want you to be good for it. It pleases me to
> be able to give it to you.
> I love being able to give it to you.

> SADIE
> *I discover Georgia does love me. That she wants to*
> *help and this is the only way she knows how. I feel*
> *both* **joy** *and* **embarrassment.**

> *On the verge of tears, I try to pull myself together.*
> *It's a speech I've delivered many times before and*
> *although I say the words, go through the motions,*
> *I believe it less and less each time I say it.*
> *(action—**to pull myself together**)* Okay.
> Things are going to break for me.
> There's not a doubt in my mind. *(action—**to justify**)*
> This has all got to be about something. This whole
> adventure. *(action—**to rationalize**)*
> Everything's stored for later use. There must
> be a pony.

Take a close look at Sadie's last speech. It has seven lines. You could say the beat of this part of the scene is "Sadie pulls herself together." And while that's true, if you limit yourself to that one conclusion you've missed out on a terrific opportunity to show other elements of Sadie's character. She not only pulls herself together, but in the process of doing that, she shifts slightly so she can justify—to herself—that this is the way the world works. Then she shifts again by spouting a philosophy that claims, "everything is good and there has to be a reward in this," as a way to rationalize what she's going through. And all the while she doesn't really believe any of it. Wow! What an amazingly complex character the actor created. It's all there in the words, waiting for an actor to find it.

The fact that Sadie doesn't gain her sister's approval, that she doesn't achieve her Main Objective, doesn't mean she doesn't try. The writer, for whatever reason, wanted to tell a story in which Sadie loses. To ensure that end, the writer put enough obstacles in Sadie's way so that she ultimately had to fail. However, it doesn't mean that Sadie should ever stop trying to win, stop trying to achieve her Main Objective.

The fact that she doesn't win, doesn't get what she wants, has nothing to do with her attempt to win.

Storytelling involves creating and maintaining a certain degree of tension, and one of your goals should be to keep that tension bubbling. If your character gets what he/she wants right away there's no conflict and the scene will suffer for it. Creating a series of tactics and the actions that go along with them as you try to achieve your Main Objective will provide you with different ways of asking for the same thing.

Please note the various emotions the actor playing Sadie used while breaking down this scene. This is a habit I encourage you to develop. By using different emotions you create variety, and variety will not only make

the work exciting for you, it also helps you stay ahead of the audience. If you use the same emotion over and over again, the audience will quickly figure out where you're headed. If they do that, you'll lose their attention and you may never get it back.

If your character is angry all of the time take another look and see if it's possible that a discovery you've made could lead you to a *different* emotion, one that's also true for your character, one that would give the scene a slightly different flavor. Instead of just being frightened all the time, perhaps for a moment you're jealous. Jealousy would nudge the scene in a different direction. Even if it's for the briefest of moments you will have added another color, making the scene richer than it was before. Instead of being sad all the time, is it possible you're embarrassed? Embarrassment will alter your course, take you down a different road. You don't have to be embarrassed for an extended period, just long enough to add another spice to the mix.

It's important to note the discoveries the actor playing Sadie made in this scene were not the only discoveries that could have been made; they were the Discoveries/Emotions *she* made. Every actor brings his or her own inter-pretation to the creative process. I guarantee you if Amy Adams or Anne Hathaway had played Sadie, they wouldn't have played it the way Jennifer Jason Leigh did. Both of those actors, like Ms. Leigh, have been influenced by their own life experiences. The same is true for you. Who you are and the values you hold will lead you to make your own discoveries.

And those discoveries, whether they're made while you're in the "tilling the soil" part of the process or in the moment-to-moment reaction process during a performance, will impact how you feel. The actor playing Sadie said she discovered several new things each time she did the scene and incorporated them into her work. After doing the homework, after prepping the scene, you too, once you're doing your scene, will also make new dis-coveries. And your choice to use or reject those discoveries helps give the scene a quality of "freshness" each time you perform it, night after night, take after take.

What helps is your making interesting discoveries, discoveries that will propel the story forward. Look at the food you eat. When you go to a res-taurant do you always order the same thing? Meal after meal, day after day? Are you so predictable that the waiter knows what you want before you even sit down? Do you want that in your work?

The newest trend in the casting aspect of our industry is self-taping your auditions (see Chapter 16). This is where this work we've been discussing—the "tilling the soil," this digging into the story and developing

your character on your own—is essential. A lot of the time, whether you self-tape or have someone do it professionally, the only person who is going to have any input is you. Sure, you might get a friend to read with you but he/she's not going to know any more than you. But if you've done everything we've talked about up to this point, you will be way ahead of the curve.

This work will give your character dimension; it will make him/her real. By doing all of this work you will have created a character that is vital and alive, someone that has a history that will serve the present, who is opinionated and makes choices. All of those things will make the scene come alive.

Years ago Mike Nichols was directing a play. After the auditions he gave his assistant a list of people he wanted to see at callbacks. The assistant questioned him about one of the names. "Why her?" he asked. "She did everything wrong." Mr. Nichols replied, "Yes, but she did it so well."

The fact this actress came in with strong choices let Mr. Nichols know she had worked on the script, she had put some thought into it. That got him excited. Seeing actors who have already made an investment in the material, whose minds are already engaged—that will get every director excited.

The things we've been talking about will prove helpful at every stage of the process. This technique will help you prep for your audition. (I have been to Network for lead roles in series with no more input than: "They want the piece to move." Or: "Make sure to show some emotion. They want to feel it.")

This technique will also help you after you've been hired because, except for sitcoms, you're not going to get a lot of rehearsal. And it will help you when you're shooting because, if the director asks you to take the scene in a different direction, you will have a wealth of knowledge to help you navigate those changes.

The goal in all of this is to make sure you have a strong foundation, one that's easy from which to pivot. You want to be flexible enough so you can accept new input while at the same time having a firm grasp on what the story is, how your character fits into it, and what he/she wants.

Humor

It wasn't until I studied with Michael Shurtleff that I understood what humor really was and the importance of using it in my work. In life I was funny: I was the joker in school. I made people laugh. I knew how to find the jokes in a script, how to set them up and pay them off, but the concept of "humor" was foreign to me.

For the uninitiated, humor isn't about being funny. It is the attitude toward life without which we all would have thrown ourselves off a bridge long ago. Humor is not jokes. It is the coin of expression between human beings that makes it possible for us to get through the day.[15]

Humor is the first thing human beings inject into a tense or emotionally charged situation. If you've ever been to a friend's funeral, you know what I'm talking about. A dear companion is dead. It's a solemn occasion. You're there to pay your respects, but before you know it, you and several friends are telling funny stories about the deceased, reliving fond childhood memories, laughing about the pranks you pulled together. We engage in this behavior to alleviate the seriousness of the situation. That's what we do in real life.

> *In life, we try to insert humor wherever and whenever possible. If we didn't, we wouldn't be able to bear the burdens of everyday life.*

Most actors, however, do just the opposite. They'll get a script that has a funeral scene in it and then proceed to suck the life right out of it. Why? Because they read the circumstances and leap to the cliché. They forget one of the most important aspects of the scene: that their characters, while they may be sad, while they may be in pain, are also human beings. And if their characters don't find the humor in a scene, even in a scene where they have come to mourn the death of a dear friend, then they'll be behaving in an unrealistic manner. If you don't know how to look for the humor, your performance will become stilted and unreal.

Humor is not reserved for comedies. The heavier the situation, the more humor we need to endure it. Humor is more important in a drama than in a comedy. Again, think of *Romeo and Juliet* or *A Streetcar Named Desire*. Both of these classics are tragedies, yet the actors performing in them, in order to deliver the full impact of that tragedy, must employ a tremendous amount of humor in their work.

Actors often confuse humor with jokes. The jokes are where the audience laughs. Humor is where the characters laugh at themselves. Rarely will those two things happen at the same time. If the audience is laughing and your character starts to laugh, the audience will stop laughing because they're afraid they'll miss something.

If you don't instinctively have the gift of "humor," you need to develop some tools so you can recognize "it" when you see it. If you're one of those lucky actors whose sense of humor is firmly in place, this next section will help you reinforce what you're already doing.

There are four elements to finding the humor in a scene. The first is **absurdity**. What does your character find absurd, despite the seriousness of the moment, either about him/herself or the other character(s) or the situation? What makes him/her think, "I can't believe I'm doing this," or, "I can't believe he just said that," or, "I can't believe this is happening?" Once you've identified what's absurd then your ability to laugh at it, regardless of how serious or sacred it may be, becomes easier.

The second is to look for are places where you can **break the escalating tension**. Tension is a good thing and in our work we oftentimes want to escalate it to a crescendo. There are other times, however, when there's a need to do the opposite. When things start to get too intense in our real lives, most of us have an automatic release valve, like a pressure gauge, that allows us to blow off steam. We may laugh, often in an inappropriate place, or do any number of things designed to discharge the mounting pressure. If we do it in real life, it is only logical that our characters would do it, too.

The third way our characters can exhibit a sense of humor is in their desire to express **irony**. We may respond to another character with a glib or sarcastic remark. We repeat what another character said under our breath or twist the verbiage to emphasize our point of view. It's important to point out that expressing a sense of humor isn't merely about laughing at what's going on around us. Sometimes your character can't laugh—he/she may not even be able to speak—but it doesn't stop him/her from expressing his sense of humor. A raised eyebrow can speak volumes.

The fourth way our characters express a sense of humor is through **self-deprecation**. We mock ourselves in order to divert attention away from ourselves, or we point out to the world that, for whatever reason, real or unreal, we think we're less than we really are.

All of these examples are things we do in real life. Actors, however, for some reason, have trouble incorporating these truths in their work. If the scene is a tragedy, we want to wring every bit of tragedy we can out of it. The problem, when we do this, is we end up beating the audience over the head with the message.

The screenwriter has already written a tragic scene, e.g., your friend is dead. If you play it tragically, heaping calamity upon calamity, then the audience, in order to protect itself, will start to tune out; it becomes too damaging to their psyche to stay engaged.

If you won't do anything to relieve the mounting pressure, they will—by checking out.

When I first moved to New York I had the opportunity to study with Herbert Berghof, the founder of HB Studios in New York City. I was doing my second scene, playing Creon in *Antigone*. When I finished, he said to me (in his very thick Hungarian accent), "John, what is it? When you're out here"—he pointed to the classroom—"you are so interesting. But, when you get up on stage, what happens to you?"

What happened was I wasn't incorporating my sense of humor into my work. In my desire to deliver the essence of the scene, I had left out my character's humanity. I failed to find his sense of humor. What I ended up with was a stiff, unrealistic Creon who was boring the hell out of everyone.

Let's take another look at the scene from *Absence of Malice*. In this scene, you may recall, Teresa Perone meets with Megan Carter, a reporter for the *Miami Herald*. Teresa's friend Michael has been falsely imprisoned on a murder charge. Teresa knows Michael is innocent because she was with him when the murder occurred. But because Teresa is afraid the real story of where she was and what she was doing (having an abortion) will

come out, she has been hesitant to come forward. After several months of struggling with her conscience, Teresa has called Megan and asked to meet her. Teresa's goal is to convince Megan of Michael's innocence.

Teresa never intends to tell Megan everything that happened the night of the murder but hopes instead that, by giving the reporter a little bit of information, Megan will write another story, one that will set Michael free. It is only when Megan refuses to believe her that Teresa blurts out what really happened—that she had an affair with a married man, got pregnant, and had an abortion. To Teresa, raised a strict Catholic, with old-world family values, having an affair was a huge sin and having an abortion was tantamount to murder. Yet, in the midst of this very tragic scene where Teresa, in order to save her friend, is forced to reveal her deepest, darkest secrets, there also resides a good deal of humor.

Here are the notes from the actor who played Teresa in my class. The scene takes place in the early 1970s.

> TERESA
> I'm Teresa Perone.

> MEGAN
> I guess we know I'm Megan Carter.

> TERESA
> Thank you for meeting me like this.
> Would you like a cigarette?

> MEGAN
> No. I'm trying to quit.

> TERESA
> *Humor—to break the tension.* *I was nervous before;*
> *I am even more nervous now. The meeting hasn't*
> *gotten off to a very good start. My attempt to break*
> *the ice—offering her a cigarette—didn't work*
> Michael hates it. I have a story for you.

> MEGAN
> Michael Gallagher is innocent, you were with him
> the night they got Diaz, you'll swear to it in
> court. I'm used to dealing with girlfriends.

> TERESA
> Why do you think I'm a girlfriend?

 MEGAN
 Just a hunch.

 TERESA
*Humor—absurdity. At many different times I have
wished that Michael and I were more than friends but
 we're not; never have been, never will be.*
 No. I've never been Michael's girlfriend.
 I've known him since
 childhood; we're friends.

 MEGAN
 Of course you think he's innocent.

 TERESA
 No. I know he's innocent.

 MEGAN
 How?

 TERESA
 Well, because I was with him at the time. But
 I don't want you to say it was me.

 MEGAN
 I see. Where were you?

 TERESA
 I can't tell you that.

 MEGAN
 How do you remember this? I mean it was
 ten months ago.

 TERESA
*Humor—absurdity. Like I'm going to ever forget that
day, the worst day of my life.*
 Do you remember where you were the day
 Kennedy was shot?

 MEGAN
 Can you prove it?

 TERESA
 I don't know.

 MEGAN
 Miss Perone, you're very loyal, if that's
 what it is. But I can't write a story
 that says someone claims to know Michael
 Gallagher is innocent and
 won't say how or why or even give her name.

 TERESA
 I am assistant to the principal at St. Ignatius
 School and the publicity
 would kill me . . . ***Humor—irony***. *I want to help my
 friend but I am still trying to protect myself,
 still putting myself first.*
 I just can't.

 MEGAN
 Suit yourself.

(Megan stands to leave)

 TERESA
 But you printed that other story.

 MEGAN
 That was different. I knew where it came from.

 TERESA
 You don't believe me?

(Megan sits)

 MEGAN
 Miss Perone, I've never met you before in my life.
 You want me to write a story that says Michael is
 innocent and then you tell me I can't use your name.
 You say that you were with him, but you won't tell
 me where. Now, what would you do?

 TERESA
 If I told you, just you, would it have
 to be in the paper?

MEGAN
Probably.

TERESA
Why? If it had nothing to do with Diaz . . .
I mean it's private . . .

MEGAN
Look, I can't promise you anything. I'll speak
to my editors about it, but I
can't promise you anything.

TERESA
But I don't understand. Couldn't you say that
you spoke to someone who
was with him the whole time?

MEGAN
I'm a reporter. You're talking to a newspaper
right now, do you understand?

TERESA
You said you could keep it out.

MEGAN
I did not say that. I said I would discuss it with
my editors. Look, if you have some information about
where Michael Gallagher was that night and you
want to help him . . .

TERESA
You don't understand. There was this
guy . . . Michael hates him . . . maybe
he's not so hot . . . but you see
I'm Catholic . . .

MEGAN
Look, Miss Perone, I don't want to be rude but
I don't understand what you're
trying to tell me and I do have a deadline.
I have to get back to the paper.

TERESA
I had an abortion. I got pregnant
and I didn't know what to do. I got a
name in Atlanta.

It was three days. He stayed with me every day,
every hour, and that's what happened.

MEGAN
That's not such a terrible thing. Have you
told anybody else this?

TERESA
Oh, God. **Humor—absurdity.** *How could she possibly*
understand what is going on with me, asking a non-
believer to understand. Ah . . .
you're not Catholic.

MEGAN
It's the 70s, people will understand.

TERESA
Are you crazy? Not my people, not my father.
Humor—self-deprecating. *I'm*
putting myself down, unable or unwilling
to understand what is happening to me,
realizing just how sad and foolish I must be
to be in this situation.
I don't even understand it.

MEGAN
How old are you?

TERESA
You believe me, don't you?

MEGAN
Yes, I do.

TERESA
Well, then don't write this.

MEGAN
You're a friend of Michael Gallagher's. He's in
trouble. You've told the truth about something that
will help him. No one is going to hate you for that,
really. Really. Now do you have any ticket stubs
or receipts or anything that will prove that what
you're saying is true?

A lesser actor might have seen the scene as a tragedy and cried her way through to the end. However, this actor saw the opportunity to use humor and expressed it in a variety of ways: nervous laughter, a mocking tone, and twice with just a look.

If she'd failed to do this, by the time she got to the climax, where the character admits to having an abortion, the audience would be completely anesthetized, having been subjected to a three-minute blubber of her "unrelenting misfortune." If that had happened, those last few very important moments where the reporter is transformed from a non-believer into a believer would have fallen on deaf ears.

Instead, by finding the humor and expressing it, the actor playing Teresa kept the scene from being a one-trick pony. She delayed the peak emotional moment until the very end of the scene where, after avoiding it for as long as possible, she revealed her dark secret. This is what happens in life. We try to avoid the pain we're feeling in the moment by injecting humor into the situation, only to have the pain return later and hit us harder.

The writer could have written this scene so that Teresa reveals her secret earlier but he didn't. The actor playing the scene needs to postpone the emotional breakdown so when her secret is revealed, it will be more compelling. If it comes too early we won't care.

An interesting side note: shortly after Teresa tells Megan she had an abortion, Megan changes her mind and plays an opposite. Up to that point Megan has been resisting Teresa; after that moment she becomes an ally.

Some characters are written to be funny but that has more to do with actor fleshing out the "jokes" the writer has written. This concept of humor is about making your characters real. To do that you'll need to develop a sense of humor and insert it in your work. The writer may have been smart enough to include some humor that is obvious but if he doesn't then you need to create it. If not, you're setting yourself up for an unpleasant ride. A character without humor is tedious and uninteresting to watch. Nobody, and I mean nobody, wants to spend an evening with people who take life so seriously that they can't laugh at themselves.

Place, Transitions, and Sense Memory

Good news! You've been cast in a film and you're going to play the Prince of Wales. The story centers around a revolt you're leading against your father, the king. Most of your scenes take place in a castle, in the banquet room. Only problem: you've never been in a castle, never seen a banquet room. The question is, just how important is a location to a character's development?

PLACE

When acting in a scene, there will almost always be at least two "places" for every one location. There will be the actual place where the scene is shot, e.g., the banquet room in the castle. Then there'll be a place from your real life that you will use to generate the emotional connection to make the

The actual, physical location is important, but what's more important is how you feel about it.

reel place, the film location, real for you. There could also be a third place, soundstage made to look like the banquet room in a castle.

If, as the Prince of Wales, you're in the banquet room and you discover your army has turned against you, your character is undoubtedly going to experience a series of emotions, betrayal being one of them. But if you've never been in a huge castle banquet room before, it's possible that the environment, whether a real castle or the facsimile built on a soundstage, might

intimidate you. Instead of being able to generate the desired emotional reaction the scene requires, the unfamiliar setting might actually diminish whatever emotion(s) you are striving to create.

However, if you use a place from your real life, a physical place where you've felt the same emotion the prince is experiencing, then it's more likely you'll be able to create the authentic emotional life you need.

Place is an aspect of the work you do for yourself. It's designed to help ground you emotionally, regardless of the setting.

How does that work? The answer is easier than it seems. Let's use **betrayal** as an example. Look back over your life and ask yourself "Was there a time when I felt betrayed?"

Let's say you're in junior high. You're at home, in the kitchen, and your parents are arguing (again). Your dad storms out of the house, never to return, abandoning you and your mother. Abandonment is a serious form of betrayal. The very emotion your character needs to feel, you've already experienced—different circumstances, different place, but the same emotion. The kitchen may have had a tiny stove with a little dinette and three spindly chairs, whereas the banquet room has an enormous fireplace, a massive oak table and dozens of chairs, but the emotion—betrayal—is the same. And as actors it's the emotional life we're trying to create.

Nobody in the audience, or any of your fellow actors, will know you're using your old family kitchen in Bayonne, New Jersey. The audience will see all the trappings of a castle (the set designer and the cinematographer will make sure of that); the audience will hear the dialogue between you and the other characters in the scene; they'll experience you as you go on your emotional journey, reliving those painful moments you experienced in that kitchen years ago. And because all of this is happening simultaneously, they'll automatically make the leap that you are the Prince of Wales, that you're in your banquet room, and that you've just learned your army has betrayed you.

Once actors master the technique of place substitution the question isn't "How does it work?" but rather "How do I know which place from my real life to use?"

Let's continue with the Prince of Wales scenario. You look over the notes you made on your banquet scene using Chapter 9, "Discoveries/Emotions," and you see that the one emotion that shows up the most is **betrayal**.

Because betrayal has come up more than any of the other emotions it is a huge indicator that betrayal is the emotion you want to focus

on to create your sense of place. Once you've determined that, look at your real life and find the incident where you felt betrayed: your father abandoning you and your mother. Remember that day in the kitchen, watching, listening to your parents arguing, and you will start to feel the sense of betrayal that emanated from that moment. The family kitchen, because of the emotion it evokes, becomes the substitution for the banquet room.

Sometimes a second—and on rare occasions, a third—emotion will also figure strongly when it comes to figuring out the "place" of a scene. If this happens, you want to be able to switch from "place" to "place" in your real life so that the scene is continuously grounded in the proper emotional setting.

Here's how this works: you're the prince in your big banquet room and you get word your troops have deserted you. But, let's say, during the scene, **jealousy** also rears its ugly head. **Jealousy** came up in the "Discoveries/Emotions" chapter almost as many times as **betrayal** did. The crown should be yours—you're the first son—but your father, the king, favors your younger brother and wants him to be king instead of you. Not only is betrayal a key emotion in the scene, but sibling rivalry is also involved and you're jealous as well. So, you can also use **jealousy** to connect you to the "place." Scan your real life, find an event where jealousy played a huge part in the outcome and use that. Example: you're in the gym, it's your senior prom and your date is spending most of her time dancing with someone else. Because both emotions are important to the scene, you'll want to switch from one "place" to the other. Use the family kitchen to help you establish the betrayal aspect you want from the "place" and then use the gym to help you with the jealousy aspect.

The goal is to have the location work for you and not against you.

It is possible you won't need to make a substitution; the actual location may be perfect. But if it isn't, if the location is unfamiliar or intimidating and it hinders you, then you need to use a place from your real life.

As far as reality goes, regardless of how you feel about reincarnation, it is extremely doubtful you were ever a prince that lived in a castle in the sixteenth century who was betrayed by his army. But that doesn't mean you can't play that prince, and play him honestly.

This place substitution technique gives you the freedom to truthfully portray any character, from any period of time, while working in any location, regardless of how foreign it may be to you.

TRANSITIONS

Actors also use a process similar to place substitution when it comes to making difficult transitions. As real people we're constantly making transitions, shifting from one thought process (and the emotions those thoughts evoke) to another, throughout the day. The difference between the transitions we make as actors playing a character versus the transitions we make as real people in our everyday lives is that in real life those transitions are, for the most part, unconscious. As actors however, because we have a story that must be told in a certain way, we must make conscious transitions. In addition, when acting we know what's coming and when things need to shift. The trick is to make these conscious transitions seem as seamless as the unconscious ones.

Time is compressed in an actor's world. In order to forward the story you may be called upon to transition quickly from one emotional state to another. Often you have to do it without any fanfare, without drawing attention to the fact that things have shifted. Your character has one piece of information; then another piece of information is introduced and your whole world changes.

Let's say you're playing a father and you've just been told your son was killed in an airplane crash on his way back to college. You're devastated; you feel like someone shot a cannonball through your stomach. Then you get a phone call. It's your son. He's calling to say the car that was taking him to the airport broke down and he missed his flight. You're relieved, elated, almost giddy.

It's important that as the father you play all those emotionally charged moments truthfully. You also have to make sure your transitions are honest and believable as you go from one emotional extreme to another. If you don't, if your transitions call too much attention to themselves, you will jar the audience and it will be a long time (if ever) before they settle back into the story.

One of the things that actors often fail to realize is that they're their own best resource. You being you is much more interesting than you trying to be someone else.

It's our job as actors to take the audience on a ride, to guide them on an emotional journey. To do this we need to give ourselves the necessary underpinning so we can get to the places our characters need to get to. If you don't do this, it's very likely you'll fall short of your goal and neither you nor the audience will be satisfied with the journey.

If you come from an honest emotional state, one that is true for you, then your work will be profoundly interesting and exciting to watch. If you don't, if you try to fake it, you're setting yourself up for a near impossible task, one that is bound to disappoint the audience.

Because storytelling involves heightened reality, our characters will undoubtedly experience circumstances that we, as human beings, haven't experienced, and hopefully never will. A father thinking he's lost his son— what could be sadder and more devastating? However, unless you have been living under a rock all of your life, you, too, have experienced sadness— under different circumstances perhaps, but sadness nonetheless. Maybe in your real life you're a man who's lost custody of his children in a nasty divorce. It's easy to transfer the suffering you experienced of having your children taken away from you to the character that has just lost his son in a plane crash. As the character, you're absorbing the news of the plane crash, while as the actor, you are remembering how gut-wrenchingly empty and quiet your house is without your children, the only sound being the ticking of the hallway clock. The audience hears the dialogue from the scene; they know the son's plane went down; they see the actor having an active thought process (e.g., thinking about the divorce, the empty house). They connect what they know of the story to the thought process they're witnessing, and they make the leap and assume the character is thinking about the plane crash.

When that thought process stirs up the appropriate emotion in the character, the audience thinks what the actor is thinking and what the character is saying and doing are directly related. In reality the two events may not be even remotely connected, but the audience will think they are. We don't do this to trick the audience. We don't do it to deceive them. We do this so we can use what we know to be true, a real emotion triggered by a real event in our life, to truthfully tell an imaginary story.

> *The audience will never know exactly what you, the actor, are thinking. However, what is important is that they see you are thinking.*

The same will be true when the dad receives the phone call from his son and finds out his boy never boarded the plane. The dad then needs to transition to joy. The actor will have to figure out what joyful event he can use from his real life, one that's so strong he can successfully make the transition from devastating sadness to unmitigated joy. For the actor, perhaps it's the birth of his own son, or standing on the sideline of the sport's field with the newly cut grass clinging to his shoes as his boy scores the winning goal for his soccer team.

Once you know what emotions need to be expressed in the scene and where precisely you want to express them, start searching your own life for an event, the result of which approximates what is going on emotionally for your character. You may need to adjust the volume of the emotion, turning it up or down, but once you have found something in your life that triggers the emotion your character needs to express, you're on the right track.

A word of caution: when you're dealing with the heavier emotions (sadness, anger, fear, betrayal), it's important the events you use from your real life are completely resolved. The whole point of this exercise is for those events (and the emotions they evoke) to serve the scene. To accomplish this you need to be able to move in and out of those events with ease. If an issue isn't resolved, you might get "stuck," and the transition to the next emotion may not be as fluid as you would like. If the actor playing the dad from the plane crash scene hasn't completely resolved his feelings about the breakup of his marriage, he may get bogged down in the sadness caused by the divorce. If this happens, he might not be able to transition quickly enough to express the joy that comes when he receives the phone call telling him his son is safe.

The benefit of using an event that is completely resolved is that you can go back into the experience, pick out what you need from it, regardless of how extreme or intense it was, and use it without the risk of getting stuck. Interestingly enough, none of us, at least none of the actors I know, have any trouble using the positive events from our lives.

The goal, whether using a positive or a negative event, is to make sure you are in charge of those events and the emotions they evoke and that those events aren't in charge of you.

SENSE MEMORY

Sometimes in a scene the information is slowly revealed to the characters and the transitions are gradual. Other times the transitions are immediate. Both instances need to be truthful. A simple sense memory exercise will help you, regardless of how fast or slow you need to respond.

Once you've identified the emotion(s) you want to express in the scene, do a quick scan back over your real life and look for an event where you felt the same emotion.

Keep in mind that there are a thousand different ways to express any one emotion. Being impatient with someone who is ten minutes late for a meeting is not the same as road rage. Both evoke anger but the volume is very different.

After you've looked back over your life and selected the event you want to use, ask yourself the following questions: Where was I? Was I indoors or outdoors? What was the weather like? What time of year/season was it? What was the temperature? What did the room/environment look like? What objects were there? How was the room furnished? Were there trees, plants, flowers? What was I wearing? Was there anyone else there? If so, who? What were they wearing? What were they doing? After you have recalled as many of the details as you can, ask yourself: What exactly happened?

Once you've done this, check to see if there is one single sensorial thing that stands out. Something you heard, saw, smelled, tasted or touched: the smell of burnt toast, the sound of a clock ticking, the heft of a rock in your hand. The goal is to shorthand this information; boil it down to one very clear sense memory. After you have gone through this process—reduced all the data and come up with that one sense memory (let's say it's the smell of burnt toast)— all you have to do is recall that smell and you'll experience the same emotion you want your character to experience.

This process, while simple in explanation, can take a while to master. Experiment with it, find out exactly what questions you need to ask yourself to get the desired results.

If you're playing the dad in the airplane scene and you need to go from grief (sadness) to elation (joy), the transition could be as simple as hearing the hallway clock ticking in your empty, quiet house and then shifting to the smell of the newly cut grass on the sidelines as you watch your son score the winning goal. Or even simpler and faster (after much practice): the ticking of a clock, the smell of freshly cut grass.

After you start applying this process to your work, the ability to transition from one emotion to another, slow or fast, gets easier. It becomes a matter of discipline and practice. Like that old joke about the stranger in New York who asks the policeman "How do I get to Carnegie Hall?" The cop replies, "Practice, practice, practice." The more you do this, the easier it gets.

The following is a portion of the scene from the film *Georgia* that we used in Chapter 10, "Beats, Tactics, and Actions." It illustrates the use of place, making transitions, and how to use this sense memory exercise.

The work here is the creation of the actor playing Sadie.

Place

The place where the action of the scene occurs is a living room, Georgia's living room. Probably a big room because Georgia is a successful singer/songwriter, so I was thinking something palatial, like you see on *The Lives*

of the Rich and Famous, a rock star's home. The only time I'm ever in places like that is when I'm working my catering job. Usually I am intimidated, always afraid I am going to knock something over or spill something.

The two predominant emotions that came up in Discoveries/Emotions were anger and sadness. I have no problem with either one of those emotions.

For my first place, for anger, I picked my dorm room at Univ. of Michigan. I had struggled all semester trying to get an A in biology. I needed the A for a scholarship I had applied for. I got a B+. After checking the board in the science building and finding my grade, I went back to my room. There I overheard one of my suite mates telling one of her friends she had cheated on the biology final. She got an A and would qualify for a scholarship (not the same one I was up for). I was furious. I never told anyone; I never had any way to prove it and I probably wouldn't have told even if I could. I am angry about that as well. That anger festered inside me for a long time. Not only that she had cheated but that I couldn't/didn't do anything about it.

For sadness, unfortunately, I have my pick of places. This emotion comes too easy for me. I had three older brothers; two, the twins, were killed in a car accident, and my oldest brother was killed in Iraq. Place: the hospital emergency room; my mom, my dad and me standing just outside, three nurses trying to console my parents while the doctors tried to revive Byron and Brian. Alternate place: my dad's office; sitting there waiting for him to get off work when my mother called to tell him Jason's status had changed from MIA [Missing in Action] to KIA [Killed in Action].

Scene

*I discover Georgia is home. I feel **fear** (anxiety) because I am high and I don't want her to know. And I feel **joy** because I'm smarter than she is and she'll never be able to figure out that I'm stoned. I also feel **joy** because I did the laundry and she'll be pleased to see that I'm helping with some of the chores. I rush downstairs, pleased with myself, and I blurt out . . .*

SADIE
*(action—**to boast**)* I stripped the beds.

GEORGIA
You didn't need to do that.

 SADIE
*I discover, to my amazement, she isn't happy with
what I have done. I feel* **confusion** *because I was sure
my participating, my helping out, would please her.*
 *(action—***to validate my actions***)* Yeah, well.
 Sure I do.

Transitions

This next section, from Georgia's line, "It's pouring Sadie," through my line, "I was cleaning motel rooms . . . or, is there anything that Sadie can't be reduced to," were the hardest transitions for me. I have no trouble with sadness or anger—I've had a lot of both in my life—but embarrassment is difficult for me. If it was anger then sadness, or the other way round, no problem. But embarrassment is a softer emotion. It is important for me to be able to access that emotion in my work, and important to be able to use it in between two emotions that come easy for me.

 GEORGIA
 It's pouring, Sadie.

I discover her disappointment with me. I feel **sad.** *I
was trying to prove how worthy I am.*

It's a party, sixth grade, Linda Drain's house. It's wintertime. It's snowing out. It is the last Saturday in January. There are fourteen of us. Seven girls and seven boys, I think. I can't remember everyone who was there but I remember there were fourteen of us. We are downstairs in Linda's parents' TV/game room. Music is playing but nobody is dancing. A couple of the boys are playing video games. I have on a red wool skirt, a white blouse and a white sweater. Billy Thompson is my date. We have been going steady for a couple of months. (Sixth grade steady.) He is wearing jeans, boots, a Notre Dame University sweatshirt his brother gave him for Christmas. Janice Richards is there. She is a girl with a reputation and usually has a lot of boys following her around. Two of my girlfriends, Sandra and Lisa, start lip-synching to an REM song. I join them. We laugh and make fun of each other.

When the song is over I get some punch, some foul-tasting, pineapple-flavored drink. I look around for Billy. I don't see him. I don't see Janice either. I casually walk around the room, sipping my drink, looking but pretending not to be looking for Billy. I walk past the door leading to

the garage. It is open. I peer in and see Janice and Billy leaning against one of the cars, kissing. I am shocked and then sad. I am so disappointed in Billy. He was my first real boyfriend. I back away from the door and go back to the party.

When the party is over, Billy's mom takes Billy and me and Sandra and Joe home. Billy tries to kiss me but I don't let him. When he asks me why, I just turn and go into my house. I never go out with him again. Remembering that pineapple punch brings up this sadness for me.

I chose this sense memory because what Sadie is feeling isn't a devastating sadness (not like the loss of my brothers) but a sadness that comes from disappointment.

(Sense memory shorthand: remembering the horrible taste of that pineapple punch.)


 SADIE
 (action—to reprimand myself) And you hang
 them out. How dumb to forget. (action—to shrug
 it off) Well, no harm done.


(Sadie notices Georgia staring at her.)

*Georgia is staring at me. Are my eyes dilated? Does she know I'm stoned? I know that look. She's angry. I feel **fear** and **embarrassment**. I need to change the subject, quick.*

When the twins were killed, my mother fell apart and my father sent Jason and me to live with my grandparents, my father's parents. They lived in a small town about two hundred and fifty miles away. They were immigrants from Norway and not warm or nurturing people. We were basically on our own. I was twelve—three months shy of my thirteenth birthday; Jason was fifteen. I hadn't started my period yet and nobody had told me anything about it. I had heard some older girls talking about it, bits of conversations, but I didn't know what to expect or what precautions I should take.

My grandmother took Jason and me to see *The Lion King*. It was a national tour that came to Detroit. I had begged them for weeks, maybe months. They finally relented. I was so excited. My grandfather had to work, so Grandmama took us. It was late September but the weather was still warm. I wore a white summer dress and a white blouse with a red and green sweater hanging over my shoulders. Grandmama had on a dark blue

dress with a fur wrap and an ugly hat. It was too warm for the fur but that was all she had that was dressy. Jason had on a sports coat that was too small for him.

The auditorium was packed. Our seats were in row R, in the middle. When we sat down, my stomach was churning; I thought it was excitement. The house lights went down and the orchestra started to play. My stomach flip-flopped a couple of times and then I noticed my seat felt wet. When the lights on the stage came up, I looked down and saw a red spot on my white dress. I stared at it. The stain got bigger and bigger. I didn't know what was happening and I was scared. I must have made some sound because when I looked at Grandmama, she was looking at me. She said, "Jesus Christ" in a loud voice and yanked me to my feet and pulled me out of the row and up the aisle. I was scared, but more embarrassed, having all those people see me, my dress getting redder and redder. Grandmama pulled me out of the theatre, past the ushers, into the ladies room. She made me sit in a stall of the bathroom while she went to a drug store. She bought me a package of sanitary napkins, gave them to me along with a handful of wet paper towels and then told me, "You're a woman now." When intermission came, she found my brother and took us home. I never did see *The Lion King*. Never have. Don't want to.

That feeling of dampness—like you've sat on a wet bench or put on a pair of pants that aren't quite dry after hanging out on a line overnight—brings up both the fear and embarrassment I felt that day.

(Sense memory shorthand: touch—feeling of dampness, spongy wetness.)

```
              SADIE (cont'd)
(to divert her attention) I borrowed this, okay?

              GEORGIA
Whatever, it's fine. You don't need to clean my
              house, Sadie.
```

*I discover that Georgia is disappointed with me, again. I feel **anger**. All I wanted to do was to be helpful.*

When Jason was first reported missing after a battle in Iraq, I went to church, the Lutheran church about three blocks from our house. I was back living at home, my senior year in high school. I had stopped going to church a couple of years before; I wasn't sure how I felt about God,

so I stopped going. But the day Jason was reported MIA, I went back and I made a pact with God. I would go to church every week, I would volunteer, I would do whatever I could. And I swear I heard him say, "I'll look after him." When I left, I felt better, that God had answered my prayers and Jason was going to be okay.

Three days later I was sitting in my father's office when my mother called and told him Jason was dead, his body had been recovered in the rubble of a small village. I went back to the church. It was winter—it is winter so often in Michigan—snowing. The church was empty. It was warm inside. The lights were dim. There was a cleaning cart in the back of the church. The place smelled like Windex. There were three large candles in big pewter candleholders burning on the altar. I had on a parka, a pair of jeans, a sweatshirt, a pair of Timberland boots. I paced around the church for several minutes, silent. Then I started talking, to God. I asked him, "Why? Why?" And then I started yelling, screaming. I knocked over one of the pews. I remember it wasn't easy; it was heavy. Then I knocked over another one. A woman, the custodian, came into the church and asked me what I was doing. I shouted at her and she left. I kept screaming, demanding to know why God had taken Jason. Why God was punishing me. Why was he reprimanding me? Why he had mocked me. Why had he gone back on his word? I remember saying, "We had a deal." I picked up one of the large candleholders from the altar and threw it. It bounced off one of the stained-glass windows. I threw a second candleholder and it shattered the window, sending fragments of glass everywhere. I was crying and yelling when the police showed up. I held them off for a few minutes, swinging the last candleholder at them. It took three policemen to get me into the patrol car. They drove me to the station, booked me. My father bailed me out an hour later. My parents agreed to pay for the damages at the church and the charges were dropped.

I chose this sense memory because I felt Sadie's anger came from the fact that she felt Georgia was reprimanding her, mocking her. I felt the same way that night in the church: that God was reprimanding me, mocking me. Anytime I smell Windex, that night in the church comes back for me.

(Sense memory shorthand: smell—Windex.)

Sadie's character makes many other transitions as the scene continues. The ones described here illustrate how the actor created a rich, truthful emotional life for her version of Sadie. Instead of faking it, making something up, she used events from her real life to give Sadie the depth and dimension necessary to make the scene work.

It is important to note that the actor *did not* do the same volume of work for every emotional moment in the scene. She used the technique described here because she wanted to make sure those specific moments rang true for her. There are going to be plenty of times when you will know how to express an emotion without doing any work at all. They'll just be there for you. Your life's experiences will have provided them. But if the emotions you want to convey are difficult for you to express, using this technique will guarantee you deliver those emotions honestly.

It is also important to note, this is not the only way to explore sense memory. There are dozens of variations. It is also important to understand that this work should be done before you step in front of the camera, before you step on stage. This is part of your homework and needs to be done well before you perform. And again I stress, you may not always have the luxury of a structured rehearsal to develop your character. That is why the individual and collective elements of this technique are so valuable.

In my classes I do not allow the actors to rehearse their scenes before performing them. They do their homework and then fifteen minutes before class starts they run their lines. We work this way because I'm preparing them for the real world of film and TV where rehearsals are abbreviated at best. I am pleased to say my students' work, in general, is pretty amazing. I invite anybody that reads this book to sit in on one of my classes. I think you will be impressed with their work too.

The actor whose homework you just read was extremely generous in sharing those events from her personal life. I am grateful she gave me permission to pass the information along to you. However, I caution you, as I cautioned her, be careful what you share. The events and the emotions they stimulate in you are precious gems and by sharing them, by going public with them, they can lose their potency and therefore lessen the impact they have on you. If someone says to you, "Wow, that was an incredible moment. How did you get there?" you're under no obligation to tell them. As humans we've been given a gift—we have the ability to recall our life experiences. As actors we are able to use those experiences in a way most other people don't. We can use the events from our real lives to enhance fictional stories.

> *By recalling something genuine, inserting it into something imaginary, and then adjusting the volume we are able to make the unreal seem real.*

Never forget, you have something nobody else has—you! You are your own best resource. Your ability to do outstanding work multiplies a thousand fold once you learn how to use what you already know.

Status, Power, and Secrets

The drive to elevate your status, to increase your power base, is a key component in the way we live our lives. The desire to better ourselves has been true from man's earliest recorded history to the present day. The cave paintings in Spain depict man's dominion over the animals. Other paintings show tribes pitted against each other. Our longing to raise our status is a trait we share with every other human being. Therefore, it follows that the characters we portray will want the same thing: to improve their situation in life, to get ahead, to gain power.

First-rate plays and films are based on heightened moments of reality when the competition between the main characters is at its highest. The more we compete, the more conflict we produce. The more conflict we produce, the better the story.

> In our desire to elevate our status we create competition and conflict. Both are essential to good storytelling.

Depending on how the writer chooses to tell his/her story, the struggle, the level of competition/conflict, can range from extremely subtle to glaringly obvious. In the Academy Award-winning film *The Lion in Winter*, Eleanor and Henry are constantly battling, competing with one another, vying to see who will come out on top. One moment Henry is wooing Eleanor and the next he is threatening her with death or imprisonment. And vice versa. This movie (and play) is made up of a series of power struggles.

One thing is certain: your character will at some point during the story attempt to increase his/her power. And this attempt, win or lose, will result in conflict. Why? Because the audience wants to see the characters struggle. If your character gets what he/she wants too easily the audience won't engage. But if he/she has to fight for what he/she wants, if he/she has to overcome major obstacles, the audience is excited when he/she gets it. Paul Newman's character in *Cool Hand Luke* wanted, among other things, respect. While working as a member of a prison chain gang he challenges the other inmates, even the authorities, and eventually wins (begrudgingly in some cases) both their admiration and their respect.

Regardless of your status you should always be trying to improve it. This, too, is human nature. Even if you're playing an emperor who rules three fourths of the known world, part of what motivates your character's behavior is to rule the rest of the world. Think of Alexander the Great or Caesar or Napoleon—the list goes on. We all want more than we have. In order to do your work, to honestly portray another human being—real or fictitious—you can't be satisfied with your character's status quo. You need to do what every human being does: you need to try to increase your power, raise your status.

There are many different ways to achieve this. You can, for example, start by picking and committing to a strong main objective and/or having a solid moment before; both will make for better storytelling. But what we're concerned with in this chapter is the use of secrets.

Recognizing that your character has information nobody knows he/she has is the first step. Knowledge is power. To increase your status you want to find and exploit any advantage possible to gain the upper hand. Look at the script and ask yourself, "Does my character know something that nobody else knows? Do I know something I'm not supposed to know?" That information, that secret, makes you powerful.

Using this power, once you know what it is, isn't difficult. We've all done it. We've all taken advantage of information that has come our way and manipulated a situation because we knew the "secret" could be harmful if the wrong people found out about it. "Don't tell Daddy I bumped into that car, okay?" That was worth an ice-cream cone at least.

There is no question that secrets give us power. The trick is finding the secret.

Sometimes the secret is written into the script, sometimes it isn't. If it isn't, you'll need to step outside the script and create it. This is similar to the work on The Bones or the Moment Before. If writers provided us with every little

detail we need to develop our characters their scripts would be 600 pages long. Sometimes, in order to create fully realized characters, we have to create things that aren't spelled out. Whether the writer supplied you with your character's secret or you had to "create" it, the goal is for you to have a secret that will increase your power and raise your status.

Secrets are everywhere. We all have secrets, all kinds of secrets. Some secrets we wouldn't tell anybody at any cost. Other secrets we secretly want coaxed out of us. Curiosity about another human being—or arousing another person's curiosity about us—is one of the most natural things in life.[16] Secrets add excitement to almost every scene. Finding them and using them in our work is merely an extension of what we do in real life. A character with a secret is much more fascinating to watch than a character without a secret.

A secret, for our definition, is something you know that you don't reveal—at least, not right away.

There are two ways to test the potency of a secret. One, does this information fuel the scene? Does it heighten the tension? Add an element of danger? Two, would the dynamics of the scene change drastically if the secret were to be revealed? When you figure out your "secret," try it and see if it stands up to this test. If it does, use it. If it doesn't, look for something else.

> The best secrets—not the only secrets, but the best secrets—are the ones in which you know something about another character in the scene.

In real life, having information about another person gives you a distinct advantage in how you deal with that person, especially if the other person doesn't know that you know what you know. The same is true in your work. Regardless of how low your character's status may be, if you know something about the other person, that information automatically elevates your position—even if you don't use it. Most of the time your secret will be an asset.

In the "Bar Scene" (see Chapters 4 and 8), the actor playing Roger made up a secret that wasn't in the script. In his homework he said there was a taxi stand a block from the bar. He could have given Debby twenty bucks and sent her home in a cab. But he didn't do that. Why? Because he was lonely. And because he was lonely he wanted to spend more time with her, and that feeds into his main objective: to get to know her better. So, instead of calling a cab, he offers to put her up for the night. The taxi stand, the availability of a cab, is his secret. This secret gives him power because it helps him achieve his main objective. It gives him the opportunity to spend more time with her.

It also fuels the scene because it adds an element of danger. Roger's plan could have blown up in his face. While there was something about Debby he liked and he was willing to help her, there was a lot about her he didn't know. She could've gone to his place, trashed it, and ripped him off.

The scene starts the next morning, but some of the negative aspects from the night before linger. "What did I do? Why did I invite this girl to stay over? I should have just called a cab and been done with it," are a few of the thoughts that Roger has in the moment before, all of which add tension to the top of this scene. Then the scene starts and the awkward dance of Roger and Debby getting to know each other begins. The tension eventually fades as these two lonely people open up to each other.

This is a case where Roger's secret is completely manufactured; there's no mention of a taxi stand in the scene. It is also important to note that Roger does not reveal his secret during the course of the scene.

That isn't always the case.

There are times when your secret (real or manufactured) is no longer an asset, and keeping it won't help you get what you want.

If your secret is no longer an asset you may choose to reveal it. If you reveal your secret during the course of the scene, the dynamics of the scene will change dramatically.

The scene from *The Thomas Crown Affair* (Chapter 7, "Opposites") is a great example of how this works.

At the top of this scene Vicki Anderson is posing as a photographer. In reality she's a private investigator and has been hired by an insurance company to investigate a series of bank robberies. Thomas Crown is the chief suspect. A wealthy businessman, he commits the robberies more for the thrill than for the money.

When the scene begins, Vicki's secret is that she is a private investigator. She knows a great deal about Thomas; she's been studying him. He knows nothing about her. He thinks she is a photojournalist but isn't sure who she works for. When the scene starts they meet and banter back and forth, flirting with each other politely.


 SHE
 Mr. Crown. I'm Vicki Anderson.

 HE
 Hello. Where's your camera?

 SHE
 You remember?


 HE
 The Daumiers. May I give them to you?

 SHE
 Then why did you . . .

 HE
 Bid? Because I wanted to buy. Anyhow, it's for
 charity, and five is the proper price. That your
 Ferrari outside?

 SHE
 Why, yes. How did you know? I just bought it . . .

 HE
 On the other hand, you stopped bidding at . . .

 SHE
 Shall we have a drink, Mr. Crown?

 HE
 What brings you out here? Charity?

 SHE
 Not really. I've been reading about you.

(He points to a newspaper he has tucked under
his arm.)

 HE
 Oh, this. I get around, I guess.

 SHE
 Not in the society pages.

 HE
 No? Where?

 SHE
 In a file.

 HE
 Oh? No kidding? Who do you work for?
 Vogue? Harpers? Life? Look? Time? I've got it.
 World Wide Polo.

At this point in the scene Vicki's secret is no longer an asset to her so she chooses to reveal it, hoping to raise the stakes, to see how he'll react—to see if he'll panic. She tells Thomas she works for an insurance company. He misunderstands and thinks she is trying to sell him a policy. He starts looking for a way to exit the situation. Immediately after this Vicki reveals exactly who she is and what she really does.

<div style="text-align:center">

SHE
Uh-huh. Insurance, Mr. Crown.

HE
I'm amply covered.

SHE
I hope so. I'm an investigator.

HE
Anything in particular?

SHE
The bank, Mr. Crown. You wouldn't expect us to take
the loss of over two-million dollars lying down,
would you?

HE
It's an interesting picture.

SHE
Not to some people.

HE
It's still an interesting picture.

</div>

(He points to her car)

<div style="text-align:center">

They must pay you well.

SHE
Depends on the return.

HE
I get it. You're one of those headhunters, huh?

SHE
You could put it that way.

</div>

 HE
 Whose head are you after?

 SHE
 Yours.

 HE
 Mine?

 SHE
 Yours.

 HE
 Interesting.

 SHE
 You really do amaze me, you know?

 HE
 How's that?

 SHE
 You've got to be curious.

 HE
 No. Not that curious. Although you have been saying
 some pretty wild things.

 SHE
 Wild?

 HE
 And a little ridiculous.

 SHE
 But only a little.

 HE
 Look, it's very enticing and all that, but you
 practically said I had something to do . . .

 SHE
 I said it, and not practically.

 HE
 Just what is it you've got?

 SHE
 Oh, I can't tell you, it would spoil the fun.

 HE
 Fun?

 SHE
 Fun. Yours, mine, your finding out just what
 I've got.

 By this point Vicki has completely revealed her secret and the dynamics
of the scene have changed dramatically. Thomas, rather than playing it safe
and walking away after Vicki reveals her secret, is intrigued by her, turned
on by her—not just sexually but also by the danger she represents. He is,
after all, a thrill seeker. She is turned on by him as well, fascinated because
he didn't panic when he found out who she was and what she was up to.
Whatever light sexual titillation might have been going on earlier in the
scene has escalated, nearing the boiling point.

 HE
 What a funny, dirty little mind.

 SHE
 So put a bullet in my leg. It's a funny, dirty
 little job.

 HE
 I suppose you think you're good at it. Your job.

 SHE
 I know I am.

 HE
 Always catch your man?

 SHE
 Of course.

 HE
 Do you think you're going to get me?

SHE
Mmm. I hope so.

The sexual tension between them now is palpable. In fact a few scenes later they're making love. Her secret fueled the top of the scene (he didn't know who or what she was, but she knew everything about him), and then, when her secret was no longer an asset, she told him what she did and it radically changed the dynamics of the scene.

A different yet equally dramatic shift occurs in the scene from *Absence of Malice* (see Chapters 3 and 11).

In this scene Teresa's main objective is to win Megan over, to convince her that Michael is innocent of murder. Her hope is that once she's won the reporter over, Megan will write a story proclaiming Michael's innocence. Teresa knows Michael is innocent. Her secret is that she had an abortion and Michael was with her on the night of the murder. However, Teresa is afraid to reveal her secret. She's fearful of what will happen to her if anyone finds out. So, she withholds the information that would set her friend free. Withholding this information, not revealing her secret, is what fuels the scene; it heightens the tension. It is only when Megan threatens to leave that Teresa blurts out the truth and her secret is revealed.

When she finally admits what really happened, the dynamics of the scene change. Megan, who has been unbending and unsympathetic to this point, is touched by the raw emotion of Teresa's confession. The confession leads Megan to change her position on Michael's involvement in the murder. She champions his cause and in subsequent scenes Megan is instrumental in getting Michael released from prison.

Teresa's secret gives her a certain amount of power (the sort of power that stems from stubbornness and pride). However, as the scene goes along and she continues to keep her secret, it starts to work against her. Her secret prevents her from getting what she wants, until finally she is left with only one choice: she has to reveal the very thing she has been holding onto. When she reveals her secret, the scene shifts and Teresa wins Megan over and convinces her that Michael is innocent.

Having and using secrets provides us with one of our most potent tools, yet this concept is foreign to most actors.

Think about your real life, the secrets you know. How powerful do those secrets make you? What circumstances have you been able to manipulate because of information you had? How many lives could you damage if you disclosed the things you knew?

The characters we play are merely doing what real people do: looking for a foothold, an edge, something that will raise their status and increase their power. If the writer has provided you with a compelling secret, great. If not, create a secret that will give you an advantage, even if you end up revealing it later. Meryl Streep said on *Inside the Actors Studio* that her secret during the entire filming of *Kramer vs. Kramer* was that her character never really loved her husband (played by Dustin Hoffman). She won her first Academy Award, Best Supporting Actress, for her portrayal in that film.

The majority of the scenes you're going to work on are not about the everyday, mundane events of your character's life but rather the turning points in your character's life. Make sure you pick a secret that has some juice, some heat—a secret that will elevate your status, or increase your power base, and/or add an element of danger to the scene. Or, even better, create a secret that will do all of the above.

The Summary

The last component of this technique is The Summary. The Summary serves two purposes. First, it gives the actor the opportunity to look at the material from a different vantage point. As actors we are often so involved with the needs and desires of our characters that we become myopic and fail to recognize there are other elements of the story that need to be advanced. By looking at the scene with a different set of eyes we can see past any limitations we may have inadvertently imposed upon the scene. In order to do this we need to look at the scene from another point of view.

But whose point of view should we take? Seeing the scene from another character's perspective is good but limiting. If you do it correctly, you're creating the same problem you're trying to fix: the other character's point of view is potentially as prejudiced as your own character's. The ideal vantage point is the director's point of view. He/she, too, is concerned with the journey the actor is revealing to the audience, but he/she is seeing it from an entirely different angle. So, while he/she is connected to the actor's journey, he/she is also removed from it. It's this unique position, this "third eye," which provides the ideal vantage point to work on the first part of The Summary.

> To get the "third eye" prospective you have to take off your actor's hat and put on the director's hat.

From the director's point of view, write a couple paragraphs that will explain the scene to your actors. You have to be careful not to favor your character when you

do this. Simply say, "This is the point we are trying to make in this scene and this is your role in making that happen." It doesn't need to be a long dissertation but it does need to be an unbiased assessment of what is happening in the scene as a whole—an assessment that forwards the story, not just your character's desires.

"Why," you might ask, after doing all this homework to develop your character, "do I have to come up with another point of view?"

As an actor you're constantly striving, trying to increase your character's power in the scene, raise his/her status and take advantage of every situation to ensure your character gets what he/she wants. That's the way it should be. You should be single minded in that pursuit. The problem is if you're too successful in that pursuit, you'll lose sight of the overall goals of the scene.

The Summary will help you see your role in the grand scheme of things.

The advantage of the director's point of view is that he/she sees the story from a more neutral position. The director is not as concerned about your character winning every scene as he/she is in telling the most compelling story.

Whether you're the star, the co-star, or a day player, The Summary will help you determine what your role is in the scene and what the important story points are.

The challenge for those of us who make our living as actors is that there are some directors who have a difficult time communicating their vision. This isn't a knock on those directors. The problem is that most film schools don't require their directing students to take acting classes. When directors graduate, they can talk endlessly about lighting, aspect ratios, and picture composition, but many of them lack the vocabulary necessary to discuss the emotional content they want their actors to achieve in a scene.

Therefore, as actors we're often left to our own devices, and because of that, we have to learn how to take care of ourselves. Being able to "third eye" your own work, giving yourself a fair, unprejudiced assessment of what needs to happen in the scene, from both an actor's and a director's point of view, is invaluable.

The second part of The Summary provides you with an outline of the beats (events) of the scene and helps you map out the emotional arc of your character's journey. Again, this is especially important in this era of self-taping. Often, even if you are auditioning with a casting director, you are very much on your own when it comes to interpreting the script. Sometimes the casting directors will know the emotional highlights the director is looking for, others

times they won't. And sometimes that information changes from the initial audition to the callback. Not too long ago I auditioned for *Black Box*, a short-lived medical series for ABC. I prepared for the audition, went in, hit the emotions I thought were called for, and was pleased when I got a callback.

However at the callback the director, Eric Stoltz, was there. Eric is an incredible actor in his own right and instead of reading with the casting director I read with Eric. Halfway through the audition I saw him get an idea. I literally saw his eyes light up. He said, "Hey, let's try it this way." It was a different take on the scene and sent me in a different emotional direction. I did what he asked and left feeling pretty good. The next day my agent called to tell me I was booked. When I shot the scene Eric told me, "I liked what you were doing. It's what gave me the idea to try something else." Because I came in with a strong choice, it allowed him to see something else in the scene, something we both realized was better, and we went with that. But if I hadn't prepared, if I didn't have a strong point of view to start with, if I didn't know the emotional arc my character needed to travel, who knows if I would have even been called back.

Finding and playing the emotional arc is very important and to successfully execute this second part of The Summary, you need to put your actor's hat on again. With that hat firmly back on look over the scene and create a list of the major beats that occur for your character during the scene. You may or may not stick to this list when you're actually doing the scene. This will depend on what the other actors do, the input your director may have, any last second things that occur to you as you're doing the scene, *but* it does give you a place to start. Playing with a completely blank slate is not a good game plan.

Every scene is a series of beats. *This* happens and then *that* happens, and then *this* and then *that*, and so on and so on, until the scene reaches its conclusion. Your job is to figure out what those major beats are, the ones that propel the scene forward for your character. Once you've determined what those beats, you then assign an emotion to each one. This outline of beats and emotions will help you as you work your way through the scene.

The following is a look at the "Bar Scene" introduced in Chapter 4, "Ten Positive Attributes," using the techniques described in this chapter.

BAR SCENE

Synopsis

Last night, Debby, an airline stewardess, ended up with a drunken and abusive date in a tavern where Roger tends bar. After Roger threw Debby's

date out, the date drove off with her purse in his car, leaving her stranded. Roger offered to have her stay at his place nearby. She spent the night in his bed. He slept on the sofa.

The next day, Sunday, Roger is already awake, reading the paper. Debby woke up a few minutes ago and has been poking around his bedroom, looking at photos, etc. Now she stands in the door of the bedroom, watching Roger reading in the living room. He looks up and sees her.

DEBBY
Can I come in?

ROGER
Sure.

DEBBY
Good morning, even though it isn't morning.

ROGER
Good morning. Did you sleep well?

DEBBY
Yeah, okay. This is really nice of you. I mean, you
don't even hardly know me.

ROGER
That's okay.

DEBBY
I thought maybe I could make some breakfast for us.
What would you like?

ROGER
On Sundays, I usually go to the deli for lox and
bagels.

DEBBY
Isn't that Jewish food?

ROGER
Yes, smoked salmon. You eat it with cream cheese.

DEBBY
Oh. I hoped I could cook something for you.

 ROGER
 There are some eggs in the refrigerator.
 You can scramble some and make coffee.

 DEBBY
 I hope your girlfriend won't be upset when
 she finds out I'm here.
 Just tell her I won't be here long.

 ROGER
 But I don't have a girlfriend.

 DEBBY
 No?

 ROGER
 No.

 DEBBY
 Don't you get lonely all by yourself?

 ROGER
 I keep busy.

 DEBBY
 What do you do?

 ROGER
 Read newspapers and watch television.

 DEBBY
 May I ask you a personal question?

 ROGER
 Go ahead.

 DEBBY
 Your parents? They been gone for a long time?

 ROGER
 My mother died about five years ago, and my
 father died a year before her.

 DEBBY
 Is that them in the picture on the dresser
 in the bedroom?

 ROGER
 Yes.

 DEBBY
 Your father was wearing one of those little
 black hats. Was he a rabbi?

 ROGER
 No, but he was an Orthodox Jew. He always kept
 his head covered.

 DEBBY
 The Orthodox are the really strict ones?

 ROGER
 Very strict.

 DEBBY
 Did you two get along?

 ROGER
 No. No, we fought a lot. When I started
 tending bar, he stopped talking to me.

 DEBBY
 And your mother? Was she strict too?

 ROGER
 She was worse than him. She used to tell me, Jews
 don't work in barrooms selling drinks to goyim.

 DEBBY
 My father was the president of the chamber of
 commerce in my home town one year. I'm from a
 small town in Iowa. Ottumwa. Ever hear of it?

 ROGER
 No.

 DEBBY
It was in the news when I was a little girl.
Khrushchev stayed overnight when he visited America.
Remember when he came here? We also had a Miss
 America a few years ago.

 ROGER
 They grow corn in Iowa.

 DEBBY
And hogs. But my father wasn't a farmer. He owns
a men's clothing store in a big shopping center.
I used to work for him before I went with the
 airlines.

 ROGER
 Small town girl makes good, huh?

 DEBBY
My father still hasn't forgiven me for leaving.
He thinks all airline stewardesses are whores, and I
 have to admit, he isn't far off.

 ROGER
 Stewardesses are okay.

 DEBBY
Sometimes I get disgusted with myself. I wonder
 what I'm doing with my life.

 ROGER
 You can't be a stewardess forever.

 DEBBY
God, that's depressing. Can . . . can we talk
 about something else?

 ROGER
Did you have any plans for today? Would you
 like to go see a movie?

 DEBBY
 I'd love to.

ROGER
I got the paper right here. Let's see what's
playing.

DEBBY
Thank you. Thank you very much.

The following are the notes from the actor who played Debby.

Looking at the script from the director's POV, I see this scene as a bonding scene where these two characters, both lost and lonely souls, come together. Her situation is more obvious than his, but he, too, is lonely, a lost soul looking for love. She is extremely embarrassed but at the same time also attracted to Roger. He is the first guy who "helped" her, did anything for her in a long time, without wanting something physical in return.

Roger is also attracted to Debby—she's pretty, friendly—but they have several issues they have to overcome. That's what the scene is about: the two of them overcoming those issues. She has an issue with men; he doesn't have an issue with women (or maybe he does; he doesn't have a girlfriend). She is very outgoing; he's very shy. She has a tendency to blurt out things without thinking and actually insults him a couple of times during the scene; he is more reserved. The thing they share, aside from loneliness, is that they are both good-hearted people. When Roger gets emotional while talking about his parents, Debby, sensing how difficult this is for Roger, shares the feelings she has about her father. This lets Roger know he is not the only person who has deep and hurtful parental issues.

This sharing gives them a common ground, helps them create the bond that allows Roger to overcome his shyness and to look past what he knows about her and to ask her out. Debby, on the other hand, understands that Roger sees her as a person, that he likes her for who she is, that he is not judging her for her past, and he's not trying to put a move on her. Because of this understanding she is deeply touched by his offer to go to the movies (a metaphor for having a relationship, or the beginning of one) and accepts it. The awkwardness they both felt at the top of the scene is gone by the end of the scene.

Beats

Moment Before—*I am standing inside the bedroom, staring through the crack in the door, looking at this guy who rescued me from a bad, and potentially dangerous, situation.* **Emotion: Embarrassment.**

I enter. We chat; make small talk, neither one of us directly making too much about what happened the night before. I am nervous, anxious. **Emotion: Fear.**

We continue to talk. He makes me feel at ease, accepts my offer to let me pay him back for his kindness by making him breakfast. I drop a couple of hints to see if there is a girlfriend in the picture. **Emotion: Jealousy.**

I find out there isn't a girlfriend and take the conversation to another level to find out more about him. **Emotion: Joy.**

I discover that he had a difficult relationship with his parents. I see how much this hurts him and share my own painful experience with my father. **Emotion: Sadness.**

I start to beat myself up, reliving the trouble and hardship I've created for myself. **Emotion: Anger.**

Roger asks me out. I realize that he sees me for who I am, the good person, and is willing to overlook what happened last night. I accept his invitation. **Emotion: Joy.**

The Summary provides you with two distinct advantages. The first section allows you to gain insight into your character by looking at the scene from a different point of view. The second section provides you with an outline of the beats that occur and helps define the different emotions your character encounters as you work your way through the scene. Both are invaluable.

A maestro would never dream of conducting a symphony without carefully studying the score and having a detailed plan of how he/she wants each section of the music to sound. From the time he/she picks up the baton to the time he/she puts it down, he/she knows what he/she wants to achieve. Don't hold yourself to a lesser standard.

The Technique—Condensed

In this chapter you'll find all the sections of the technique in one place. While it is possible to separate the components, the technique works better when intact, each section supporting the next as it overlaps and coalesces into a whole. The effort you put in will easily quadruple the benefits you get out. Here are the twelve steps:

1 THE BONES

(a) **Physiology**
(b) **Sociology**
(c) **Psychology**

For the Physiology section, your answers should be short—a word or two, a sentence at the most. For the second two sections, Sociology and Psychology, you should expand and expound; here, more is better. This is the part of the homework where you have the opportunity to breathe life into your character, to develop a fully realized person, warts and all.

2 POSITIVE ATTRIBUTES

Ten Attributes that help describe the positive aspects of your character. These will help you find the humanity of your character. They serve as anchors to prevent the characters you're playing, especially the ones you perceive as being bad or evil, from becoming caricatures.

3 RELATIONSHIPS

(a) **Facts**: what is the fact of your relationship with the other character(s) in the scene? Is the other character your brother, your mother, your archenemy, what? Include characters who are mentioned but don't appear in the scene.

(b) **Feelings**: once you know the facts, the next question is: how do you feel about that person? There are six possible choices:

I love him/her.

I admire him/her.

I want to help him/her.

I hate him/her.

I resent him/her.

I want to get in his/her way (hinder him/her).

(c) **Conflict**: once you know how you feel about the other person, see if the opposite of that feeling is also true. For this "conflicted feeling" stick to the same six choices listed above.

Variety is crucial for the success of every scene. Knowing how you feel about the other people in the scene, and having some sort of conflict regarding those feelings, ensures variety. Variety keeps your character from becoming predictable.

4 MAIN OBJECTIVE

What do you want from the other character(s) in the scene or from the situation? What motivates that desire—love, attention, sex, survival—then pick a simple action-based verb, e.g., *to seduce, to manipulate, to charm, to belittle, to win over*, and pursue that objective throughout the scene. Remember the other character is going to say "no" to what you want most of the time, so pick something you can really sink your teeth into and go for it.

5 OPPOSITES

After you've determined your main objective, find at least one place in the scene where the opposite of what you want is also true. Find it and play it. Your opposite(s) should be played as intensely as the main objective, but for a shorter period of time.

6 MOMENT BEFORE

Including a Moment Before to every scene is crucial if you want to be successful. Make sure it has:

(a) **Scenario**: this is the mini-scene that leads you into the real scene.
(b) **Positive expectations**: these are the things you hope will happen in the scene, things that are exciting.
(c) **Negative expectations**: these are the things that make you nervous, anxious, or apprehensive. If one of the negative expectations includes an element of danger, all the better. Nothing heightens the tension in a scene quicker than danger.

7 DISCOVERIES/EMOTIONS

Every time another character speaks or takes an action indicated in the script, you need to make a discovery about what he/she said or did. Sometimes you may discover more than one thing. Once you've made the discovery, you need to figure out how you feel (what emotion comes up for you) about what you discovered.

Eight basic emotions

Yes, there are other emotions but keep your choices simple.

Joy

Anger

Sadness

Jealousy

Fear

Betrayal

Embarrassment

Confusion

There will also be discoveries you make during rehearsal/performance. Making those discoveries will be easier if you do the homework in this section. Once you awaken the Discovery muscle, it loves to work out.

8 BEATS, TACTICS, AND ACTIONS

In TV and film work there will be mini-beats within beats. Based on whether you're getting closer or further away your main objective, you will come up with a set of tactics to help you accomplish that objective. The actions (deeds or words) you use to fulfill those tactics will be influenced by the emotions that came out of the Discovery/Emotion process. These actions will occur during various stages of the process—in your prep, in rehearsal, or "in the moment" of performance.

9 HUMOR

It is essential to find the humor in each and every scene. Humor isn't the jokes. A joke is where the audience laughs; humor is where the character laughs at him-/herself or his/her circumstances. There are four reasons to express humor in a scene:

(a) **Finding the absurdity**: when the character either laughs at the absurdity of the situation he/she is in, or at how absurd he/she is behaving in that situation, or at the absurdity of another character's behavior.
(b) **Breaking the tension**: when the character laughs in a tense situation, often in an inappropriate place.
(c) **Discovering and playing irony**: when the character uses words or actions to suggest something different than their real intention. Sarcasm is one way of expressing irony.
(d) **Using self-deprecation**: when the character wants to deflect attention away from him/herself; to make it seem as if he/she is less than he/she really is.

Don't be afraid to express your character's sense of humor. Don't be afraid to laugh, especially at yourself. It makes you human.

10 PLACE, TRANSITION, AND SENSE MEMORY

Once you've identified the emotion that comes up most often in the scene, scan your real life for a place where you experienced the same emotion and place the scene there.

You are your own best resource when it comes to expressing emotions. In your real life you have already experienced the emotions your character needs to express—maybe not at the same volume, but the same emotion. It's

simply a matter of bringing those past experiences into play and turning the volume up or down. Once you've recalled an event that triggers the emotion you want, reduce the experience down to a sound, a smell, a taste, a touch, or a strong visual.

A note of caution: only use those events from your life that are completely resolved. You want to be in charge of the emotions, not have them be in charge of you.

11 STATUS, POWER, AND SECRETS

Having a secret helps to elevate your status and increase your power. A secret is something you know that the other character doesn't know you know. You may or may not reveal it. Sometimes you may need to step outside the script to find your secret.

12 THE SUMMARY

Step back from the scene and look at it as if you were the director explaining the scene to your actors. Then, wearing the actor's hat again, figure out the beats of the scene. Add an emotion to each beat to create an emotional outline for the scene. This will help you generate the roller coaster ride that can make the scene exciting for both you and the audience.

Self-Taping

Whether it's for a commercial, a TV show, or a film, self-taping is a reality. In every major market (New York, Los Angeles, and Chicago) and especially in the minor ones (Washington D.C., Dallas, Atlanta, Seattle, etc.) self-taping has become a significant part of the audition process. Sometimes you'll submit your auditions directly to a casting director who will then sift through the tapes and present what they consider the best of the best to the director, producer, ad agency, or whoever hired them. Other times, tapes will go directly to producers and they will winnow through the submissions to choose the actors they'll bring in for a "live" callback. Either way, if you want to be seriously considered for the project, your work must stand out. In a good way.

WHAT DO YOU NEED TO ENSURE YOUR SUBMISSIONS WILL STAND OUT?

This is where the work described in this book will really help you. Except for a brief overview of the project and an even briefer description of the character the only other information you'll get will be your scene(s), if you're doing a film or a TV show, or your lines, if you're reading for a commercial. That's it. Not very much to build a character on—unless you have a technique that allows you to mine that scant bit of information and turn it into something.

Everything we've talked about—from *The Bones*, to fleshing out the *Relationships*, to finding a *Main Objective* that will sustain you for the entire scene, to creating variety with *Opposites*, to using *Discoveries/Emotions* to

fulfill the emotional needs of your character, to applying the principles of *The Summary* to identify the beats in a scene—all of these components will ensure that your work separates you from the rest of the actors who also submitted for the project.

WHAT EQUIPMENT DO YOU NEED?

It can be as simple as a smart phone or as elaborate as going to a professional studio. I have used both successfully. Much of it depends on the turnaround time and your finances. I would suggest, if you're going to do a lot of self-submitting, you invest a few dollars and buy a basic lighting package and a tripod. You can find all of these online for just over 100 dollars. If money is tight, chip in with some other actors. The reality is a grainy, poorly lit tape is not going to get the same sort of attention as a tape with good production values. We, casting directors, producers, directors, and just regular folks, have been spoiled and have come to expect good production values. So while your work is the most important ingredient, it isn't the only ingredient.

A few things you should be aware of if you're doing this on your own: you should have a **neutral background**, for example a blue wall or a large piece of blue material pinned to a wall to shoot against. Not too dark but not too light either, a medium blue. **Someone to read with**, if you're doing a scene. Please pick someone who knows a little bit about acting so that your "reader" doesn't kill your audition. If you go to a professional studio make sure the person who is taping you knows what he/she is doing. Some are great. Some aren't. Some will read with you, some won't. Go on the Internet and check out their work.

WHERE DO I FIND THESE AUDITIONS?

Ask your friends, read the trades, go on the Internet. Go to Google and type in "casting websites" and you'll get a myriad of choices. But, like everything on the Internet, be judicious. Some of these sites charge a fee, some don't. Some are good, some aren't. This will require your doing a little bit of homework. And as always, be careful what personal information you share until you're sure the site is legit.

The great thing about self-submitting is you aren't restricted to one physical location. Just last week one of my students asked me to coach her (in New York) for a film that was shooting in Oklahoma. We worked for an hour, went to the studio, rehearsed, and shot her scenes. She gave the engineer a link and less than an hour after we walked in the door her tape was in the producer's office in Tulsa.

. . . And Now a Few Words about Commercials

INTRODUCTION TO COMMERCIALS

Actors have a love/hate relationship with commercials. They want to do them because the money is good but they don't understand the complexities of the form. Commercial acting is a very specialized type of acting.

Actors of every type and stripe have performed in commercials. Bryan Cranston recently said in an interview that commercial residuals kept him afloat for nearly ten years while he was waiting for his career to take off. Dustin Hoffman, Jodie Foster, and Hilary Swank made commercials long before winning their Academy Awards. Robert Duvall performed in commercials both before and after winning his Academy Award.

Actors tend to approach commercial auditions as if they were shooting craps, never realizing there is a technique that can turn the audition process into a series of simple acting exercises. What most actors lack isn't talent, but rather technique.

There are many similarities between commercial acting and film and/or stage acting. There are also some glaring differences. The biggest difference is that 95 percent of commercials are problem/solution scenarios. Someone has a problem, you have the solution and you're going to help the other person solve his/her problem. This flies in the face of almost everything actors are trained to do.

In "regular" acting classes, actors are taught to fight to get what *their characters want*. They're taught this because striving to fulfill their character's wants and desires creates tension and conflict and the more tension and conflict there is, the better the story will be. This is true.

This isn't how commercials work.

Commercials are about resolving problems, not creating them.

Madison Avenue figured out a long time ago the best way to sell a product is to *help,* not *hinder.*

This is true whether it's one character talking directly to the camera or a group of characters talking amongst themselves who never actually address the camera. With the former, the information divulged is direct; with the latter, the information revealed is implied. Either way, built into the script, there is a problem/solution scenario designed to sell a product.

This is important because if you can't figure out the problem, you won't be able to come up with a solution, which means you won't book the job.

The problems will be many and varied. Is someone having car trouble? Money issues? Do they have a headache? Are they trying to quit smoking? Get a stain out of a blouse?

Finding and solving the problem is crucial and I encourage you to test this premise. Once you discover its validity you will understand a piece of the puzzle that eludes most actors.

Another thing that differentiates commercial acting from film/stage acting is that commercial actors are, for the most part, restricted to expressing only one emotion: joy. That doesn't mean you won't brush up against sadness or anger or jealousy or some of the other "negative" emotions, but your contact with those emotions will be the exception rather than the rule as you travel through commercial land.

Actors (and writers) are adept at manipulating scenarios and will often use a negative to set up a positive. The writer will write, "I hate you," so that when the character finally says, "I love you," it has more impact. Because there is no real, sustainable anger in commercials, actors can't depend on this. They have to learn how to set up a positive situation with another positive. This can be tricky if you're not used to doing it; tricky, but not impossible.

Because ad agencies know that the best way to promote a product is to put a positive spin on it, joy is the default emotion for commercials.

This isn't to say there won't be any negativity in commercials, but whatever negativity there is will be resolved quickly rather than amplified and drawn out.

In order to be successful in commercials you have to switch your approach and come at the craft from a different perspective. Instead of trying to create conflict, you have to promote resolution.

Language is the next hurdle. The dialogue for film, TV, and stage is written to sound as realistic as possible. Screenwriters write to create a mood. They know a false line can jar the audience and break the magical spell they have worked so hard to create. This isn't necessarily the case with commercial copy.

Commercial copy is written to sell a product. That doesn't mean the writing is bad, but it is different. Think about it; nobody in real life talks like a character in a commercial. When was the last time you had a conversation with someone about the lettuce, onion, and pickle on your hamburger? Yeah, I've never had one either.

> In order to be successful in the commercial world you have to master "commercialspeak."

Commercials are, for the most part, written in code. Part of your job is to learn the code and be able to translate it, and this is one of the many things we will work on.

In order to make it past the first round of auditions you need to:

- Figure out the problem and come up with a solution.
- Learn how to use joy as your main emotion.
- Become fluent in commercialspeak.

The Slate

The slate is the first thing that happens at an audition. It's also the most important part of the audition. Yet very few actors know how to do it properly. When you walk into a studio, the casting director is going to point the camera at you and ask you to say your name. That's the slate.

Sounds simple enough, right? We all know our names. But do you know how to say your name so that the people watching the playback of your audition will lean forward in their chairs and be excited to hear what you have to say or do next?

Here's the deal: the people watching the playbacks have the power of the remote. If your slate grabs their attention they'll watch the rest of what you do. If the way you say your name doesn't get their attention, they'll fast-forward to the next person.

Look at it from their point of view. Let's say an ad agency is casting a national detergent commercial. They're looking for a "young mom" between the ages of twenty-eight and thirty-three. The ad agency hires a casting director and the casting director calls you and a hundred and forty-nine other actors in for the audition. The agency people are going to watch everything the first ten actors do. Seven of those actors won't be properly prepared; they're either having a bad day or they haven't done their homework, or any variety of things.

After the twentieth person, and the fourteenth or fifteenth not-so-good audition, the ad agency people are getting upset. "What's wrong with these actors?" is one of the more polite questions being asked. Other things, not

quite so polite, are also being said while they watch, fingers poised on the remote, ready to fast-forward at the slightest provocation.

To understand this, let's back up a step. The ad agency people have a problem: they need to find somebody to help them sell their product. They're watching the auditions with great expectation. This commercial is huge for them and for their careers. The money they plan to spend on the spot is outrageous. A national commercial will run, including production and buying ad time, anywhere from 2 to 10 million dollars. If it goes well they'll get to keep their jobs (or get promoted); they'll be able to make their mortgage payments, keep their kids in private school, buy a boat; whatever. If it goes badly, well . . . all those things could go away.

They want the actors to do a good job. They are rooting for every actor that comes in. But because so many actors aren't properly prepared, the ad agency people are in a constant state of frustration. They see their hopes for the project crumbling as actor after actor fails to meet their expectations. You'd be frustrated too.

Your slate is your passport to the next part of the process.

You're the eighty-fourth person called in. They have already seen way too many bad or unprepared actors. This is why your slate has to be really good.

If your slate sends the message "I know what I'm doing," the ad agency people will watch the rest of your audition. If it doesn't, one push of the button and you're gone.

What can you do to make sure your slate gets their attention? First, put someone in the camera you don't know, someone you like, someone you would like to hang out with, and introduce yourself to that person. Let me say this again, *put someone in the camera you don't know, someone you would like to meet and hang out with.* By doing this, you create a sense of anticipated excitement that is the stock and trade of commercials. The ad agency people will see your playback and think, "Hey, that guy's sincere. He's really talking to me. Let's hear what he has to say." By making it personal, you've made a connection and you've created a sense of aliveness that most actors won't bring to the slate.

Whom you pick to slate to is important.

Commercials aren't written to be too "meaningful" or "overly serious;" they are written to sell products. So, although the person you'd most like to meet more than anyone else in the whole wide world is the prime minister of Outer Uzbekistan, he may not be the best

person to slate to at a commercial audition. Pick someone you think would be fun to meet: Will Smith, Anne Hathaway, Jim Parsons; someone like that.

If you're used to working in film or TV or on stage, you'll need to make an adjustment when auditioning for commercials. There is a lightness, an eagerness, to a commercial audition that doesn't work with other auditions. In commercials, resolution is king and if you don't bring a quality of lightness and eagerness to your audition, you won't book. This is not about being all smiley-faced but about generating the feeling of joy that happens when you help a friend solve a problem.

PROFILES

Commercial auditioning is in a transition. Used to be you would slate and then do the copy. Then profiles were added. Then they started doing full-body shots and then the slate. The other day I was asked to do a "head slate" and a "tail-slate" (slating at both the beginning and the end of the audition). I'm including **profiles** so you'll know what to do if they ask you for your "profiles."

So, you've done your slate and it went well—you put someone in the camera, you created a feeling of excitement and anticipation—but then the casting director asks for your profiles and all the energy that went into the initial introduction drains away. It's important to maintain that energy.

When you turn to show your profiles, put the person you slated to in the camera on the wall to your left and see them there. Same when you turn to the right. Don't make a big deal out of it; just see them when you turn to either side and maintain the same vitality you had when you first

The time you spend in profile should be short: one to two seconds.

saw them in the camera. Just by seeing that person and by thinking how cool it is to meet them will help you maintain your energy.

Don't automatically turn to show your profiles unless the casting director asks for them—not every casting director will. Also, ladies, if you have long hair, please make sure to brush it back so we can see both of your ears.

One last thing about slating: if you picked a celebrity, take all the hero-worship out of the slate. Will Smith wants to meet you just as much as you want to meet him. Same with Anne Hathaway. Same with whomever you choose to put in the camera for the slate. It's like you're at a party, you turn around and that person is standing right there looking at you. All you have to do is say, "Hi, I'm John Smith," or "I'm Jill Jones."

Each step of the audition is important, but slating properly, getting the attention of the people watching the playback, is the most crucial.

EXERCISE

Pick four different people you would like to meet. Fun people, people whom you think it would be great to hang out with.

Practice putting them in the camera (don't see them full length, just their head and shoulders) and introduce yourself. If you don't have a camera, draw a small circle on the wall at eye level and practice putting them in there. Use your imagination; pretend you see them and say, "Hi, I'm _____." And then turn and see them on the wall to your left and the same thing on the wall to your right.

From Slate to Copy

For the slate, you want to put someone in the camera *you don't know but would like to meet*, but for the actual copy you want to put someone in the camera *you do know and want to help*.

Because creating this relationship is vital to your success, it's important for you to know "whom" you're talking to.

Let's look at single-person copy to start with. Single-person copy is just what it says: it's one person (you) talking directly to the camera. This scares the crap out of most actors. It's like doing a one-man show; it's all you and there's no place to hide. But it doesn't have to be daunting.

Once you've identified the problem, ask yourself who from your real life, past or present, has or has had a similar problem. My friend Tommy is always having money issues, so if I'm doing a commercial for loans or banks or credit cards, I'll use him. Richard is always having car issues, so if the spot concerns car repair or renting a car or buying a car, new or used, I'll put him in the camera and talk to him.

By putting someone you know in the camera, someone with a problem similar to the problem mentioned in the copy, you've made your job immeasurably easier.

A couple of guidelines about whom to put in the camera: pick someone you like, someone who will be receptive to your advice. Do not, if possible, use your best

If you don't do this, if you don't put someone in the camera, you'll end up trying to talk to a one-eyed, three-legged monster.

friend or a close relative. We shorthand the way we speak to these people and while the two of us may know what we're talking about, other people, the people viewing the playback of your work, may not. Clarity isn't only desired, it's essential.

Picking the right person to talk to is extremely important. A good way to determine if you've picked the right person is to ask yourself this question: will this information, the solution to this problem, change that person's life? If not, you've picked the wrong person and should pick someone else.

Wait! Hold on! These are commercials we're talking about here. What do you mean, "change a person's life?" Really?

Absolutely. Don't forget, commercials, like films or plays, deal with heightened moments of reality. Someone has a problem and your job is to help solve that problem. The copy may be trite (e.g., advising your neighbor about what lawn products to use may seem trivial), but you need to keep the stakes as high as possible.

If you don't think what you're saying is important, it will seem as if you don't care.

If you don't keep the stakes high it will appear as if you don't care and the clients won't hire you to represent their product. As actors you need to understand that if you don't maximize the stakes in every situation, you end up playing indifference, and indifference is not only difficult to play, it's also boring as hell to watch.

This isn't a license for you to get heavy-handed or overly dramatic; just the opposite. Joy, in one of its thousand different manifestations, is the constant emotion you'll use as you navigate your way through commercials. The people watching the playback need to know you care. They need to know you're serious about solving the other person's problem, but at the same time they need to know you're delivering the solution from a place of joy.

Again, this doesn't mean you smile your way through the commercial. The smile, if there is one, is a result of the joy that comes from helping your friend. The smile is internal. If it manifests into an external expression, an actual smile, that's great, but you have to work from the inside out. You can't simply plaster a grin on your face, say the words and expect to book the job.

Also remember to ask yourself why is the person you put in the camera asking you for help? Because they know you've either had the same problem in the past and you've solved it or you're a spokesperson for the company. (More on the spokesperson thing in the next chapter.)

If your roommate needs to know which brownie mix to use, you'll need to create an appropriate scenario in order to give the copy some real substance. The reason she is seeking your advice is because she's trying to impress a new guy. And she knows you make dynamite brownies. If her brownies are great, he'll ask her out again and soon a romance will be in full bloom. Melodramatic? Yes. But by creating this scenario, by advising her on which brownie mix to use, the commercial has taken on a level of importance it didn't have before. And that level of importance has made the situation easier to play and more interesting to watch.

Sometimes you'll have to stretch your imagination to give the problem the oomph it needs.

Once you've determined what the problem is, and you've figured out whom from your real life you're going to put in the camera to talk to, and you've raised the stakes so that solving that problem takes on an amplified sense of importance, then you'll be well on your way to hearing those words we all love to hear: "You're booked."

EXERCISE

Practice switching from the person you're slating to, someone you don't know but think it would be fun to meet, to a friend, someone you do know and want to help.

To do this, you'll need a couple of pieces of copy. There are samples in the back of this book. If you want more copy, you can find plenty online. A word of caution: don't use radio copy. Radio copy isn't supported with pictures the way television copy is. It makes a difference.

Read the copy. Determine what the problem is and then figure out who you know that has or had this problem, someone who will listen to you and follow your advice.

After you've done that, practice slating to the camera (or the circle on your wall) and showing your profiles, and then, as you are turning back to the camera from your second profile, switch from seeing the person you want to meet to seeing the friend whose problem you are going to solve, allowing one face to replace the other.

This takes a little practice, but it is doable and very important.

Relationships

It's important to understand that, when you go on an audition, your job isn't to show the casting director how good an actor you are.

What?

Your job is to show the casting director how good you are at creating relationships, and the degree to which you can do that tells the casting director how good an actor you are. If you can turn a mop into a dance partner, you've got it made. If you can hold up an empty plate and convince people that it's a dish of steaming, mouthwatering lasagna, you'll get the job. If you can instantly turn a stranger into the love of your life, you'll work forever.

There are six key elements to breaking down a commercial script. The first, and perhaps the most difficult, is to *identify* all the relationships in the copy. Relationships are the key to all good acting.

We've already discussed two of the most important relationships you need in order to have a successful audition: the person you're slating to and the person whose problem you're going to solve. You also need to know who you are in the commercial. Are you merely a friend to the person you're talking to or are you a spokesperson for the product? And you could be both. Either way, you're a friendly authority on the subject—with an emphasis on friendly.

The reason it's important to know if you are a friend or a spokesperson is a question of status. If you're a spokesperson, you'll want to deliver your lines with more authority, more pride. As a friend, your approach will be

If there is an event (e.g., an anniversary) or situation (e.g., a baseball game) mentioned in the spot, you'll need to create a relationship with those as well. In other words, you'll need to create a relationship with every person, situation, or event that is mentioned in the script.

more casual. How can you tell who you are? If the words *we, our,* or *us* are part of your dialogue, you're a spokesperson.

You'll also need to have a relationship with the product—The Hero. And you may need to have a relationship with the competitor's brand—Brand X. If other people are mentioned in the spot, you'll need to create a relationship with them. Example: if you talk about Aunt Agnes, we the viewers need to know how you feel about her.

Then, once you have identified all the relationships, you'll need to assign a positive or negative value to each one. Sometimes a relationship will have a neutral value. These neutral relationships are rare and are hard to play, but every now and then one will pop up.

Here's an example of finding relationships in a commercial script.

Royal Bakeries

(Talent sits with a small group of people at a picnic table in a backyard. He holds a plate with a large slice of chocolate cake on it. Behind him we see a birthday party in full swing: guests talking; kids playing games; balloons, streamers, etc. Several groups of partygoers sit or stand in various clumps around the backyard, socializing.)
TALENT (turning to camera): IT WAS MY BIRTHDAY PARTY AND MY AUNT JEAN MADE HER FAMOUS ROYAL BAKERIES CHOCOLATE CAKE.
UNFORTUNATELY, MY COUSIN JOEY WAS INVITED TOO.
BUT HEY, EVEN JOEY CAN'T RUIN A GREAT CAKE.
(Talent, using a fork, cuts a bite of the cake and eats it).

When it comes to identifying the relationships, here's what we've got:

IT WAS MY BIRTHDAY PARTY (***event—positive***) AND MY AUNT JEAN (***person—positive*** [we're assuming you like her; she made your favorite cake]) MADE

HER FAMOUS <u>ROYAL BAKERIES CHOCOLATE CAKE</u> (**Hero product—positive**). UNFORTUNATELY, <u>MY COUSIN JOEY</u> (**person—negative** [the word *unfortunately* tells you all you need to know about how you should feel about Joey]) WAS INVITED TOO. BUT HEY, EVEN <u>JOEY</u> (**person—negative**) CAN'T RUIN A GREAT <u>CAKE</u> (**Hero product—positive**).

So, in addition to the person you're slating to and the person whose problem you're trying to solve, there are six other relationships in this spot, and the viewers need to know how you feel about each one. (Please note that Joey and the cake are counted twice because they're mentioned twice.)

Once you've identified the relationships and assigned a positive or negative value to each, you may want to "adjust the volume" to reflect those feelings. How you feel about the birthday party is positive, but maybe not as positive as how you feel about the cake—the cake is The Hero, after all. Same for Joey; you mention him twice, but perhaps the second time his name comes up, you don't feel quite as negative as you did the first time.

Please understand that the problem in this commercial isn't the fact that Joey showed up at your party. The problem is you have a friend who needs to know what's the best cake to serve at a party and you're telling her the story about the cake that was served at your party, the idea being that the story and the suggestion of the Royal Bakeries cake will solve her problem.

Finding the various relationships in commercial copy and then figuring out how to express them is not easy. (And please note: the word *negative* is used simply to add a different color. Cousin Joey isn't a child molester; he's just an obnoxious relative.) However, once you figure this out, once you master the art of identifying the relationships, your chances of booking the spot have increased a 1,000 percent. *Really!*

This step, finding and evaluating the relationships, is the hardest part of this technique and the most important.

When auditioning for a commercial, remember that all of your product relationship choices, except for Brand X and its attributes, are going to be positive. You're not acting in an intense drama like The Revenant; *you're simply trying to help a friend decide what cake to serve at a party.*

SUBSTITUTIONS

In making relationship choices you may need to do some substituting. If you don't love the product you're auditioning for, you need to focus on something you do love and be thinking about that while you're talking about The Hero or the attributes of The Hero.

Never forget, the camera can "see" what you're feeling by what you're thinking.

For instance, if you're thinking, "Chocolate isn't my favorite thing," when you're auditioning for Royal Bakeries Chocolate Cake, the camera will pick that up and the people watching the playback will sense that something is wrong and, because they're trying to sell chocolate cake, you won't book the job.

So, if ZZZ Detergent doesn't make your heart sing, think about something that does, and make sure you're thinking about that while you're extolling the virtues of ZZZ Detergent.

Whatever you use as a substitute has to be something you *love*, not just something you like a lot. There is way too much money involved for you not to make this simple adjustment. The residuals from a national commercial could pay your rent for the next three years. However, if anyone involved in the hiring process has even the remotest inkling that you don't love the product, you aren't going to get hired.

The substitutions you make are necessary to generate the feelings you want to convey.

If the product is frozen peas and you can't stand frozen peas but you love vanilla ice cream then think about ice cream and how good it is each time you mention anything to do with the frozen peas. The viewers will "see" the love you have for vanilla ice cream and they will automatically make the leap that the vanilla ice cream you're thinking about and the frozen peas you're talking about are one and the same. It doesn't matter what you use as a substitute: rock 'n' roll, fish sticks, money, mom's homemade cookies, sex, whatever; just make sure that if you don't love the real product, you use something you do love as a substitute.

THE HERO VS. BRAND X

Okay, I know I need to love The Hero, but what do I do with Brand X? Today's television audience is much more sophisticated than it used to be.

In today's climate there is no need to trash Brand X in order to celebrate the virtues of The Hero.

The best way to handle Brand X is to dismiss it lightly. This works especially well by elevating the status of The Hero (whether you actually love the real product or you're using a substitute).

The following is an example of how a commercial works when Brand X is used to help sell The Hero.

Cream Crisps

TALENT: MOST COOKIES ARE ALIKE.
BUT A CREAM CRISP IS SOMETHING SPECIAL.
LUSCIOUS CHOCOLATE, MIXED WITH DELICIOUS VANILLA ON
THE INSIDE; CRISPY, CRUNCHY WAFER ON THE OUTSIDE.
CREAM CRISPS.
ONE BOX WON'T BE ENOUGH.

Here's how it looks when it's broken down:

Problem: *A friend is having guests over for tea and she wants to serve a tasty, sweet snack.*

Solution: *Cream Crisps.*

Substitution: *Do I (the actor) love Cream Crisps? Or do I need to substitute something else for this? I've never heard of these cookies before so I'm going to substitute Rocky Road ice cream for The Hero.*

Who am I? *A friend. The words* **we, our** *or* **us** *are not used in the copy.*

Who am I talking to? *June, my next door neighbor. Why is she seeking my advice? June knows I entertain all the time, for all sorts of occasions.*

TALENT: MOST COOKIES ARE ALIKE. *(The cookie is Brand X. I don't want to do anything to elevate its status, so I'll treat this as a negative and be slightly dismissive.)*
BUT A CREAM CRISP IS SOMETHING SPECIAL. *(This is The Hero product. I want to be positive. I want to make sure I have a warm-fuzzy-feeling thing happening, so I'll use my substitute, Rocky Road.)*

LUSCIOUS CHOCOLATE, MIXED WITH DELICIOUS VANILLA ON
THE INSIDE; CRISP, CRUNCHY WAFER ON THE OUTSIDE.
(*These are the attributes of The Hero. I want to be
positive so I'll use my substitute again.*)
CREAM CRISPS. (*Again, this is The Hero. I want to
stay positive; I need to love this—I'm thinking
Rocky Road.*)
ONE BOX WON'T BE ENOUGH. (*This too is about The
Hero. Still positive, still needing to love it—I'm
thinking Rocky Road, a double scoop.*)

Because both The Hero product and Brand X are mentioned, the actor has to strike the proper chord for each in the commercial. By creating joy and warmth for The Hero product, and by mildly dismissing Brand X, the story favors The Hero product. The goal is for the commercial to influence consumers so that the next time they're shopping for a cookie-like snack they'll buy Cream Crisps.

EXERCISE

Start breaking down several pieces of copy, identifying the various relationships in each commercial. Once you've identified the different relationships, figure out if they're positive or negative. When you've done that, start playing with the "volume." Is one relationship more positive than another? If so, adjust the volume so that relationship sounds a little better than the others.

Look for lists. If you have a list of three (or more) attributes, practice making those attributes sound different from each other. A good way to do this is to assign a "good," "better" or "best" value to each attribute. In the Cream Crisp spot, the third line—"LUSCIOUS CHOCOLATE, MIXED WITH DELICIOUS VANILLA ON THE INSIDE; CRISPY, CRUNCHY WAFER ON THE OUTSIDE"—"luscious chocolate" is good, "delicious vanilla on the inside" is better, and "crispy, crunchy wafer on the outside" is best. This creates variety, and variety sparks interest.

Also, see if you can find a line in the copy where you have both a negative and a positive relationship, such as in the Royal Bakeries spot—"But even Joey (negative) can't ruin a great cake (positive)." Practice going from one to the other. The key to making these transitions work is to slow down. Going too fast will hinder your ability to give each relationship its full weight and value. And each and every relationship is important.

Line-to-Line Objectives

This is similar to what we discussed in Chapter 10, "Beats, Tactics, and Actions," with one major difference. In that chapter we were talking about discovering the beats in a scene and choosing the different tactics and actions to fulfill the beats. In commercials there is only one beat, one overall sentiment to express—*to pass on information that will solve the other person's problem in the most pleasant manner possible.* That's it.

Because of that the actions required to fulfill that beat in a commercial become much more about word play rather than deeds, physical activity. That doesn't mean you'll be frozen in place, never moving but with commercials it is more about finding the sub-text, the objective, of the words you have to deliver.

As actors, we don't have a lot of choice as to what words our characters will say. However, we have a tremendous amount of choice as to what the sub-text of those words will mean. You can say, "I adore everything you do," and if you say it with great affection it comes across as a loving compliment, the sub-text, the objective, being to flatter the other person, to make him/her feel loved, appreciated. Or you can say those same words with biting sarcasm and it comes across as disapproval, with the sub-text/objective being to hurt, to damage the other person.

Instead of using the term "action," which has a broader context that could include physical activity, we are going to refer to this step as "line-to-line objectives."

Films, as a rule, have less dialogue than plays. The director of a film uses images and pictures to support the dialogue of the story. A commercial

director does the same thing, but a commercial director may have as little as fifteen seconds to deliver his/her message. This is why each line, even partial lines, whether it's a voice-over or actual spoken dialogue, needs to have its own objective. The sub-text of the line has to be crystal clear. The audience doesn't have the luxury of figuring out what a line meant two or three minutes after it's delivered, it has to be clear immediately.

Line-to-line objectives (L2LOs) can help you translate an obtuse line of commercialspeak into a clear, precise message.

The disadvantage of acting in a commercial is that you're trying to swim with one hand tied behind your back. Not only are you limited, for the most part, to a single emotion—joy—but you're also hampered by awkward, coded language.

Check out how using L2LOs helps break down a piece of copy.

Dental Floss

(Talent holds up a piece of dental floss.)
TALENT: THIS CAN SAVE YOU THOUSANDS OF DOLLARS ON YOUR DENTAL BILL.
REALLY . . . THOUSANDS.
DENTAL FLOSS. WHO SAYS YOU DON'T HAVE THE WORLD ON A STRING.

The problem is the expense caused by poor dental hygiene. The solution is dental floss. The dental floss is The Hero. Pick a friend who is (or was) facing huge dental bills because of poor dental hygiene and put him in the camera. He's come to you because he knows you had a similar problem in the past and you fixed it (maybe not you personally but your character).

You have four lines to solve your friend's dilemma. Yes, four. The actor's third speech is really two different lines. In commercials, please pay close attention to the punctuation. The writer knows he won't be around for the audition (or the shoot) so his punctuation is his way of telling you, "This is how I hear it."

A period at the end of a line means *pause, new thought* (on the next line). A comma means *pause, new or continued thought.* An ellipsis (three dots) means *pause, new or continued thought.* Of course, there are exceptions to every rule but the examples stated above apply 95 percent of the time. Learning how to play the punctuation is immensely helpful.

The language in the Dental Floss spot, while not as stilted as in some commercials, is still commercialspeak. Have you ever had a conversation like this with anyone? Unless you're a dental hygienist, probably not.

What you need to do now is create an objective for each line; figure out what you want each line to mean and then come up with a L2LO to help you make each one of those points, the result of which will help solve your friend's problem.

Here's what the copy looks like after doing the L2LO work.

Dental Floss

(Talent holds up a piece of dental floss.)
TALENT: *(L2LO—to enlighten)* SEE THIS. THIS CAN SAVE YOU THOUSANDS OF DOLLARS ON YOUR DENTAL BILL.

(L2LO—to reiterate) REALLY . . . THOUSANDS.

(L2LO—to announce warmly [The Hero]) DENTAL FLOSS.

(L2LO—to joke) WHO SAYS YOU DON'T HAVE THE WORLD ON A STRING.

It doesn't matter how "unnatural" the copy sounds or how strange the phrasing may be, the words—whatever they are, in whatever order they're written—need to roll off your tongue with ease. You can't stumble over the language and expect to get hired.

For your L2LO choices you want to use action verbs that are simple to understand and easy to play. Here's a short list to get you started. There are many, many more.

We don't use commercialspeak in our everyday lives but a big part of your job as a commercial actor is to make the stilted language of commercials sound real.

to announce	to entice	to prod
to boast	to exclaim	to prompt
to brag	to guarantee	to provoke
to caution	to help	to question
to celebrate	to hook	to rebuke
to challenge	to inform	to remember
to connect	to inquire	to reprimand
to convince	to introduce	to save

to discover	to invite	to seduce
to draw in	to joke	to solve
to educate	to laugh	to sympathize
to emphasize	to mock	to tease
to energize	to praise	to tempt
to enlighten	to proclaim	to warn

Some of these objectives have what could be considered negative connotations. We use these objectives because they best describe the point we're trying to make. If the L2LO you pick appears to have a negative undertone, you need to give it a positive spin. For example, "to warn" becomes "to warn lovingly," or "to challenge" becomes "to challenge affectionately." This expands, rather than restricts, your vocabulary as you search for the exact right L2LO.

Some actors find this process difficult. They say, "I can't do two things at the same time. I can't be thinking one thing while I'm saying something else." And I say, "*Are you kidding?*" We do this all the time. How often have you manipulated the meaning behind your words in order to get what you wanted? This is no different. It's just that now you have to manipulate someone else's words in order to win the job.

EXERCISE

Using a piece of copy, go through the steps one at a time—figure out what the problem is, whom from your real life you're talking to, identify the various relationships—and then assign each line a L2LO. Don't forget, partial lines need to have their own separate objectives.

When you've finished, rehearse the copy, keeping in mind the sub-text for each of the scripted lines. That's what L2LOs provide: the subtext for each line. And SLOW DOWN so you can layer in that subtext.

The Moment Before and the Tag

In a commercial, as in a film or an episode on TV, or in a play, your character needs to be coming from someplace. His/her life can't begin with his entrance or his/her first line of dialogue. If you don't find some way of engaging in the storytelling before the story begins, you'll always be at least a beat behind and you'll never catch up.

The good news is you don't need to do the elaborate work for a commercial that you would do in preparing for a film, but you do need to do something. So, what do you do?

The best way to make sure you're engaged is to come up with a question your first line of dialogue answers. Then have the person you put in the camera, the one with the problem, ask you that question.

This is like the game show *Jeopardy*. You know the answer; the answer is your first line of scripted dialogue. What you have to do is come up with a question that the first line of dialogue answers. If your first line is, "Snappy Cereal Sugar Pops are my kids' favorite," then the question your friend asks could be, "What do your kids like to eat for breakfast?"

Think of this as priming a pump. Answering your friend's question not only prompts your first line but also provides you with a spark of life to make sure you are fully engaged.

> *A question begs a response; a statement doesn't.*

What if my first line is a question?

Simply have the person you put in the camera ask you the same question. Example: if your first scripted line is "What's it like driving a hybrid?" then the question in the moment before is the same question. It goes like this: Your friend asks you "What's it like driving a hybrid?" and you respond with your first line—"What's it like driving a hybrid?"—your response then becomes a rhetorical question.

Please understand, when the casting director calls, "Action," it is not your cue to talk. It is your cue to hear the question your friend in the camera asks you. This slight delay after "Action" helps create the reality of being in the moment. Creating that reality, hearing that question, could be the difference between booking the job or filing for unemployment. Again, it's not brain surgery but it's important.

As each commercial needs a beginning, the Moment Before, it also needs an ending, a "tag." Often the tag (aka "the button") is written into the copy, either in the dialogue or by an action indicated in the script. But if it isn't, the actor needs to create it.

All too often, actors rely on the person running the camera to finish their auditions for them. Don't. They're busy making notes, eating lunch, or any of a thousand other things.

If a tag isn't written into the copy then your job is to come up with one. How do you do that? The last thing you want to do is to make up any additional dialogue. By the time you audition for a commercial, the script has been in the works for about a year. It has gone through the ad agency's legal department to make sure there aren't any copyright infringements. The agency has the copy the way they want it, so don't try to improve it by adding dialogue.

The way to tag a spot is to look for the next, most logical *action* to take and then take it. Example: if the commercial is about the virtues of So-and-So's Luncheon Meat, and you're holding a sandwich (real or imagined) made with The Hero luncheon meat, when you finish the copy, take a bite of the sandwich. That bite will be your tag, your way of saying the story is over.

If the product is *Time* magazine and you're holding a copy of the magazine in your hand, when you've finished the scripted dialogue open the magazine and start reading. If you tag the spot properly—and sometimes it will be as simple as nodding your head—the people who make the casting decisions will see that you know the story is over. Not only did you come up with a beginning but you also created an ending. You book-ended the story. This will put you light years ahead of most of the other actors auditioning for the same spot.

EXERCISE

Take a few pieces of copy and start creating questions that the first line of scripted dialogue answers. Keep the questions short and simple.

For Royal Bakeries, your first line is:

IT WAS MY BIRTHDAY PARTY AND MY AUNT JEAN MADE HER FAMOUS ROYAL BAKERIES CHOCOLATE CAKE.

The question in the moment before could be "When was the last time you had really good cake?" See what I mean about brain surgery?

Read over the copy you've been working on. When you find a piece of copy with an ambiguous ending, figure out the next, most logical step to take and take it. This should be an action; don't add words. You can add sounds—a hum of delight, a moan of pleasure—but no words.

Don't use mirrors to monitor your work. With mirrors we see ourselves in the immediate. By using a camera, in playback, we see ourselves after the fact and can analyze what we've done. Another reason using a mirror isn't a good idea is that most of us (me included) are too concerned with what we look like to really focus on the work. By using a camera you can see what you are and what you aren't doing; Both are important.

Don't forget, when the casting director calls, "Action," it is not your cue to talk; it is your cue to hear the question in the moment before.

Banter

Once you've figured out what the problem is, who you are, who to put in the camera, what your L2LOs are, what the relationships are, what the Moment Before is, you need to work on the banter.

Commercial scripts, like film scripts, only give you about 30 percent of the information you need to tell the story. The rest is up to you, and the banter is a huge part of it.

The banter is a word or short phrase that the person you've put in the camera says to you before each of your scripted lines. It, like the Moment Before, is something you make up. Here's a piece of commercial copy without any prep work.

Cupid Perfume

TALENT: IF YOU WANT HIM TO TREAT YOU SPECIAL, WEAR SOMETHING SPECIAL.
CUPID PERFUME, THE FRAGRANCE
IN A CLASS ALL BY ITSELF.
YOU'LL LOVE IT AND HE'LL LOVE
YOU FOR IT.

Here's the same piece of copy prepped by an actor to include the banter.

The moment before is the first line of banter; notice how it and the rest of the banter turn the script from a monologue into a dialogue.

Problem: A woman trying to get her boyfriend to pay attention to her.

Person: My friend Mary who thinks her boyfriend takes her for granted.

Solution: Cupid Perfume—The Hero. Mary came to me because she knows I had trouble getting my boyfriend to pay attention to me.

Moment Before: [Mary's banter: What can I do to get Bob to treat me special?]

TALENT: *(L2LO—to suggest)* IF YOU WANT HIM TO TREAT YOU SPECIAL, WEAR SOMETHING SPECIAL.

[Mary's banter: Like what?]
(L2LO—to boast) CUPID PERFUME, THE FRAGRANCE IN A CLASS ALL BY ITSELF.

[Mary's banter: Will it work?]
(L2LO—to guarantee) YOU'LL LOVE IT AND HE'LL LOVE YOU FOR IT.

The banter helps you engage in the storytelling; it forces you to slow down so you can shift from one L2LO to the next and, most important, it sets up each line of scripted dialogue.

Now, instead of just having some random, nonsensical lines, you have a scene. It is written in commercialspeak, but it is a scene. Of course, when you're auditioning, only the real dialogue will be spoken out loud, but the banter, the dialogue you made up, will have a significant impact on your work.

EXERCISE

Take a piece of copy and create a question for the Moment Before. Then add the banter, a word or short phrase your friend says to you before each scripted line. Do yourself a favor: keep the banter short.

Each line of banter should set up the next line of scripted dialogue. Look at Mary's second line of banter in the above example— "LIKE WHAT?" That is a perfect setup for "CUPID PERFUME, THE FRAGRANCE IN A CLASS ALL BY ITSELF."

Environment

Many audition studios are converted office spaces with few amenities. You'll need to transcend these limitations to turn the studio into whatever you need it to be. Sometimes the casting directors will have some furniture or a few set pieces, but ultimately it will be up to you to make the place your family patio, or McDonald's, or a service station.

Sometimes the copy will tell you where you are: "Here at Jack's Chili Shack . . ." Sometimes it won't. If it doesn't, don't be afraid to ask. It's okay to ask questions at your audition. Remember, you aren't there just to rush through the copy so they can get to the next person. You're there to get the job.

The environment is always at eye level. Don't look up and don't look down (for too long) and don't get locked into profile. The people watching playback need to see both your eyes. Keep the environment in front of you, about 120 degrees from left to right.

Good actors, using their imagination, can easily turn a chair into a car, a card table into a fancy restaurant, a blank wall into a house. And so can you. I booked a national commercial because I was able to transform a tiny, dark wood-paneled casting studio into the Grand Canyon. I saw the Grand Canyon in my mind's eye and my eyes conveyed the message.

One aspect of creating the environment is miming. Sometimes at your audition they'll have the actual product. Sometimes they won't. If they don't, you may be asked to mime. Actors who are versed in mime have a distinct advantage over actors who aren't.

But you don't have to be Marcel Marceau to do the kind of miming I'm talking about. Simply practice handling objects: a glass of water, a newspaper, a cup of coffee, a steering wheel. Once you get a sense of how various objects feel in your hand, how big they are, how heavy they are, put them down and then mime holding them.

Same with eating. You may be called upon to take a bite of an air sandwich or to sip from an imaginary cup. This is only hard if you haven't practiced it.

The thing that makes miming seem real is honesty.

If you take a bite of an air sandwich, not only do you have to chew but you have to swallow as well. If you don't, and you say your next line, something clicks in the viewer's mind and they label you as being dishonest. Once that happens, the rest of your audition is tainted. If you take an imaginary drink of water then you have to swallow before you speak. Try taking a real drink of water and see what happens if you don't swallow before you talk. Yeah, you end up with water all over yourself, which is the equivalent of having egg on your face for not being honest with your miming.

Another part of creating the environment depends on how adept you are at using your body to communicate. Because we have so little time to tell our stories we have to make sure we aren't sending mixed signals. In order to accomplish this make sure your eyes and your hands are working together. If you point at something, make sure you look at it; and if you look at it, make sure you see it; and when you see it, make sure you have a relationship with it.

You don't have to look at whatever you're pointing to for long but you do have to look.

And you do have to see it. If you don't, you'll split the viewer's focus: "Should I look at what he's pointing to or should I look at him?" The goal is to enhance your work, not detract from it.

This is not advanced physics, just good acting. Even if you have to place something behind you, look at it quickly. Quickly doesn't mean you don't see it; it means you see it, you form a quick relationship with it, and then you return to the relationship you have with the person in the camera. "Behind me, at Happy Joe's Discount Store . . ." Your thumb points over your shoulder as your head turns to look in the direction your thumb is pointing. You see Happy Joe's Discount Store behind you and you come right back to the camera. You've gone from talking to your

friend in the camera to having a quick relationship with Happy Joe's and then back to talking to your friend in the camera, all in less than two seconds. And, as odd as it may sound, we can tell from the back of your head whether or not you saw the thing you were talking about.

If the words *these*, *those*, *this*, *that*, *here*, and/or *there* appear in the copy, you need to acknowledge the space or object those words represent. Your body language needs to support the copy.

Don't forget, you need to know how you feel about what you're talking about and/or looking at. The people watching the playback will pick up on whatever it is you're feeling. If you're not thinking, not feeling anything, they'll know it. This is another reason why substitutions are so crucial.

Here is a piece of single copy to illustrate this.

Omega Batteries

(Long shot. Dead of winter. Desolate stretch of
highway. THE WIND HOWLS; the snow blows.)
(A stalled car is parked on the shoulder of the
road. A tow truck is parked facing the car. The hood
of the car is open and battery cables extend from
the tow truck into the open hood of the car.)
(The tow truck driver—a big man in his late
thirties, early forties—attaches the battery cables
to the car's battery.)
(The tow truck driver turns to the camera.)
DRIVER: I GOT STRANDED ONCE. IT WAS WINTER; I LEFT
MY LIGHTS ON. IN THIS WEATHER, IF YOU HAVEN'T GOT AN
OMEGA BATTERY, YOU HAVEN'T GOT A CHANCE. THIS WAS
ME, I'D MAKE SURE I HAD AN OMEGA.
(The driver taps on the windshield of the car. The
car's engine turns over and roars to life.)

Here's the same piece of copy after an actor in my class did the prep work.

Problem: People left stranded by a faulty car battery.

Solution: Omega batteries.

Friend: Jack Johnson. He got stranded at his kid's soccer game last week for this very reason; he left his lights on. Not exactly life or death but he did have four kids that needed to go to four different places afterward.

185

Substitution: Car batteries don't really mean much to me; they start my car, I drive. And one brand is pretty much the same as another. So, I need to use a substitution. I'm a carpenter by trade so I'll use my new power saw. The fact I got it on sale makes me love it all the more.

Moment Before:

[Jack's banter: YOU EVER BEEN STRANDED?]
DRIVER: *(L2LO—to sympathize)* I GOT STRANDED ONCE.
(Negative relationship to being stranded.)

[Jack's banter: WHAT HAPPENED?]
DRIVER: *(L2LO—to recall)* IT WAS WINTER; I LEFT MY LIGHTS ON.
(Also negative relationship to the winter and leaving my lights on.)

[Jack's banter: BAD, HUH?]
DRIVER: *(L2LO—to warn with genuine concern)* IN THIS WEATHER, IF YOU HAVEN'T GOT AN OMEGA BATTERY, YOU HAVEN'T GOT A CHANCE.
 (Physical gesture on "In this weather . . ."—point back over my shoulder to indicate the snowstorm. Negative relationship on the weather. Product is mentioned here too; need to use my substitution and switch to a positive relationship.)

[Jack's banter: WHAT SHOULD I DO?]
DRIVER: *(L2LO—to proclaim)* THIS WAS ME, I'D MAKE SURE I HAD AN OMEGA.
 (Physical gesture on "This was me . . ."—nod my head toward the driver behind the car's windshield. Come back to camera for the rest of the line. Product mentioned, use substitution and keep it positive.)
(The driver taps the windshield of the car. The car's engine turns over and then roars to life.)
 (Tag: After the car starts I give a "thumbs-up" to the camera. Again positive relationship—product solves the problem. If the camera is still running I'll mime detaching and rolling up the cables).

With this piece of copy, the actor is talking directly to the camera. That means the person he is talking to would be out in the storm with him.

This doesn't necessarily make any sense, but the audience's ability to suspend their disbelief rests with the actor.

It is the actor's job to make the unreal real, and the better we are at doing it, the less the audience will question the plausibility of an implausible situation.

Think *Star Trek* and you'll realize what I'm talking about. The same thing applies to commercials. Our job isn't to question the circumstances; our job is to make those circumstances work.

EXERCISE

Read over several pieces of copy and see if you can tell what the environment is. Look for things you can do to "establish" that environment. Remember, keep the environment at eye level and make sure the camera "sees" both of your eyes most of the time.

Make sure you're not sending mixed signals. Look for the words these, those, this, that, here, and there, and look for ways to physically reference the things those words are referring to. If the words are "this boy" or "that repair shop," you need to look at them, see them, reference them and have a relationship with them. If you don't, you're likely to confuse the people watching the playback.

Pick up a basketball, a slice of pizza, a telephone, and get a sense of how each one feels. Then mime the activity. Pick up a real coffee cup and take a real sip. Then pick up an imaginary cup and take an imaginary sip. Don't forget to blow on it if it's hot. And after you take a sip, swallow.

Pick several non-related things: a box of tissue, your Uncle Bill, a box of Wheat Chex, your favorite team winning the World Series. Figure out what feeling you want to convey for each person, object, or situation and then communicate those feelings for each one. Maybe the tissue is Brand X.

Because the camera can see what you're feeling, what you're thinking is extremely important. So make sure you engage in an active thought process that produces the feeling you want to convey. When you do, the camera will pick up on that feeling and broadcast it. You don't have to worry about projecting the feeling; the camera will do it for you. Your job is to generate the feeling; so, please, no overacting!

Embracing the Cliché

If you do what I'm about to tell you in a scene study class, most teachers would shoot you. I would. But in commercials this next step can make or break your audition. Because you have only fifteen or thirty or, at most, sixty seconds to tell a story, you have to use every possible means to tell that story as completely as you can.

So, what are clichés? They're a series of internationally recognized, silent gestures that we use all the time to make a point. Want to let someone know the food you're tasting is great without using words? What do you do? Rub your stomach and smile. Want to gesture something is okay? Put your forefinger and thumb together to form a circle and hold it up. Or give a thumbs-up.

Add dialogue to these gestures and the meaning becomes even clearer. Tap your finger lightly to your head and pull it away while saying the line, "I've got this great idea," and that gesture, the international sign language for a light going off in your brain, reinforces the words and bolsters the story. We use dozens of these gestures to convey or reinforce a meaning.

Look for clichés and embrace them; don't run from them. I learned this from Kate Carr, a casting director at Young & Rubicam in New York. Kate, I don't know where you are now, but thank you for everything you taught me.

Because commercials are truncated stories, we need to make sure we're doing everything we can to enhance the storytelling.

About 50 percent of the time the cliché could also be your tag. Warning: only one cliché per spot. Don't, in one spot, rub your stomach, lick your lips, smile, and then give a thumbs-up for good food. One cliché is enough.

EXERCISE

Look at the copy we've used so far and see if there are any clichés.

Examples: For Dental Floss, the talent could, after the spot is over, give the person he/she is talking to a thumbs-up. For Royal Bakeries, the talent could, after taking a bite of the cake, rub his/her stomach. Or he/she could simply smile and nod.

Not every spot will have a cliché.

All clichés will seem corny, but ask yourself if adding a cliché helps tell the story. If it does, use it.

Double Copy

When doing single copy you'll almost always speak directly to the camera. With double or multiple-person copy, sometimes you'll speak directly to the camera and sometimes you won't.

If there are two or more characters involved in the commercial you need to determine if the story requires an "in-the-camera" character. If it does, the "in-the-camera" character will be part of the storytelling and should be included, looked at, and spoken to. Usually the "in-the-camera" character will be the person who has the problem. Again, whichever of the other characters you are, pick a real person from your life, a person who has a similar problem to that described in the copy, and put him/her in the camera.

If, however, the camera is merely an observer of the action and there is not an "in-the-camera" character then neither you nor any of the other *on-camera* characters should ever directly address the camera. In this case, one of the on-camera characters will have the problem (it could be you) and the problem will be addressed and solved in an indirect manner during the interaction between you and the other character(s).

It is actually pretty easy to tell if there is an "in-the-camera" character or not. Ask yourself, "For the story to be successful do I need to directly relate to another character or not?" If you do then put that character in the camera.

If, on the other hand, the camera is merely going to record the action between you and the other on-camera characters then you don't need to create an "in-the-camera" character. Either way, someone's problem is going to be solved, directly or indirectly.

Be careful not to get locked into profile when doing double or multiple-person copy. Actors will often turn to look at each other and then stay in that position. If you do that, the camera can only see one of your eyes. Your eyes are the avenues to your soul and if the people watching the playback can only see one eye, the information you're trying to share is compromised.

At an actual shoot, if the director wants a shot of you over the other actor's shoulder, he/she has the luxury of doing so. This is not possible at an audition. The casting director isn't going to move the camera around, so you need to find as many ways as you can to stay open so the camera can see both of your eyes.

Here are two pieces of double copy: first without, and then with, the prep work.

Trends

(Talent: Two women standing in front of the Channel Twelve news logo. Character A: Twenty-five to thirty years old; Character B: Early forties.)

A: IF YOU WANT TO STAY IN TOUCH WITH WHAT'S HAPPENING . . .

B: BUT DON'T HAVE TIME FOR AN HOUR LONG SHOW . . .

A: TUNE INTO TRENDS.

B: IT'S A NEW FIFTEEN-MINUTE SEGMENT ON CHANNEL TWELVE NEWS AT FIVE.

A: WE'LL GIVE YOU A PEEK AT THE LATEST FASHIONS.

B: SHOW YOU THE BEST WAY TO LOOK FOR A JOB.

A: EXPLAIN THE NEWEST FADS IN DIETING.

B: HELP YOU PICK THE RIGHT WINE . . .

A: AND LET YOU KNOW WHAT'S HOT . . .

B: AND WHAT'S NOT IN THE LOCAL RESTAURANT SCENE.

A: THERE'S SOMETHING FOR YOU EVERY DAY ON TRENDS.

B: STARTING MONDAY ON THE CHANNEL TWELVE NEWS AT FIVE.

This piece of copy needs an "in-the-camera" character. It's unlikely the two actors would use the same person and it doesn't matter. What does matter is that each actor picks a person, someone they know who needs this information, and puts that person in the camera.

This is how the actor in my class reading for Character A in my class broke down the copy.

Problem: People who don't have a lot of time but want to stay up-to-date on the latest events.

Solution: A fifteen-minute TV news show—Trends—that will keep those people in the loop.

Friend: Alice Long. She's a single mom and a lawyer. She's always jammed up, always looking for the condensed version of anything.

Substitution: The product is local news. I don't really love local news but I do love to watch Oprah so I'll use her show.

Moment Before and Banter: Except for the question to get us started, which comes from the person I place in the camera (because I have the first line), all the rest of the banter is built in; Character B supplies me with all my setups and I set up all of her lines.

Moment Before: [Alice's banter: HOW CAN I STAY IN TOUCH WITH WHAT'S HAPPENING IN TOWN?]

A: *(L2LO—to inform)* IF YOU WANT TO STAY IN TOUCH WITH WHAT'S HAPPENING . . .
B: BUT DON'T HAVE TIME FOR AN HOUR LONG SHOW . . .
A: *(L2LO—to invite)* TUNE IN TO TRENDS.
B: IT'S A NEW FIFTEEN-MINUTE SEGMENT ON CHANNEL TWELVE NEWS AT FIVE.
A: *(L2LO—to entice)* WE'LL GIVE YOU A PEEK AT THE LATEST FASHIONS.
B: SHOW YOU THE BEST WAY TO LOOK FOR A JOB.
A: *(L2LO—to draw in)* EXPLAIN THE NEWEST FADS IN DIETING.
B: HELP YOU PICK THE RIGHT WINE . . .
A: *(L2LO—to tempt)* AND LET YOU KNOW WHAT'S HOT . . .
B: AND WHAT'S NOT IN THE LOCAL RESTAURANT SCENE.
A: *(L2LO—to guarantee)* THERE'S SOMETHING FOR YOU EVERY DAY ON TRENDS.
B: STARTING MONDAY ON THE CHANNEL TWELVE NEWS AT FIVE.

*(**Tag:** It sounds corny but because my partner has the last line, I know I'm going to be looking at her as she says that last line, so when she's done, I am going to turn back to the camera and nod. This will tag the spot for me, affirming that what my partner*

*said is true and letting Alice know this is exactly
the information she wanted in the first place.*

*Because this is a piece of double copy, I need to
stay open and say most of my lines to the camera,
to Alice. However, I also need stay in relationship
with Character B and I do that by looking to her when
she is saying her lines. This way, this two-person
dialogue becomes a three-way conversation, and even
though Alice has only one line—the imaginary question
that starts us off—both Character B and I will direct
our conversation toward her, in an attempt to solve
her problem.)*

There are three important things to note about this piece of copy. First, both Characters A and B are more than friends trying to solve another friend's problem; they also work for the company/product being advertised. The words *we*, *our*, and *us* are clues that will help you determine whether you're a friend or a spokesperson. Remember, you could be both and, in this case, Characters A and B are.

Being a spokesperson will elevate your status and infuse you with a sense of pride, and this, will in turn, affect how you deliver your lines. Because you work for the company, the way you address the problem is different than if you were merely a friend trying to solve another friend's problem.

The second thing to note here is that Character A has many similar line-to-line objectives—"to entice," "to draw in," "to tempt"; similar, but not exactly the same. The reason you want to use different L2LOs and not repeat the same one over and over, even though you're essentially expressing the same sentiment, is that you want to create variety.

Variety is crucial in commercial copy because you're basically limited to one emotion—joy.

Though seemingly similar, "to entice" is different than "to draw in," which is different than "to tempt." However, each lends a distinct flavor to its respective line and helps achieve variety.

The third thing to note in this commercial is how Character A says she stays in relationship with Character B. She speaks directly to the camera on her lines but when Character B is speaking, Character A turns to look at her. Character B does the same thing: says her lines to the camera and then turns to look at Character A when A speaks. This is how they keep the relationship between them alive.

When doing this don't snap your head around to "listen" as soon as you finish your line. Say your line to the camera and then allow the sound of the other actor's voice to get your attention, and then turn to see what they have to say. When they finish their line, turn your attention back to the "in-the-camera" character and say your next line (which is pretty much what we do in real life when two people are talking to a third person). This prevents you from getting locked into profile and keeps you open to the camera for most of your audition.

Another way to enhance the relationship between the characters is to have the actors, when "Action" is called, turn and acknowledge each other before either one of them speaks. This creates a positive bond between them before either one has said a word. Once they've acknowledged each other, the actor who has the first line turns to the camera and speaks.

Here's the second two-person commercial. This one does not involve an "in-the-camera" character.

Grandview National Bank

(A man in his early sixties. A woman in her mid-thirties.)
(Both stand looking at a beautiful parcel of property. The property is covered with trees and has a creek running through it.)
FATHER: ARE YOU SURE THIS IS A GOOD THING?
DAUGHTER: WHAT, DAD?
FATHER: YOU AND TIM, BUILDING YOUR OWN HOUSE?
DAUGHTER: IT'S WHERE WE WANT TO BE.
FATHER: IT'S BEAUTIFUL HERE, DON'T GET ME WRONG. IT'S JUST . . .
DAUGHTER: WHAT?
FATHER: WELL, THE EXPENSE.
DAUGHTER: DON'T WORRY, SAM TOOK CARE OF THAT.
FATHER: WHO'S SAM?
DAUGHTER: OUR BANKER AT GRANDVIEW NATIONAL BANK. HE GOT TOGETHER WITH THE ARCHITECT AND THE BUILDER AND WORKED OUT THE ESTIMATE FOR THE LOAN. IT'S LESS THAN WE'RE PAYING NOW FOR OUR OLD HOUSE.
FATHER: REALLY?
DAUGHTER: REALLY. WANT TO SEE WHERE YOUR ROOM IS GOING TO BE?

(The father smiles, hugs his daughter. They walk toward the trees. As they walk, the daughter gestures, showing the father where the house is going to be built.)

Because there is no third person involved in this commercial, the actors never directly address the camera. The problem and the solution are written into the story and the viewer/consumer receives the information about the product in an inferred manner.

The actor playing the father broke the script down this way.

Problem: *A person, anybody, getting in over his/her head financially.*

Solution: ***Grandview National Bank***—*they will make sure that doesn't happen.*

Friend: *With this piece of copy there is no third person to put into the camera. At the audition I was paired up with a young woman I had never met before so I felt I needed to use a substitution for her. I have a young friend, Lena, who just graduated from medical school and her loans are staggering. I have genuine feelings for her and know these loans are troublesome for her.*

Substitution: *I never heard of Grandview National Bank before. For the product I'm going to use my bank as a substitution because they have treated me very well over the years. For Sam I will use Donna, the VP at our branch who has handled several out-of-the-ordinary transactions for me. For Tim I will use a young man I was in a show with last month, Jason. He's the first person who came to mind so I'll use him. Nice guy, good actor, pleasant to work with.*

Moment Before and Banter: *I had the first line so I needed to come up with a question to get us started. We had a chance to rehearse in the lobby and during rehearsal I asked the woman playing the daughter to ask me, "What do you think, Dad?" She said okay and that became our Moment Before. When we went in to the audition and the casting director called "Action," the woman playing my daughter didn't say anything but in my mind I heard her say, "What do you think, Dad?" and I responded with my first line of dialogue.*

(A man in his early sixties. A woman in her mid-thirties.)

(Both stand looking at a beautiful parcel of property. The property is covered with trees and has a creek running through it.)

Moment Before: *[Daughter's banter: WHAT DO YOU THINK, DAD?]*

FATHER: *(L2LO—to probe gently)* ARE YOU SURE THIS IS A GOOD THING?

(The word "this" is used here. I used it to break up the sentence, to set the right pace, to make sure we didn't start too fast. I pointed to a spot off camera as I said it.)

DAUGHTER: WHAT, DAD?

FATHER: *(L2LO—to clarify)* YOU AND TIM, BUILDING YOUR OWN HOUSE?

*(**Substitution**—Lena for the actress playing my daughter and Jason for Tim.)*

DAUGHTER: IT'S WHERE WE WANT TO BE.

FATHER: *(L2LO—to back off slightly)* IT'S BEAUTIFUL HERE, DON'T GET ME WRONG. *(L2LO—to prod, tentatively)* IT'S JUST . . .

(I wanted to play this as if she was getting a little frustrated with me—not angry, just a father/daughter thing—and I wanted to backtrack a little and come at the problem from a different direction. I didn't gesture toward the property on "here." I felt I had already used that gesture and didn't want to repeat it.)

DAUGHTER: WHAT?

FATHER: *(L2LO—to stop beating around the bush)* WELL, THE EXPENSE.

*(This is the **problem**. I'm afraid my daughter is getting in over her head, biting off more than she and her husband can chew. I used Lena and her loans to generate the feeling I wanted to convey.)*

DAUGHTER: DON'T WORRY, SAM TOOK CARE OF THAT.

FATHER: *(L2LO—to inquire)* WHO'S SAM?

(I'm not sure who she is talking about and I'm concerned. Not angry, just curious.)

DAUGHTER: OUR BANKER AT GRANDVIEW NATIONAL BANK. HE GOT TOGETHER WITH THE ARCHITECT AND THE BUILDER AND WORKED OUT THE ESTIMATE FOR THE LOAN. IT'S LESS THAN WE'RE PAYING NOW FOR OUR OLD HOUSE.

FATHER: *(L2LO—to admire her thoroughness)* REALLY? *(After her explanation I've gone from being concerned to being relieved/happy. To help me make this transition I used my bank and the things they had done for me [house loan, car loan, etc.] for the Grandview bank and used the VP Donna who works at my bank for Sam.)*

DAUGHTER: REALLY. WANT TO SEE WHERE YOUR ROOM IS GOING TO BE? *(The father smiles, hugs his daughter. they walk toward the trees. As they walk, the daughter gestures, showing the father where the house is going to be built.)*

*(**Tag:** I don't have any more lines but after the actress pointed out where the house was going to be, I used both hands to draw out a very large room for myself. We laughed and walked toward the camera and out of frame.)*

Commercials without an "in-the-camera" character are more like a legit acting job than other commercials.

In this spot the actors work together and never have to concern themselves with the camera, other than to stay open. They accomplish this by focusing on the site where the house is to be built and stay in relationship by checking in with each other. When the daughter speaks, she is looking in the direction of the house, and thus out toward the camera, and the father is looking at her. When the father speaks, the daughter is looking at him and he is looking in the direction of where the house is going to be built. This way each actor is open on his/her lines.

Again, they don't snap their heads around when it's their turn to talk or to listen. They simply let the other person's words get their attention and turn to see what that person is saying.

However, as the actor playing the father noted, they do have to concern themselves with some other realities of commercial acting. They have to keep the situation within the realm of joy—although the father may sense the daughter is getting frustrated with him, she never gets angry. They also have to let the audience know that The Hero product—the bank—solves the father's anxiety that his daughter and her husband are taking on too much debt. The actor playing the father pointed this out in his notes. He said, after his daughter's explanation of how the banker and the bank were

handling everything, his feelings changed. He went from being concerned to being happy.

When you first start auditioning for commercials it can feel as if you're wearing a straitjacket: you have to learn to help someone else get what he/she wants instead of getting what you want; you have to limit yourself to one emotion; when working with another actor you have to learn to stay open instead of staring meaningfully into another actor's eyes—all of which can feel very restrictive. However, once you learn a few simple rules, you'll be able to spread your arms, and the straitjacket becomes a life preserver that holds you up as you learn how to traverse these very different waters.

EXERCISE

Find a few pieces of double or multiple-person copy and ask yourself, "Does this copy need an 'in-the-camera' character or not?" If it does, put someone in the camera and include that person in the commercial. If it doesn't, don't.

Remember, someone in the commercial has a problem—it could be you.

Work with a partner and practice looking into the camera to say your lines. Then, when you hear your partner's voice, turn to him (or her) and stay with him/her until his lines are over. Then turn back to the camera to say your next line. Continue doing this for the rest of the commercial.

If you can't find enough double copy (with an "in-the-camera" character), you can use a sequence of numbers or the alphabet. Your line would be, "One, two, three" (or "A, B, C"); your partner's would be, "Four, five, six" (or "D, E, F"), and so on. The important thing is to get used to turning out to the camera to say your lines and then turning to look at your partner as he/she speaks You could also alternate naming all the cars you know, or animals, or fruits, or vegetables.

The Dreaded Interview

What if there isn't any copy? Sometimes commercials are made up of short vignettes that don't have dialogue. Or you'll have only one brief line. If that is the case, you still need to audition. But the audition is going to be different: you're going to be asked an interview question.

Casting directors don't do this to torture you. Most actors won't agree with this, but it's true. Casting directors do it because they know their clients need to learn something about you. The way you slate will give them some information but not enough. The ad agency is going to make a substantial investment in you—millions and millions of dollars—and they're entitled to know what they're getting.

Hence the dreaded interview. The questions are fairly inane: "Tell us something about yourself." "What are you doing this weekend?" "What's your favorite color?"

How will you know if they're going to ask you an interview question? If you go to an audition and there isn't any copy or if there's only one short line of dialogue, they're going to ask you a question. Then you'll have fifteen to twenty seconds to answer it. Five seconds isn't long enough and sixty seconds is way too long. You have twenty seconds max to make them fall in love with you.

But while the questions themselves may not seem important, the way you answer them is.

Here are some guidelines to facilitate that:

- Answering an interview question is a chance to show off your personality. Make sure yours shines.
- Your answers should be short, interesting, and (ideally) humorous.
- *What* you say isn't nearly as important as *how* you say it.
- Don't mention anything about acting unless specifically asked. In the thousands of commercial auditions I've been on, I've been asked about my acting career twice. (You'd think they would be more interested in our fabulous professional lives and the wonderful roles we've played but they aren't.)
- This is the time to put your best friend in the camera. That way, regardless of how many times you've told your story before, your best friend will still be happy to hear it.
- Make sure you enjoy telling your story. If you don't enjoy it, why should they?
- Make the story specific; stick to one subject. You don't have enough time to introduce five or six thoughts and tie them together.
- Don't appear desperate. Don't talk about the job at hand unless specifically asked. (I actually said this at a Ford Explorer audition: "If you hire me for this spot, I'll go out and buy a Ford." Needless to say, I didn't book the job.)
- Your stories don't have to be true. Invention—a much kinder word than *lying*—is the thing that keeps most of us from being boring. However, if you're going to infuse your story with "invention," make sure it has at least a grain of truth in it.
- Don't lie about your skills. If you're asked about a specific skill, don't tell them you're an expert if you aren't. However, you don't want to slam the door closed either. Let them know that whatever it is they're looking for, you're willing to learn. "I don't rumba but I've always wanted to learn." It's important to keep the door of possibility open. (Years ago I auditioned for a PGA spot. As I was leaving—my hand was literally on the doorknob—the director asked, "Do you play golf?" I turned and without hesitation said, "I don't. But I look like I do." He not only hired me, he also changed his shot list so I never actually had to swing a club.) Keep the door of possibility open.
- If you get a question you aren't expecting, repeat it to give yourself time to come up with an answer. This is a lot better than standing there looking all "duhhhh."

- Remember the real question, no matter what they ask you, the real question is, "We're about to invest two to ten million dollars in this project. Are you the right person for the job?" The way you answer that question lets them know if you are.

EXERCISE

Create a list of questions—"How's your day going?" "Any plans for tonight?" "Seen any good movies lately?"—and answer them. Keep your answers short, your enthusiasm high, and enjoy telling your stories.

A Few Last Things

MAKE SURE YOU STAY POSITIVE

Your audition starts before you walk into the casting director's office and ends after you get back on the street. If the casting director asks how you are, you're great. It doesn't matter if your husband just ran away with his secretary or your cat just died; you're great. You can cry about your divorce later. You can mourn your cat another day. You have three to five minutes to get them to like you enough to call you back. Don't blow it by indulging in the melodrama of your life.

MAKE SURE YOU STAY IN RELATIONSHIP

Make sure you have done as much of the homework as you can before you get in front of the camera. Once you're in front of the camera, your major task is to stay in relationship—with the person you're slating to, with the person you've put in the camera to deliver the dialogue to, with your audition partner(s), with the product, and with whatever events and situations are mentioned in the copy.

Never forget, the camera knows what you're thinking, so the more engaged you are in your relationships the better the storytelling will be.

MAKE SURE YOUR BODY GOES TO THE AUDITION WITH YOU

Learning the mechanics of a new technique can be a very cerebral experience. This technique is no exception. Actors, when learning new concepts, get stuck in their heads trying to remember everything that's coming at them and their bodies get left behind.

There are three things you can do to make sure your body shows up at the audition along with your mind. This is true whether you are auditioning at a casting director's office or you are self-taping.

The first is to jump up and down.

Really? Jump up and down?

An interesting thing happens when our feet leave the ground: the masks that we hide behind come off. You want those masks off; you want to make sure the real you is the one that shows up.

Next is to laugh. If you're laughing, you're breathing. There is nothing more frightening than to watch an actor who isn't breathing. The people watching your playback become concerned in all the ways you don't want them to be concerned if you aren't breathing. So, don't be afraid to laugh. By laughing it doesn't mean that something is funny; it is merely a way to engage your body, a way to ensure that you are present. However, if you do laugh and it produces a smile, that's not such a bad thing. We are talking about commercials.

I suggest you do one or the other or both of these first two things—jumping and laughing—before you slate. If you don't get the chance to do either before the camera is turned on then laugh and/or jump anyway. Don't be concerned that the people watching the playback of your audition will think you're weird because you're jumping and laughing. Better they think that and then see you have a great audition than for them to think you're dead inside and not connected to your body.

Actors (and athletes) do this all the time. Before the cameras roll or when they're standing backstage waiting to make their entrance, they're moving their bodies, swinging their arms, jumping up and down.

Why?

Because they want to get the energy flowing, they want to be 100 percent engaged!

The third way to make sure you're connected to your body is to use a yoga exercise called *mula bandha*. Ladies, think Kegel muscles. Men, think

the muscle under your testicles. It may sound strange but it works. In fact, it may become your favorite new tool. Squeezing those muscles sends a bolt of energy up through the body that puts a sparkle in your eye. And that sparkle says, "I'm here," and it makes you a lot more interesting than actors who don't have the sparkle.

The eyes are the avenues to the soul and one of the messages you want to send, whether you're working or auditioning is, "I am here. I am present. My mind, body and soul are activated and I'm ready to work." Engaging those muscles will make that happen.

MAKE STRONG CHOICES

Find a way to keep the stakes high. If you don't it will seem as if you don't care and indifference, as I have said before, is not only hard to play, it's boring to watch. Your job as a commercial actor is to solve someone else's problem. If you make the problem important, it'll be easier to solve.

Commercials are by their very nature artificial. Nobody talks that way in real life, but when you're auditioning for a commercial, whatever you're saying needs to be said with complete sincerity.

DON'T MEMORIZE—NOT YET

One way actors shoot themselves in the foot is by trying to memorize the script . . . too early. By doing the other work first, by breaking it down as described in this book, you turn the script into a story in which things happen in a logical sequence. One line automatically leads you to the next and this makes memorizing easier.

If you spend all your time trying to memorize the words, you may not fully comprehend the "story" of the commercial or the best way to tell it. Get to your audition early, break down the script and, once you know what the story is, you can start memorizing your lines. If you do make a mistake, it's better to screw up a couple of words than to screw up the story idea.

Remember, the story, especially at the initial audition, is more important than the words.

If you get jammed at the audition—if you're late, or if they call you in early and you don't have a lot of time—do as much of the work as you can and then memorize the first line and the last line. That way, you can

deliver those lines with confidence directly to the person you've placed in the camera.

If they have a cue card (a board) with the script written on it, don't be afraid to use it. The trick is to not get stuck reading the words off the board. Remember, you want to be in relationship with the person you put in the camera, not glued to the board. Learn to look at the board and pick up phrases instead of individual words. The best way to do this is to look at the board and pick up a phrase, then look back at the camera, and reconnect to the person you were talking to. Then, once you have reconnected, deliver the line to the person in the camera. This is a skill you can learn but, like anything else, it takes practice.

SPEED IS YOUR ENEMY

Going too fast lets everyone know you're nervous. Nobody wants a nervous actor on set. Good actors know it takes time to create relationships. Good actors know their purpose is to tell a story. Good actors know to create sub-text for their lines. And good actors know to listen to the other characters. All of this takes time. Slow down and be a good actor.

You don't get a prize for telling a thirty-second story in ten seconds.

ASK FOR A REHEARSAL

Actors will often go on a commercial audition, a job that could pay their rent for the next three years, and don't ask for a rehearsal. They expect some-how, magically, the gods will smile on them and they'll be perfect. And then when they aren't, they blow the whole thing off, saying, "Commercials—I don't know why I bother to go. I never book." No kidding!

You need to rehearse, in the room. I've been perfect on every audition I've been on . . . IN THE LOBBY. There's no pressure—IN THE LOBBY. You're sitting in a corner by yourself mumbling your lines at half volume. Then suddenly you're in the audition room staring at a one-eyed, three-legged monster and 95 percent of the work you were doing IN THE LOBBY has flown out the window.

Asking for a rehearsal takes courage. As actors we don't want to come off as being difficult. I'm not suggesting that. I'm suggesting you take care of yourself. You got dressed, put on your make-up, drove or took the subway to the audition, did your prep work; for what? To do a bad job? If that's the case, stay home. Save everyone, including yourself, a lot of time and effort.

A rehearsal is a vital piece of the audition process. By asking for a rehearsal you'll have a chance to say the words out loud in the room. Hopefully you'll get some feedback and pick up some information you didn't have before. If you don't ask for a rehearsal the people who watch your playback are judging you on your first take. Good job, bad job— you've made an impression.

If it's a bad impression, it will be hard for them to get over it. And if it is really bad, they'll fast-forward to the next person. Even if you do an outstanding job on your second take, chances are they won't see it.

Remember why you're there: you're there to book a job. And know this, a lot of people are rooting for you. Your agent is rooting for you; the casting director is rooting for you; the ad agency people are rooting for you; the client is rooting for you; the roommate you owe money to is rooting for you.

They all want you to do a great job. If you do a great job their problem is solved.

Everybody is rooting for you.

It is very possible that at some point during the day the casting director will fall behind schedule. If you were on time and you've done everything you were supposed to do, don't let their time problem become your problem. You don't have to be a jerk about it; you want to be as diplomatic as you can be, and you want to make sure you do everything you can to get a rehearsal.

If they're hesitant, say, "I know you want me to do the best job I can, and if you would let me have a rehearsal, I could do that." That's exactly what they want: they want you to do a wonderful job. By asking for a rehearsal in this manner, it takes the onus off you. You're merely reminding them of why they asked you to audition in the first place.

For the most part, casting directors are decent, hard-working people. Casting a commercial isn't easy and casting directors often face an arduous task. They have to take the "not-as-yet-completely-realized" idea that the ad agency is trying to convey and find the talent that will bring full expression to that idea. This is hard. Show them how professional you are by doing your job well and they'll be more inclined to give you a rehearsal when you ask for one.

The best time to ask for a rehearsal is when you first get into the room, before your slate. However, if you've already slated and the camera is rolling, you can still ask for a rehearsal. Sometimes the casting director will hit the pause button but even if the camera continues to roll, because you asked for a rehearsal, you've already set it up in the minds of the people

If the casting director gives you a rehearsal, be respectful.

watching the playback that the next thing they're going to see is a rehearsal, not a performance. This is an important distinction.

Do everything in your power to incorporate the feedback you get. You asked for help. You got it. Now use it.

KNOW YOUR FRAME

It's also important to ask for your frame. You need to know how much of you the camera is seeing. If you're planning to use a prop, you need to know if that prop is going to be in the frame. There's no sense in holding a box of Cheerios in front of your stomach if they're shooting a close-up of your face. You need to know what part of your body is working, what exactly the camera is seeing.

The tighter the frame, the less you'll need to do to get your point across. Think about it this way: how expressive would you need to be to communicate an idea to someone standing twenty feet away, and how expressive would you need to be to convey that same information if the person was just two feet away? What is going on inside you is the same it's just that your outward expression of it is less.

A FEW WORDS ABOUT IMPROV

In the past, actors would occasionally be asked to improvise during commercial auditions. And actors, being the obliging people we are, would do it. Then somewhere in the process, an improvisation created by an actor during the audition would show up in the commercial, but not necessarily by the actor who created it. Another actor would be hired and directed to "use this bit" (usually a piece of business but occasionally a line of dialogue), and the actor who created the "bit" not only didn't get the job, he/she wasn't compensated for the contribution either. This behavior was reported to the Screen Actors Guild and the Screen Actors Guild passed a rule that actors could no longer be asked to "improv" at auditions.

Nowadays casting directors may ask you to "loosen it up" a little at your audition. This is another way of asking you to improvise without actually saying the word. Either way, it puts you between a rock and a hard place, and you have to decide: "To improv or not to improv?" If you don't, you may come across as being uncooperative; if you do, you run the risk of having your creativity "borrowed." Unfortunately, this is a line you have to draw for yourself.

Non-union actors face an even more precarious position when it comes to improvising at auditions because they don't have a powerful union watching their backs.

EXERCISE

Make sure your body shows up with you.

Practice laughing and jumping. Sounds weird I know. But if you have a camera you'll see what I'm talking about. First slate without laughing or jumping and then, after you've done your impression of a hysterical kangaroo, slate again. You will see a huge difference.

The initial results may be too "big" to use for your slate, but you will see a sparkle in your eye that wasn't there before. Once you have the sparkle it is very easy to modify the amount of laughing and jumping you'll need to do to make your slates stand out.

And don't forget mula bandha. This, too, will put a twinkle in your eye.

Use the boards.

Write out a series of commercials. Use poster-size paper (butcher paper will do). Use commercial copy you haven't worked with before. Write it and tape it next to the camera. Practice looking from the board to the camera. Work on picking up phrases and whole sentences instead of just "grabbing" one word at a time.

Slow down.

Using the same pieces of copy, write out the banter and then make sure you hear it before going on to the next line. This is easier when you're doing double or multiple-person copy because, except for the moment before, the other character's lines are your banter.

Your Greatest Asset—You

Acknowledging Your Power

The last and most important thing to remember is how much power you have at a commercial audition. It may not seem that way, but it's true.

What is a commercial audition? It's a job interview. Except you have advantages at a commercial audition you don't have when interviewing for a "regular" job. If you've done the homework, you know all the pieces to the puzzle. You know how the commercial's going to start and how it's going to end. You know what the problem is and you know what the solution is. You know what the relationships are and you know how you feel about each one. You know what your frame is, what the camera is seeing. You know which physical actions are necessary to enhance the story and when and how you're going to execute them. You know whom you're talking to and what you're going to say to them, and you know what they're going to say to you. Heck, if you've done the banter right, you've written half of the script yourself. All of this knowledge puts you in a very advantageous position, light years ahead of the other actors auditioning for the same spot.

I trust you will use this newfound power wisely. You never need to make anyone else wrong in order for you to be right. Let the quality of your work speak for itself. At the end of the day, after luck and all the other fickle forces have been factored in, talent ultimately wins out.

Talent enhanced with technique is an unbeatable combination.

A shortstop will practice an endless number of hours to perfect playing his position. He doesn't get to tell the batter where he wants the ball hit or how hard to hit it. He plays each ball as it comes. It's the same for actors. Your responsibility is to do the best job you can regardless of the material you're given. Sometimes you'll be handed diamonds; other times, dirt. What you do with it is up to you.

Be the best actor you can be. Whether you're auditioning for a commercial or playing a small role in your community theatre, co-starring in a Broadway show or playing the lead in a feature film, know there is value in what you do. Honor your craft and be proud of your work.

Commercial Practice Copy

Here are several pieces of copy with room for you to add in your work, i.e., relationships, the Moment Before, banter, L2LOs, tag, etc.

Round-up Barbecue Sauce

(Talent: Man at an outdoor grill, cooking.)
TALENT: PEOPLE ASK ME ALL THE TIME . . . HOW COME
YOU'RE SUCH A GOOD COOK?
I TELL 'EM IT'S THE SAUCE.
(He holds up a jar of Round-up.)
IT'S TRUE.
IF YOU WANT TO BE A GRILL MASTER, YOU NEED TO START
WITH GOOD SAUCE.
(He opens the jar and pours some on the meat on the
grill.)
ROUND-UP BARBECUE SAUCE.
NO QUESTION, YOU'LL BE THE BEST COOK IN TOWN.

Wipe Once Cleaner

(Talent: Woman, mid-forties, in kitchen, cleaning.)
TALENT: CLEANING ISN'T THE PROBLEM; HAVING TO
RE-CLEAN EVERYTHING IS.
FIRST YOU USE A SPRAY THAT TAKES OFF THE
GRIME . . . AND THEN YOU HAVE TO USE ANOTHER CLEANER

TO GET RID OF THE STREAKS THE FIRST CLEANER LEFT
BEHIND.
THAT'S WHY I USE WIPE ONCE CLEANER.
IT GETS RID OF ALL THE DIRT AND GRIME IN ONE STEP.
DON'T DOUBLE YOUR WORK LOAD . . . USE WIPE ONCE
CLEANER.

Atlantas Television

(Talent: Salesman or saleswoman in a showroom.)
TALENT: ATLANTAS ARE THE BEST TELEVISIONS IN THE
BUSINESS.
FROM 9 INCHES TO 60 INCHES, NOBODY GIVES YOU A
BETTER PICTURE.
AND NOW THROUGH DECEMBER 25TH, WE WILL GIVE YOU 25%
OFF EVERY ATLANTAS TELEVISION SET YOU BUY.
THAT'S RIGHT, 25% OFF EVERY SET.

Nicoteam

(Talent: Man or woman in office. Several team
members work the phones in background as talent
talks.)
TALENT: IF YOU'RE AN EX-SMOKER LIKE ME, YOU KNOW HOW
HARD IT IS TO QUIT SMOKING.
ESPECIALLY IF YOU'RE DOING IT ALONE.
THAT'S WHAT MAKES NICOTEAM SO UNIQUE.
NICOTEAM IS MORE THAN JUST A PATCH.
NICOTEAM IS A GROUP OF VOLUNTEERS, EX-SMOKERS LIKE
ME, AVAILABLE 24/7 TO HELP TALK YOU THROUGH YOUR
CRAVINGS.
SO, IF YOU'RE READY TO QUIT SMOKING . . . PICK UP A
PACK OF NICOTEAM PATCHES AT YOUR LOCAL PHARMACY AND
PUT YOUR TEAM TO WORK.
NICOTEAM.

Vision Clear

(Talent: Man or woman in vision clear office.)
TALENT: WHEN EVERYTHING'S BLURRY, LIFE ISN'T MUCH
FUN.
STOP IN AT VISION CLEAR AND WE'LL GIVE YOU AN EYE
EXAM FOR FREE.

AND IF YOU NEED GLASSES . . . WELL, THAT'S WHAT WE DO.
DON'T WAIT TOO LONG . . . OFFER EXPIRES SOON.

Champion Raisin Bran Nutrition Bars

(Talent: Man or woman, mid-thirties. Fit, in good
shape. Outdoors; camping setting in background.)
TALENT: IF YOU'RE A GET-UP-AND-GO PERSON, YOU WANT A
BREAKFAST THAT MOVES WITH YOU.
CHAMPION RAISIN BRAN NUTRITION BARS ARE PACKED WITH
ALL THE VITAMINS AND NUTRIENTS YOU'LL NEED TO KEEP
YOU GOING ALL MORNING LONG.
AND THEY TASTE GOOD TOO.
CHAMPION RAISIN BRAN NUTRITION BARS.

Fab Four Daily Lottery

(Talent: Man or woman. Character, quirky.)
TALENT: HURRY! HURRY!
FOUR OF THESE NUMBERS COULD WIN YOU $1,500.00 IN
TONIGHT'S FAB FOUR DAILY LOTTERY DRAWING.
COME ON! COME ON!!
DID YOU GET THEM?
YOU DID?
GOOD!

Leary's Steak House

(Talent: Couple, early thirties, sitting in a
restaurant.)
WOMAN: CAN WE AFFORD THIS?
MAN: YES.
WOMAN: DID YOU GET A RAISE?
MAN: NO.
WOMAN: A BONUS?
MAN: NO.
WOMAN: THEN WHAT ARE WE DOING HERE?
MAN: IT'S OUR ANNIVERSARY.
WOMAN: I KNOW, BUT IT LOOKS SO EXPENSIVE.
MAN: NOTHING'S TOO GOOD FOR MY BABY.
(The woman swoons.)
ANNOUNCER (VO): LEARY'S STEAK HOUSE SPECIAL. STEAK
AND LOBSTER FOR ONLY $15.95.

Tower Bank Card

(Talent: Man, early thirties; woman, early twenties; having lunch.)

MAN: SO, HOW ARE YOU DOING?

WOMAN: THINGS ARE GOOD.

MAN: MOM AND DAD WERE CONCERNED . . .

WOMAN: ABOUT WHAT?

MAN: YOU KNOW. YOUNG WOMAN, BIG CITY, NEW JOB. THEY WERE AFRAID MONEY MIGHT BE A LITTLE TIGHT.

WOMAN: I'M GOOD.

(Waiter puts check on table. Man reaches for it.)

MAN: HERE, I'LL TAKE CARE OF THAT.

WOMAN: NO WAY. I'VE GOT IT.

(She places a tower bank card on the check. Man picks up the card and looks at it.)

MAN: TOWER BANK, HUH? I'M GOING TO LET MOM AND DAD KNOW THEY CAN STOP WORRYING.

WOMAN: YOU CAN STOP WORRYING, TOO.

MAN: ME? I WASN'T WORRIED.

WOMAN: YEAH, RIGHT.

Peterson's Yogurt

(Talent: Middle aged couple on a first date. Talent should be prepared to read both parts.)

ONE: TASTE?

TWO: NO, THANKS. I'M NOT REALLY INTO YOGURT.

ONE: IT'S NOT JUST YOGURT, IT'S PETERSON'S YOGURT. IT TASTES LIKE . . .

TWO: (TASTING) OH, WOW! THAT'S THE BEST TASTING ICE CREAM I'VE EVER HAD.

ONE: ONLY IT'S NOT ICE CREAM.

TWO: IT'S NOT?

ONE: IT'S YOGURT. NON-FAT AND ONLY TEN CALORIES.

TWO: TEN CALORIES?

ONE: YEP.

TWO: WELL, I GUESS THAT'S OVER.

ONE: OVER?

TWO: YEAH, NO MORE ICE CREAM FOR ME. FROM NOW ON IT'S JUST PETERSON'S . . . AND YOU.

Jordan's Fish & Chips

(Talent: Customer, man, early forties, seated at a restaurant. Waitress, any age, sets a plate down in front of him.)

CUSTOMER: EXCUSE ME, I DIDN'T ORDER THAT.

WAITRESS: YES, YOU DID.

CUSTOMER: NO, I DIDN'T.

WAITRESS: YOU DIDN'T ORDER A JORDAN'S FISH AND CHIPS BASKET?

CUSTOMER: THAT'S NOT A JORDAN'S FISH AND CHIPS BASKET.

WAITRESS: YES, IT IS.

CUSTOMER: BUT IT HAS COLE SLAW AND HUSH PUPPIES.

WAITRESS: THAT'S THE WAY JORDAN'S FISH AND CHIPS BASKETS COME NOW . . . WITH COLE SLAW AND HUSH PUPPIES . . . ALL FOR THE SAME PRICE.

CUSTOMER: SAME PRICE?

WAITRESS: SAME PRICE.

CUSTOMER: OH . . . YOU KNOW, I THINK I DID ORDER THAT.

Begalman's

(Talent: Two women sit on a bench in a suburban mall.)

ONE: WHAT A HUGE MALL. I CAN'T GET OVER THE NUMBER OF SHOPS.

TWO: I TOLD YOU.

ONE: WITH ALL THESE STORES YOU'D THINK I COULD FIND A DECENT PAIR OF SHOES.

TWO: I KEEP TELLING YOU, YOU'RE LOOKING IN ALL THE WRONG STORES. THE ONLY PLACE TO BUY SHOES IS AT BEGALMAN'S.

ONE: BEGALMAN'S IS A DEPARTMENT STORE.

TWO: YEAH, BUT THEY STARTED OUT AS A SHOE STORE. THEY'RE FAMOUS FOR THEIR SELECTION. AND FOR HAVING EVERY CONCEIVABLE SIZE. EVEN YOURS.

ONE: CUTE. WHY DIDN'T YOU TELL ME THAT BEFORE WE WENT TO TWENTY-EIGHT DIFFERENT SHOE STORES?

TWO: I THOUGHT EVERYONE KNEW ABOUT BEGALMAN'S.

ONE: NOW EVERYONE DOES.

(Talent One Gets Up And Walks Away.)

TWO: HEY, WAIT FOR ME.

219

Soymates

(Talent: Two women at the gym talking to a friend.
friend is in the camera.)

A: WOW. YOU LOOK GREAT. DOESN'T SHE LOOK GREAT?

B: YEAH, GREAT!

A: LOSING WEIGHT, TONING UP.

B: LOOKING HOT!

A: BUT ARE YOU DENYING YOURSELF CHOCOLATE?

B: DON'T WANT TO DO THAT.

A: AND YOU DON'T HAVE TO.

B: NOT WITH SOYMATES DELICIOUS DESSERTS.
SOYMATES COME IN MOCHA FUDGE . . .

A: CHOCOLATE ROYALE . . .

B: AND DOUBLE MINT CHIP.

A: THEY'RE SO GOOD YOU'LL FORGET THEY'RE HEALTHY.

B: SO GOOD.

Community Recycling

(Talent: Two men, neighbors, putting their trash out
on the curb for pick-up. Man #1 is in his forties;
man #2 is younger.)

ONE: THAT'S QUITE A STACK OF NEWSPAPERS YOU'VE GOT
THERE.

TWO: JUST A WEEK'S WORTH.

ONE: YOU'RE GOING TO RECYCLE IT, RIGHT?

TWO: WHAT FOR? IT'LL JUST GET PILED UP SOMEWHERE
ELSE.

ONE: YOU DON'T THINK THEY COULD BE MADE INTO NEW
PRODUCTS?

TWO: WHAT CAN YOU MAKE OUT OF OLD NEWSPAPERS?

ONE: WELL, HOW ABOUT NEW NEWSPAPERS?

TWO: OH, YEAH. I HADN'T THOUGHT ABOUT THAT.

ANNOUNCER (VO): RECYCLING. IT JUST MAKES SENSE.

1 Ben Brantley, "How Mark Rylance Becomes Olivia on Stage", *New York Times*, August 14, 2016.

2 Lajos Egri, *The Art of Dramatic Writing* (New York: Simon & Schuster, 1946).

3 Please note that we have slightly modified Mr. Egri's original paradigm.

4 *Absence of Malice* (1981): written by Kurt Luedtke, directed and produced by Sydney Pollack. The film starred Paul Newman, Sally Fields, and Melinda Dillon.

5 This scene was given to me by one of my students several years ago. I have searched the Internet but haven't been able to identify the author. I would like to be able to give him/her credit, as we use this scene often. It provides some wonderful challenges for actors to deal with in order to develop their characters.

6 Michael Shurtleff, *Audition* (New York: Bantam Books, 1980).

7 *Lantana* (2001): produced by Jan Chapman.

8 *Longtime Companion* (1989): written by Craig Lucas, directed by Norman Rene, produced by Stan Wlodkowski, Lydia Dean Pilcher and Lindsay Law.

9 *Carol* (2015): screenwriter Phyllis Nagy, based on a novel by Patricia Highsmith, directed by Todd Haynes, produced by Christine Vachon and Elizabeth Karlsen.

10 *La La Land* (2016): directed by Damian Chazelle, produced by Fred Berger, Black Label Media, Summit Entertainment and Marc Platt Productions.

11 Shurtleff, *Audition*.

12 *The Thomas Crown Affair* (1968): produced by Hal Ashby and Norman Jewison. This scene remained virtually intact in the second (1999) version.

13 *Body Heat* (1981): produced by Fred T. Gallo.

14 *Georgia* (1995): produced by Ben Barenholtz, Amanda DiGiulio, Ulu Grosbard, Jennifer Jason Leigh and Barbara Turner.

15 Shurtleff, *Audition*.

16 Shurtleff, *Audition*.

Recommended Reading

The following are books that, one way or another, helped shape my career as both an actor and a teacher. A couple, *Audition* and *Adventures in the Screen Trade*, served as bibles. Happy reading.

Barr, Tony
Acting for the Camera
New York: Perennial Library, 1986

Boleslavsky, Richard
Acting, The First 6 Lessons
New York: Theatre Arts, 1933

Caine, Michael
Acting in Film
New York: Applause Theatre Books, 1997

Egri, Lajos
The Art of Dramatic Writing
New York: Simon & Schuster, 1946

Goldman, William
Adventures in the Screen Trade
New York: Warner Books, 1983

Hagen, Uta
Respect for Acting
Hoboken, NJ: John Wiley & Sons, Inc., 1973

Lumet, Sidney
Making Movies
New York: Vintage Books/Random House, 1996

Meisner, Sanfrod
On Acting
New York: Vintage Books/Random House, 1987

Psacharopoulos Nikos and Jean Hackett
Toward Mastery: A Class with Nikos
Hanover, NH: Smith & Kraus, 1999

Shurtleff, Michael
Audition
New York: Bantam Books, 1980

Stanislavski, Constanin
An Actor Prepares
New York: Theatre Arts, 1936

Tucker, Patrick
Secrets of Screen Acting
Oxfordshire and New York: Routledge, 1993

A

ABC 139
Absence of Malice 25, 76, 105, 135
action 18
actions 1, 13, 21, 62, 67, 91–2, 95, 100, 119, 121, 150, 173, 213
Adams, Amy 101
Adler, Stella 51
Air America 6
Angels in America 7
Antigone 105
Art of Dramatic Writing, The 22, 223
Audition 51, 221, 223

B

banter 130, 181–2, 186, 193, 196–7, 211, 213, 215
Bar Scene 44, 129, 139
Berghof, Herbert 105, 221
Bitter Harvest 17
Black Box 139
Blake, Rachael 55
Blanchett, Cate 58
beats 21, 67, 91–2, 95, 119, 138–9, 144–5, 150–1, 154, 173
beats, tactics, actions 21, 67, 91, 95, 119, 150, 173
Body Heat 64, 81
bones, the 21–3, 25, 30, 40, 41, 43, 52, 62, 76, 128, 147, 153
Bovell, Andrew 55, 221
Bridges, Jeff 6
Brody, Adrien 6

C

camera rehearsal 18
Capone, Al 44
Carol 6
Carr, Kate 189

casting director 51, 74–6, 138–9, 153–4, 159, 161, 167, 178–9, 183, 189, 192, 201, 205–6, 209, 210
Cat On A Hot Tin Roof 59
Chazelle, Damien 58
cinematographer 19
close-up 5, 16, 210
continuity 18
Cool Hand Luke 128
commercials 155–58, 160–1, 164, 173–5, 182, 1871, 189, 198–9, 201, 206–8, 211
coverage 2, 5, 18, 19
Cranston, Bryan 156
Creon 105
cut 5, 18, 19
cutter 19

D

Davison, Bruce 58
Death of A Salesman 62
Dillon, Melinda 40, 221
director 2–7, 11, 16–19, 24, 51, 59, 61, 67, 74–6, 80–1, 102, 137–9, 144, 151, 153–4, 173–4, 178, 192, 207
discoveries 6, 80, 89, 91, 101, 149
discoveries/emotions 79, 81, 95, 101, 114–15, 120, 149, 153
dolly 19
double 16
Downey, Robert Jr. 6
DP, Director of Photography 19
Dunaway, Faye 68
Durning, Charles 13
Duvall, Robert 156

E

editor 19
Egri, Lajos 22, 221
embracing the cliché
environment 183–4, 187

P

Pacino, Al 7
Parsons, Jim 161
Pianist, The 64
pick-up 19
place 113–16, 119, 120, 124, 150
Pollack, Sidney
Psacharopoulos, Nicos 51, 221

R

reaction shot 19
Redford, Robert 51
relationships 13, 51–3, 57–9, 148, 153, 167–9,
 172, 176, 181, 205, 208, 213, 215
reverse close-up 16
reverse over-the-shoulder shot 16
Romeo and Juliet 52, 62–3, 104
running order 19
Running With Scissors 76
Rylance, Mark 5, 221

S

script person, scriptie 18
self-taping 101, 138, 153, 206
sense memory 118–19, 122–5, 150
Shakespeare, William 53
Shepherd, Cybill 75
shooting script 19
shooting out of sequence 17
Shurtleff, Michael 51, 58, 76, 103, 221
Silence of the Lambs 44
slate, slating 150–61, 163, 201, 206, 209
Smith, Will 161
Stanislavski, Constantin 51, 223
Stars Wars 52
Stoltz, Eric 139
Stone, Emma 58
Strasberg, Lee 51
Streep, Meryl 6, 7, 21, 64, 136
Streisand, Barbara 51

Swank, Hilary 156
summary 137–9, 145, 151, 154

T

tactics 21, 67, 91–2, 100, 119, 150, 173
tag 177–8, 186, 190, 193, 198, 215
take 19
ten positive attributes 43, 50, 78, 139
Terminator 2: Judgment Day 76
Thomas Crown Affair, The 68, 130, 221
Thompson, Emma 7
Titanic 76
tracking shot 19
transitions 116, 118–19, 121, 124
Trustman, Alan 68
two shot 16
Turner, Barbara 92, 221
Turner, Kathleen 64, 81

U

Untouchables, The 76

W

Warren, Leslie Ann 15
wide shot 5, 15, 16
Willis, Bruce 75
Wilson, Patrick 7
Winningham, Mare 92
wrap 19
Wright, Al vii
Wright, Jeffrey 7

Y

Young & Rubicam 189

Z

zoom 19

14628375R00133